T0021394

"While all of this is the sort of stuff that professional medievalists love to see, the thing I like most about Perry and Gabriele's effort is that it is fun. *The Bright Ages* is written in such an engaging and light manner that it is easy to race through. I found myself at the end of chapters faster than I wanted to be, completely drawn in by the narrative. You can tell how much the authors love the subject matter, and that they had a great time choosing stories to share and evidence to consider." —*Slate*

"Incandescent and ultimately intoxicating, for as the chapters progress, it dawns on the reader that those who lived in this period were more conventional than cardboard figures. . . . They were, in essence, human." —*Boston Globe*

"This revisionist history of medieval Europe takes apart the myth of a savage, primitive period . . . with passion and verve, [Gabriele and Perry challenge] the reader to tackle assumptions, bias, and prejudices about the past to create a more joined-up, inclusive picture of the thousand years that followed the sack of Rome." —Peter Frankopan, *The Guardian*

"*The Bright Ages* is a necessary book. It does the hard work of introducing audiences to a world that we too often overlook for expressly political reasons. It is also a joyful work. The medieval period, Perry and Gabriele argue, has good news for us. The world can be beautiful without centralized and brutal imperial power." —*Los Angeles Review of Books*

"*The Bright Ages* shines a light on an age too often obscured by myth, legend, and fairy tales. Traveling easily through a thousand years of history, *The Bright Ages* reminds us society never collapsed when the Roman Empire fell, nor did the modern world wake civilization from a thousand-year hibernation. Gabriele and Perry show the medieval world was neither a romantic wonderland nor a deplorable dungeon, but instead a real world full of real people with hopes, dreams, and fears making the most of their time on earth."

—Mike Duncan, author of *Hero of Two Worlds:*
The Marquis de Lafayette in the Age of Revolution and
The Storm Before the Storm: The Beginning of the End of the Roman Republic

"This book is perfect for people who are interested in the period but don't know where to start. Because the scale is sweeping but so well organized. . . . Most importantly, it's really entertaining. . . . I recommend."

—Brandon Taylor, author of *Real Life* and *Filthy Animals*

"A lively, searing, and transformative reimagining of the medieval world, *The Bright Ages* is brilliant in every way, both lucid in its arguments and sparkling in its prose. A gripping and compulsive read."

—Bruce Holsinger, author of *A Burnable Book* and *The Gifted School*

"In this engaging new history of the medieval period, Gabriele and Perry achieve a feat: they have written something eminently readable, suffused with academic rigor, and ethically responsible."

—Candida Moss, author of *The Myth of Persecution*

"Historians Gabriele and Perry argue in this accessible revisionist history that the so-called Dark Ages was actually a period of innovation that helped pave the way for the Renaissance and

Enlightenment. . . . They add nuance and complexity to popular conceptions of the Dark Ages and make clear that beauty and achievement existed among the horrors. This is a worthy introduction to an oft-misunderstood period in world history."

—*Publishers Weekly*

"Although traditional politics-and-great-men history makes an appearance, the authors keep current by including a surprising number of great women and emphasizing their disapproval of racism, sexism, and slavery. The result is an appealing account of a millennium packed with culture, beauty, science, learning, and the rise and fall of empires."

—*Kirkus Reviews*

"Noted medieval historians Gabriele and Perry provide an engaging overview of a complex, yet often oversimplified era . . . sure to become a new standard for those seeking a comprehensive and inclusive review of medieval times."

—*Booklist*

"Matthew Gabriele and David M. Perry liberate the Middle Ages from stereotypes and half-truths in *The Bright Ages*, revealing that world as 'not simple or clean, but messy and human' . . . [a] lively account of a misunderstood era."

—*Shelf Awareness*

"This accessible trip through the medieval world is well worth taking for anyone wishing to better understand its complexity."

—*Library Journal*

"[Gabriele and Perry] also point out the risk of mobilizing the past for nefarious ends, such as white supremacists who look back at an oversimplified, torqued version of the past to frame their own crusade. Gabriele and Perry's new look at an old time is welcome Especially now."

—*Globe & Mail* (Toronto)

The
BRIGHT
AGES

The
BRIGHT
AGES

A New History
of Medieval Europe

Matthew Gabriele
and David M. Perry

HARPER PERENNIAL

NEW YORK • LONDON • TORONTO • SYDNEY • NEW DELHI • AUCKLAND

HARPER PERENNIAL

HarperCollins books may be purchased for educational, business, or sales promotional use. For information, please email the Special Markets Department at SPsales@harpercollins.com.

FIRST HARPER PERENNIAL EDITION PUBLISHED 2022.

Designed by Nancy Singer

Map on page viii by John Wyatt Greenlee

Library of Congress Cataloging-in-Publication Data has been applied for.

ISBN 978-0-06-298090-8 (pbk.)

22 23 24 25 26 CPI 10 9 8 7 6 5 4 3 2

Printed and bound by CPI Group (UK) Ltd, Croydon, CR0 4YY

To Rachel, Uly, Shannon, Nico, and Ellie.

And to all of our colleagues working to exorcise the ghosts of medieval studies that still haunt us, laboring to make the study of the past a more just, open, and welcoming field.

CONTENTS

SELECTED KEY LOCATIONS

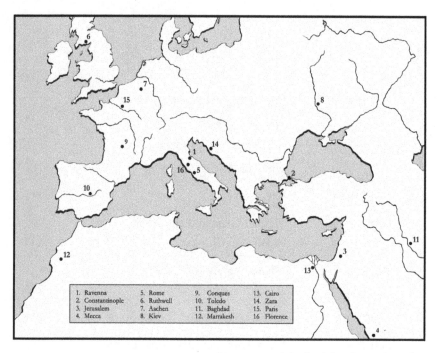

1.	Ravenna	5.	Rome	9.	Conques	13.	Cairo
2.	Constantinople	6.	Ruthwell	10.	Toledo	14.	Zara
3.	Jerusalem	7.	Aachen	11.	Baghdad	15.	Paris
4.	Mecca	8.	Kiev	12.	Marrakesh	16.	Florence

Map by John Wyatt Greenlee

THE BRIGHT AGES

Our story begins on the east coast of Italy on a sunny day sometime around the year 430 CE, when artisans entered a small chapel and turned the sky blue. The workers labored in the city of Ravenna at the behest, we think, of a woman by the name of Galla Placidia, sister of a Roman emperor, queen of the Visigoths, and eventually regent herself of the Western Roman Empire. A devout Christian, she built or restored churches in Jerusalem, Rome, and right here in Ravenna. Perhaps she commissioned and ordered the decoration of the small chapel as a reliquary; perhaps she planned it for her eventual tomb or to house the body of her son who died in infancy. We have theories, but no sure answers. What we do have is a building where once artists pressed into fresh mortar glass tesserae, small trapezoidal shapes infused with the blue of lapis lazuli, to turn the ceiling into the richest blue sky. They then took glass infused with gold and filled the heavens with stars on the ceiling. On the blue wall, they added other tesserae of white, yellow, and orange to the mix, replanting the flowers of the Garden of Eden. The technologies behind the mosaics were ancient but the people depicted in this world of blue sky and golden stars emerged from a very specific combination of time and place, part of a complicated—but not cataclysmic—transition that

would shift balances of power, cultural norms, and ideas about the deepest meanings of human existence.

In sunlight or candlelight, to this day, each mosaic piece, seen at fractionally different angles, can catch the light and reflect it toward its fellows or the eye of the beholder. Nearly 1,600 years later, the space still shimmers like the stars themselves.

On one wall inside the building, Jesus takes precedence as the kindly Good Shepherd sitting among his flock. Other depictions of the Good Shepherd had emphasized Christ's rough humanity, picturing him holding a lamb over his shoulder. But here the sheep stand apart, looking at Jesus, one nuzzling his hand. In brilliant robes of gold, the artist or artists perhaps sought to emphasize his divinity, seeking a different kind of truth for them than the more human-like art of the late classical world. On another wall, a male saint confronts a hot iron grill. Perhaps it's St. Lawrence, now the patron saint of chefs but famous for the story of his martyrdom—burned to death but serene enough to tell the centurion before his death to turn him over, since he was nicely cooked on the one side. Or it might be St. Vincent, a saint popular in Iberia, where Galla spent her time as a Visigothic queen, a man who had to watch as pagans burned his books and then was tortured with fire. Regardless, the stories being told on these walls—and throughout the fifth-century Mediterranean—are synthetic, weaving together strands of time, culture, and place that affirm continuity just as they mark significant change.

Beginnings and endings are arbitrary; they frame the story that the narrator wants to tell. Our story is one that escapes the myth of the "Dark Ages," a centuries-old understanding of the medieval world that sees it cast in shadow, only hazily understood, fixed and unchanging, but ultimately the opposite of what we want our modern world to be. So, let's for now forget those traditional transition points between the ancient and medieval worlds, the Council of Nicaea in

325 CE, the sack of Rome in 410, or the deposition in 476 of Romulus Augustulus as the "last" Roman emperor in the West. If we as a culture decide that the Middle Ages existed and had a beginning and end, we don't need to start with decline, darkness, or death. We can start in this shining, sacred, quiet space. This doesn't, of course, erase the violence of the past to replace it with naive nostalgia. Instead, it shows us that paths taken were not foreordained. Shifting our perspective brings people, traditionally marginalized in other tellings, into focus. Starting somewhere else shows us possible worlds.

And nearly a thousand years later, in 1321, we might end the Middle Ages in the exact same place, in the same city, in the same building. Here, once again, we can affirm continuities and mark change, walking with the medieval poet Dante Alighieri as he lingered in the churches of Ravenna, drawing inspiration from these same mosaics as he composed his grand vision that encompassed the whole universe. Dante was an exile from his native Florence and ended his life in the court of the prince of Ravenna. He traveled to Venice and saw the industrial Arsenale, built in the early twelfth century, and placed it in Hell. Alongside it, facing eternal torment, we find popes and Florentines alike. He seethed at the factional politics of the papacy and in the medieval democracy of Florence, and damned them. But in Ravenna, he seems to have been moved by the tranquility of Galla Placidia's mausoleum and the majesty of the neighboring imperial mosaics of Justinian and Theodora in the church of San Vitale. It was here in Ravenna, maybe among the shimmering skies of a church built nearly a millennium before, that he found the inspiration to finish the *Paradiso*, the last book of *The Divine Comedy*.

Dante's is one of the great works of art of the Middle Ages, or of any age, firmly grounded in its political and cultural moment, inspired by a whole world and a whole millennium of art, culture, and religion that had passed through Italy. *The Divine Comedy* wallows in death and

darkness, even as it captures beauty and light; Dante's ascent through hell, purgatory, and eventually heaven is completed with his vision of God as pure brightness. It's the same journey, perhaps, that devout viewers might imagine as they gaze at the stars and sky of the mosaic in the mausoleum, carrying their thoughts into the bright heavens. The Bright Ages begin and end bracketed by the hope of basking in light.

Medieval beauty is not all sacred, of course, at least not only sacred. The portraits of the Byzantine emperors next to Galla Placidia's mausoleum, too, belong to the Middle Ages, not only because hundreds of thousands of medieval eyes would have rested upon them as residents of Italian cities or travelers across the Adriatic moved through the imperial city, but also because of the multiple embedded meanings of these portraits. The mosaics of the emperors are symbols of a Mediterranean world, a medieval world, always in flux, with permeable borders, and signs of movement and cultural intermixing everywhere you look.

And so we look. We also listen to the mixing of languages in the sailors' patois and to the commonality of multilingualism across Europe, Asia, and North Africa. We find marketplaces where Jews spoke Latin, Christians spoke Greek, and everyone spoke Arabic. We find coconuts, ginger, and parrots coming in on Venetian ships that would eventually reach the ports of medieval England. We mark the brown skin on the faces of North Africans who always lived in Britain, as well as on French Mediterranean peasants telling dirty stories about horny priests, raunchy women, and easily fooled husbands.

But things that begin need to end, otherwise there's no *medium aevum*, no "middle age," no "medieval." So we select one potential end with Dante in the fourteenth century. The Italian humanists who followed him explicitly rejected the medieval and said they existed in a new age, a renewal, a so-called renaissance. We could instead draw

the medieval to a close just a bit later in the fourteenth century as plague ravaged Asia, Europe, North Africa, and the Middle East. Or we might say the medieval ends in the fifteenth century as the Ottoman Turks overwhelm the entire Eastern Mediterranean, creating a new empire that extends from the Indian Ocean to, from time to time, the walls of Vienna—an empire that would fight with the Christian Venetians and ally itself with the Christian French. Some have even argued that the medieval world comes to a close only with the French Revolution and the fall of the monarchy at the end of the eighteenth century.

But none of these moments are ultimately satisfactory. When we look closer we see how those Italians—Dante included—were very much products of the preceding centuries, very much themselves "medieval." The plague arrived because of connections between Asia and Europe that had been established across centuries. The Ottoman Turks emerged out of generations-long interactions between steppe and city, a people fully steeped in an intellectual culture that shuttled competing interpretations of both scripture and Aristotle from Persia to Iberia, a people carrying the same luxury goods and bacteria across regions. The French Revolution was possible only because medieval people experimented with democratic representation, oftentimes at a small scale, and had a long history of anti-authoritarian revolt. The peoples, the plague, the art, the governments, and the wars all belong to the medieval world.

But if there are no satisfactory endings, if all moments are close to what came before, why do we imagine there was a Middle Ages at all? Indeed, history doesn't have a starting point or a terminus. What is clear is that people in fourteenth- and fifteenth-century Italy, frustrated with the political chaos and warfare of their ugly era, decided to draw nostalgic links to the worlds of ancient Rome and Greece, using the distant past to sever their connection to the

previous thousand years of history. Later, throughout the eighteenth and nineteenth centuries, imperialist European powers and their intellectuals (often the forerunners of, or scholars in medieval studies themselves!) sought a history for their new world order to justify and explain why whiteness—a modern idea, albeit with medieval roots—justified their domination of the world. They found the proto-nations of the Middle Ages useful as a past to point to for their modern origins, pointing to both medieval connections to Greece and Rome and the independence and distinct traditions of medieval polities. These modern thinkers used the fiction of Europe and the invented concept of "Western Civilization" as a thread to tie the modern world together. They looked outside themselves and saw barbarism. They looked into both the medieval and classical European past and imagined they found white faces, like theirs, looking back at them. They were wrong about all of this.

Today, the Middle Ages are a sort of paradox. When people want to kick a current problem back into the past—whether Islamic terrorism, bungled responses to Covid-19, or even the process for getting a driver's license (it involves a lot of bureaucracy)—they call it "medieval." Yet when white supremacists want to claim an origin story for whiteness, they, too, look to the Middle Ages to seize on golden and glorious artifacts, big castles and cathedrals, to offer a simplification of racially pure patriarchal militarism, one that legitimizes their bigotry. The period is good and bad, transparent and opaque. The myth of the "Dark Ages," which survives quite ably in popular culture, allows the space for it to be whatever the popular imagination wants. If you can't see into the darkness, the imagination can run wild, focusing attention on and giving outsized importance to the small things you can see. It can be a space for seemingly clean and useful myths, useful to people with dangerous intentions.

Our story is a lot more messy.

The Bright Ages contain the beauty and light of stained glass in the high ceilings of the cathedral, the blood and sweat of the people who built them, the golden relics of the Church, the acts of charity and devotion by people of deep faith, but also the wars fought over ideas of the sacred, the scorched flesh of the heretics burned in the name of intolerance and fear. The Bright Ages reveal the permeable nature of the interwoven cultures of Europe in the thousand or so years before Dante. The Bright Ages looked outward from Europe but were not constrained to Europe. They were aware—as the medievals themselves were—of a much larger, round globe.

There were people who spoke different languages and ascribed to different religious traditions—or different versions of the same tradition. There were, for example, many Christianities and one catholic (with a small "c," meaning "universal") church. But throughout Europe and the Mediterranean there were also Muslims, Jews, and polytheists. Every single one of these people loved and lusted and hated and befriended in all the ways that humans do; often enough, they wrote about their lives, or made art, or left material traces unearthed after a millennium that we can still access today.

In these Bright Ages, scientists looked to the sky and measured the stars, built the university, laid the foundations for the European contribution to the global scientific revolution, and did so without surrendering their beliefs in a higher power. There were also, just as now, people who limited debate, prosecuted thought crimes, repressed freedom, and killed people who were different from them. The Bright Ages stand out as a pivotal place and time in history because they contain all the multitudes of possibility inherent in humanity. But until now those lights have often been hidden under a bushel of bad history and a persistent popular assumption about the Dark Ages, too often created and reinforced by medieval historians ourselves. We can at times revel in the weirdness of the medieval and forget to

teach the connections. At the same time, we can so insist upon those continuities, we forget how much things have changed over time.

WE ARE BOTH HISTORIANS OF MEDIEVAL EUROPE, having spent years with primary sources, producing our own research. But we've also, perhaps more important, been blessed by the work of hundreds of scholars who have shaken loose the old stories of the Dark Ages to reveal a much more complicated, more interesting picture of the period. Our colleagues and mentors have helped place Europe into broader global systems of trade, religion, movement of peoples, and disease. We've learned about medieval ideas of tolerance, but also the formation of ideas about racial difference and hierarchies. We've learned about moments of incredible beauty and others of shocking ignorance. Medievalists have built and then torn down the construct of feudalism as a system and replaced it with ideas of complex networks of affinity and hierarchy that morphed and flowed with big ideas and hyperlocal tradition. We now know so much more about medieval sex, violence, gender, beauty, reading, hate, tolerance, politics, economics, and everything else that humans do and are and make. Medievalists are complicit in the creation of the idea of the Dark Ages and how the medieval world is used in the service of hateful ideologies even today, but medievalists are also acknowledging mistakes and trying to tear that scaffolding down.

Here in the third decade of the twenty-first century, the Middle Ages seem to persistently intrude into modern society, but the stereotypical Middle Ages presented so often in popular culture is unrecognizable to historians like us. In part, this interest is spurred by the explosion of medieval fantasies such as *Game of Thrones*, the History Channel's *The Vikings*, or video games like the *Crusader Kings* or *Assassin's Creed* series. Sometimes, though, this interest is sparked by contemporary events or comments from those in power, such as

when politicians use "medieval" to describe a wall or "western civilization" as code for white nationalism. Sometimes symbols of the Middle Ages are used approvingly by the far right, emblazoned on shields in Virginia, fluttering on flags as the US Capitol is stormed, or peppered across the screed of a mass murderer in New Zealand. And the left embraces that language on occasion too, agreeing that a wall or some particularly horrific violent act is "medieval." In these cases, the adjective is used as an epithet—a term to signify backwardness, something we've moved beyond, that modernity has left behind. The "Dark Ages" lingers long on the tongue, it seems.

What this all reveals is that both the political left and right ultimately agree on the general parameters of the past. They can both claim an action to be "medieval" because they're both invoking the "Dark Ages"—the political right out of nostalgia for something lost, the left as dismissive of a past best forgotten. In medieval history classes, students arrive looking for darkness and grit, in part because TV shows and movies claim "authenticity" to the medieval as a defense for their depictions of sexism, rape, and torture. They never claim the same for their depictions of tolerance, beauty, and love. But the Middle Ages, and thus the Bright Ages, contain all of these things—light and dark, humanity and horror (but alas not a lot of dragons).

This is a new story of the European Middle Ages. We're going to start by following the travels, wiles, victories, and tragedies of Galla Placidia to offer a simple reframing of the fifth century under one premise: Rome did not fall.

Things continue and things change. Power will reorient around the great city of Constantinople and then the urban centers of the new Islamic empires, with Jerusalem always lingering in the imagination of these early medieval peoples, but never quite as consistently contested as later narratives would contend. In the far north, men

and women will dream and worry about the nature of time itself, as an elephant strides across Germany. Cities never vanish but they do shrink, both in population and in importance, as people find new ways to organize political, economic, and cultural life in seeking stability. That stability comes with innovative ways of thinking about God and their religion, sparking a fire that will nourish a blossoming of intellectual and literary life. But those same fires will consume anyone perceived as outside the truth, lit by men with hate in their eyes. But then circles turn again. Cities grow. Towers climb toward the sky. Connections between regions that were never severed did stretch and attenuate over the centuries, bringing with them ideas and bacteria, but also creating the conditions for a medieval Italian poet to follow in the footsteps of a late Roman empress. Welcome to *The Bright Ages*.

The
BRIGHT
AGES

SHIMMERING STARS ON THE ADRIATIC

Let's head back to the chapel of the empress Galla Placidia in Ravenna, built in the fifth century, and remembered today as a mausoleum even though she was never buried there. Though this is now changing, the empress doesn't always figure in histories told about this period except sometimes regarding when she held power as regent for her son, with the focus often revolving instead around the men, blood, and battles. But if we reframe our view around this woman and this space, we see a very different "beginning" to the European Middle Ages—one in which Rome doesn't fall.

The small enclosed space of the mausoleum embodies the continuation of Roman sacred, artistic, political, and technical culture as the empire transitioned into a new—and indeed different—Christian age. The mausoleum's dedicatee moved across the Mediterranean world: was born in Constantinople, then moved to Italy as a young girl, and from there to France and Spain, back to Italy, to Constantinople, and finally again to Italy. In the city of Ravenna, she took command of the whole of the Western Roman Empire in 423 CE, ruling in the name of her young son. In doing so, she was as much a ruler of Rome as

any person from the past five centuries, man or woman (women had, of course, always played in the Roman games of factions, power, and thrones). When she died in 450, she did so in an empire in peril and in transition, but a peril not necessarily different in kind or degree from what had befallen the empire before. In Rome, there had always been factional strife. There had always been external threats. There had always been a permeable world that spanned thousands of miles, one that engendered beauty, that revealed tenderness, and that at the same time demonstrated an almost limitless capacity for violence.

Why do the stars of Galla Placidia's mausoleum shine so brightly in this quiet, gentle space in Ravenna? The answer reflects the genius of fifth-century artists. A field of golden, tightly packed stars graces the highest part of the ceiling (the vault), but below, a second field of flower-like stars float in another celestial array of lapis blue glass. For the viewer, the brilliantly red, gold, and white patterns play on the eye like a kaleidoscope. Bands of darker colors trick the eye into seeing movement in the static glass. Walls of brilliant alabaster intensify the light, whether from the sun or flickering candles, making the gold itself seem like the source of the radiating light. The floor is artificially raised, drawing the viewer closer to the ceiling, intensifying the magical effect. Ancient sacred spaces across the Mediterranean world—both polytheistic and Jewish—had long relied on the manipulation of light and depictions of the sky to bring earth and heaven together in the gaze and mind of the viewer. This continued into Galla's Christian centuries. For the devout, this juxtaposition could become conjunction, bringing heaven and earth together, making the two feel both real and immediate to the viewer.

But what of Rome and the empire? Since at least the fourteenth century, but arguably since Galla Placidia's lifetime itself, the political, social, and religious turmoil of the 400s has enabled arguments about the fall of Rome. It's true that in 410, a large group of soldiers under

the command of the Gothic general and tribal chief Alaric, many of whom traced their lineage to Germanic peoples who had recently crossed into Roman territory, sacked Rome. It's also true that in 476, the military leader Odoacer would depose Romulus Augustulus, the Western Roman emperor at the time, and not bother to take the title for himself. It would seem that the empire in the West ended then.

Taken together, these two moments have often been presented as the end of one thing and the beginning of another. The famous bishop Augustine of Hippo, an earlier contemporary of Galla Placidia, had dedicated the entire first book of his mammoth *City of God* to explaining the violence visited against the city of Rome in 410. He was sure of two things: that it was absolutely not the Christians' fault, and that something had changed definitively. In modernity, that narrative was picked up again most famously in Edward Gibbon's eighteenth-century *The History of the Decline and Fall of the Roman Empire* and finds itself repeated (with, of course, some nuance) to this day. These are foundational moments of the so-called Fall of Rome and beginning of the Dark Ages.

But it's more complicated than that.

In 476, Odoacer did indeed depose one Roman emperor, but when he did so, he presented himself as a client to the other Roman emperor, in Constantinople, thus in a sense reuniting the Eastern and Western Roman empires once more under a single ruler in Asia Minor. And that precedent was followed. For centuries thereafter, leaders in Western Europe found ways to assert political legitimacy through ties to the still very much alive Roman Empire in the eastern Mediterranean. There was never a moment in the next thousand years in which at least one European or Mediterranean ruler didn't claim political legitimacy through a credible connection to the empire of the Romans, all the way back to Augustus. Usually, more than one ruler made equally credible assertions of "Romanness" (*Romanitas*), even

as the precise nature of the connections might vary widely. What's more, even medieval peoples who might not have thought of themselves as governed in any meaningful way by a Roman emperor still found themselves entangled in cultural and social norms (especially via Christianity) that depended for their shape on a Roman imperial legacy.

Moreover, Rome itself as a city remained important for elites in the region even though power centers had by then moved to Ravenna and Constantinople. In part, we're talking about an ideological connection, one enhanced by nostalgia and the need for political legitimacy, drawing lines all the way back to the legendary founders of Rome, Romulus and Remus. But it was more temporal as well, the city still being a location of social and cultural production throughout this period, and one in which elite Roman women, in particular, played critical roles in the city's governance and power structures. This brings us back to Galla Placidia and her canopy of brilliant stars.

Galla ruled the Western Roman Empire for her young son Valentinian from 425 to 437, when he turned eighteen and became emperor in his own right. Her seat of power was Ravenna, a city that had become capital of the Western Roman Empire only in 402, when Galla's half brother, Emperor Honorius (who reigned from 393 to 423), moved it there from Milan. The idea behind the move was that the easy access to the eastern Mediterranean from the Adriatic coast would enable more cohesion among the rulers of the empire, while the marshy ground surrounding the city would protect it from invasion. When Galla ruled there, she seems to have built a magnificent sacred complex of which only the small cross-shaped chapel remains, and which tradition rather than evidence has labeled her mausoleum. Still, even as she ran an empire from that city on the east coast of Italy, she never lost her belief in Rome's primacy, in its continuity.

Toward the end of her life, around 450, Galla wrote letters to her niece and nephew in Constantinople, Emperor Theodosius II (reigned 416–450), and his sister Pulcheria. Galla acted like a stern aunt, chastising them on how they had neglected their religion, telling them to get their acts together, because (she felt) the Christian church in the eastern Mediterranean was in shambles. On the other hand, she said that she and her son Emperor Valentinian III (reigned 425–455), had been treated very nicely by the bishop of Rome, Pope Leo I (440–461). Leo had himself greeted Galla and her party "on our very arrival in the ancient city," and informed her that church disputes in the eastern Mediterranean were threatening the empire's support for Christianity that stretched back to Constantine. Something had to be done. So she wrote her letter—a letter that, at its core, asserted her status, referring to herself as "most pious and prosperous, perpetual Augusta and mother," contrasting the order and antiquity of Rome with the more jumbled events of the newfangled Constantinople.

The solution was to listen to the bishop of Rome (i.e., Leo), since Saint Peter "first adorned the primacy [and] was deemed worthy to receive the keys of heaven." She lightly chided her august relatives, "It becomes us in all things to maintain the respect due to this great city, which is the mistress of all the earth; and this too we must most carefully provide that what in former times our house guarded seem not in our day to be infringed." In other words, even here in the middle of the fifth century, even decades after the city's "sack" by the Goths, she easily asserted that Rome was the center of the Christian religion. Rome was the center of the empire. The East should be more deferential to its elders in the West.

GALLA PLACIDIA'S VISIT TO ROME NEAR 450 was not her first, as she'd been there many times during her six decades of life, including once

around 410, at the moment when Visigoths besieged the city, sacked it, departed, returned, perhaps sacked it again, then took Galla herself as a prisoner of war.

Her fellow Christians were of two minds about the fate of Rome. The Church Father Jerome thought it was very, very bad. Writing to correspondents in Italy from around Jerusalem, in the Roman province of Palestine, he described the events of 410—from his vantage point of well over a thousand miles away—as a calamity, saying, "The capital of the Roman Empire is swallowed up in one tremendous fire; and there is no part of the earth where Romans are not in exile."

But others were more sanguine. Augustine in his *City of God* pointed out that this wasn't the first time Rome had been subjected to internal or external violence. Augustine had an agenda, of course. He wanted to exonerate Christianity because the religion was being blamed by polytheists for the violence of 410. So he noted that this sack was hardly an unusual calamity—and certainly not an empire-ending cataclysm—in the city's long history. Augustine (and later his influential student Orosius) wrote that a whole "cloud of gods" had protected Rome during the pagan era, yet both fires and fighting had ravaged the city frequently. The city of man was one of discord and strife. Rome—neither city nor empire—wasn't any different.

But historians are situated in their own context, and Jerome and Augustine were no different. In their cases, we need to see that context in order to understand what really may have happened—or perhaps better, what it meant. To contemporaries, Jerome positioned himself as a monk, someone who renounced the world to worry more about spiritual matters. His screed about the devastation of the attack on Rome came in the middle of a letter to a correspondent about whether or not a daughter should marry. His portrayal of Rome's plight had to do with frightening his friend (the letter's recipient) into letting his daughter become a nun in order to save her from

sexual violence (and link up with Jerome's ascetic ideals). Augustine was a bishop, a role in the Middle Ages that was just as much an administrative as a spiritual position. As such, he was taking a much longer view, placing one event within the grand sweep of sacred history that stretched out to eternity. But at the same time, he wanted to make sure his flock, his fellow Romans, didn't panic. None of this, of course, means that we should summarily dismiss their work, but we must surely move beyond the writings of Church Fathers and their theological goals to assess the rise and falls of empires. We can consider other evidence.

So let's start with the Goths. Who were these people who sacked Rome in 410? The story of massive "barbarian" invasions springing from nowhere, like so many other tales of collapse blamed on external forces, must be pushed gently into a more complex story of mass migration, accommodation, and change. Germans—a loose term indicating many different groups of people connected by language, religious, and cultural similarities—and other peoples from northern and eastern Europe, and from northwestern and central Asia, had been crossing Roman borders back and forth for centuries. Sometimes they came as raiders, sometimes they joined up as allied troops, often they came as trading partners, and, especially beginning in the later 300s, they came as refugees. A famine broke out in the 370s as a large group of Gothic peoples crossed into eastern Europe (mostly into the Roman province of Thracia, in the Balkans). The Roman officials who were supposed to help the refugees instead forced them into camps and starved them. In some cases, the Goths had to sell their children into slavery in exchange for dog meat just to survive (according to the historian Ammianus Marcellinus, at least). If these stories are true, it's no wonder the Goths seized the first opportunity they had to fight back.

It's easy and understandable to focus on the brutal war that

followed, which included the famed battle of Adrianople in 378, which the Goths won, somewhat to everyone's surprise, even killing the Roman emperor Valens. But the subsequent peace is just as significant. The Goths struck a deal with Valens's successor, Emperor Theodosius I, and settled en masse throughout southeastern Europe, effectively becoming Roman themselves over the course of a generation or two, even serving in legions throughout the empire. But internal Roman power struggles once again intervened and led the Goths, now known as "Western" or "Visi"-goths under the leadership of Alaric, to take to the field of battle in Italy against the Roman empire in the west.

The military and diplomatic exploits, blunders, alliances, betrayals, last-minute rescues, and narrow-minded stubbornness that led to three sieges and ultimately the conquest and plundering of Rome in 410 are the stuff of legends. Alaric battled Stilicho, the general (a Germanic half-Vandal himself) who led other German forces that made up the bulk of the Roman army. Later, Alaric allied with Stilicho. After that, Emperor Honorius I (Galla Placidia's brother) executed Stilicho, his son, and the families of many of his soldiers. The remaining Roman soldiers fled to Alaric, leaving him with an undefeatable army in the field. And even through all that, as the Visigothic general laid siege to Rome, he kept suing for peace.

The point wasn't that Alaric didn't think he would win if he were to march on the city of Rome; instead, he may have feared just the opposite—that he would win. He didn't necessarily want to press the war to that particular conclusion. He, a Goth leading an army composed primarily of other Romanized German peoples, may well have thought himself as standing in the shadow of Roman generals from the past who faced the powerful taboo—even amid the many civil wars that plagued Roman history—against bringing troops into the sacred city. In other words, he thought of himself as a Roman.

Rome continued, and so he wanted to restore his alliance—albeit with himself in a dominant position—with the great empire.

But the campaign did continue and he did sack Rome. There the Goths found Galla Placidia in residence, where she remained throughout the war, playing a central role in the defense of the city. She was the wedge that broke the alliance between her brother Emperor Honorius and his general Stilicho when Galla had Serena, Stilicho's wife and Galla's cousin, accused of conspiring with the Goths, probably falsely, then had Serena strangled to death. Galla throughout was an agent in her own story, a power to be reckoned with in her own right.

She survived the initial sack of the city in 410, but when Alaric died soon after of natural causes, the new Gothic leader, Athaulf (411–415), seems to have returned to Rome and taken Galla Placidia as a prisoner of war (our sources are a little fuzzy on how it all played out, but they are clear that Galla ended up with Athaulf). But Athaulf soon left Italy, heading into southern France and then across the Pyrenees to Iberia, and we know that in 414 Galla and Athaulf were married. She wore silk. He gave her spoils taken from Rome as a wedding gift.

It's easy to get distracted by Galla Placidia's relationship with powerful men and to see her as a mere object in the game of thrones. We can't, for example, know whether she willingly married Athaulf, but diplomatic marriages were common for elite Romans of all genders, and given her role in subverting Stilicho's position in the emperor's war against the Goths, it wouldn't be out of the question to suggest she worked with her brother to settle the Gothic war once and for all. Indeed, what we do know is that their marriage is not a sign of the destruction of the Roman Empire, but rather signals the desire of the Goths to be Roman and the willingness of Romans to marry Germanic "invaders," to merge a regime legitimated by conquest with the legacy of Roman imperial rule.

Jordanes, a bureaucrat in Constantinople of Gothic origin (be-
cause again, Germanic peoples working in the Roman Empire was
normal), writing a history of the Goths in 550, describes the marriage
by writing, "Athaulf was attracted [to Galla Placidia] by her nobility,
beauty, and chaste purity, and so he took her to wife in lawful mar-
riage at Forum Julii, a city of Aemilia. When the barbarians learned of
this alliance, they were the more terrified, since the Empire and the
Goths now seemed to be made one." Jordanes was perhaps overeager
in declaring Gothic-Roman unity based on this one marriage, as the
Italian peninsula would be the site of warfare for centuries to come,
but just the fact of this statement demonstrates how clearly he and
his fellow officials in the eastern Roman Mediterranean did not see
the movement of Germanic peoples as evidence of collapse. Groups
of people came and went in the Roman Empire, seeking office and
status. Often, they preserved elements of their own identities without
challenging their equal sense of being Roman.

In any event, Galla's marriage was short-lived. She and her hus-
band moved to Spain, began setting up a new Roman-aligned state,
and had a son named Theodosius—thus giving a proper Roman im-
perial name to the son of a Gothic king. The child died within the
year of natural causes, though, and was buried in a silver coffin in a
church outside the walls of Barcelona. Then, the next year, Athaulf
was murdered in the bathtub by an angry servant. Athaulf's brother
Sigeric, wanting to rid the area of rivals, ordered Galla to walk from
Barcelona out of Spain, but before that could happen he, too, was
murdered, by another Visigoth named Wallia. Wallia then negotiated
a truce with Rome that included Galla's return to Italy. She did return
and by 417 had married the Western Empire's leading general, Con-
stantius. They very quickly had more children—a daughter, Honoria,
and a son named Valentinian. By 421, Galla's fortunes seemed to be

rising once more when Constantius was elevated to co-emperor by Galla's brother Honorius.

But it didn't last. Constantius III died later that same year of natural causes.

With Galla's husband dead, Emperor Honorius seized power back for himself and grew suspicious of his sister's influence, forcing Galla to flee from Italy with her children. She went east and took refuge in Constantinople for a few years. But once more, fortune moved quickly and she returned to Ravenna in triumph in 425, with her brother dead and her enemies defeated by the forces of her protector and nephew, Eastern Roman Emperor Theodosius II. Valentinian, her son, then just six years old, was proclaimed Augustus of the Western Roman Empire before the Roman Senate, in large part because Galla was able to negotiate a deal with the general Flavius Aetius (popular with the Germanic peoples of the empire), naming him the West's chief general (*magister militum*). Galla then settled in at Ravenna and ruled as regent for the next twelve years.

Throughout, she demonstrated her ability to negotiate the complicated politics of the empire in both East and West. Kings, emperors, generals, brothers, cousins all fell, and yet Galla Placidia remained standing, seeing at the end her son safely installed as Emperor Valentinian III. One could say that through the early fifth century, Galla herself embodied the continuity of Rome. Nor were her gifts merely political; our records indicate that she was engaged personally in the design of the mosaics for her sacred buildings; her few surviving letters indicate a rich education in theology, with confidence and knowledge enough to debate with bishops, monks, and emperors about the very nature of Jesus's Godhood and humanity, as well as the role of the Virgin Mary.

In 450, as she approached sixty, Galla and her son the emperor

traveled to Rome and met with Pope Leo. The journey was routine and uneventful, but Galla took ill and died in Rome later that year. She was buried in St. Peter's Basilica in Rome. But she accomplished one more thing just before she passed. Right before she died, she reburied her infant son Theodosius at St. Peter's—the baby who died so long ago during her years in Spain. How he got to Rome is a mystery. Did she send someone to fetch the little silver coffin? Or was this the final act of a woman who so mourned her long-dead son that she had kept the small coffin with her all those years? Maybe she commissioned that small chapel in Ravenna not for herself or for the relics of saints, but instead intended the blue ceiling of the mausoleum to shelter and comfort her lost son. Perhaps she only changed her mind as she grew ill in Rome.

Galla's life tells a story of a Roman Empire very much still alive, but certainly in transition. It's a complex story in which new religions and peoples merge with extant ideas and customs, setting the stage for the coming era. A new form of imperial power, in which rulers of all sorts asserted their legitimacy through close ties to various groups of Christians and religious leaders, became the norm throughout the Mediterranean world and much of Gaul (the lands that would later become the kingdom of the Franks, and eventually France). Newly arriving peoples eagerly sought to ally themselves with Roman sovereignty, elite Roman families, and adopted Roman traditions. Christianity, as it spread, divided territory into administrative regions based on Roman bureaucratic norms. New religious orders, monks whose stories we will tell more fully in later chapters, read and copied Latin texts and created their own. The Roman Empire evolved, but still, it endured both in practice and in the hearts and minds of the rulers of western and Mediterranean Europe.

We have to remember that Rome as "empire" changed, but that it had always been changing. Change was part of the story from the very

beginning. Its centers of power moved. Its spheres of influence fragmented, coalesced, and fragmented again. The idea that Rome "fell," on the other hand, relies upon a conception of homogeneity—of historical stasis. That ages-old idea suggests a centralized proto-modern nation-state that in its idealization much more resembles Gibbon's own eighteenth-century British Empire than any reality of Antiquity. For him, the crude passion of early Christianity, as he saw it, ruined the glories of Rome and led the clean, stable empire to crumble. But then Gibbon was upset at the time by the turbulence of the French Revolution. Passion, Gibbon thought, was dangerous. He longed for a purer Italy, one he imagined as he gazed upon Rome's and Ravenna's ruins as a dilettante traveler. For him, when Rome adapted to deal with the new realities of a shifting European and Mediterranean world, it "ceased to exist." Germans couldn't *really* be Romans, women couldn't *really* be rulers, etc. But as we've seen, Romans themselves in this period often had no such problem with the above scenarios.

New groups entered its population willingly or, as had happened for centuries, wars ended with mass enslavement of large populations who were forcibly marched to slave markets and scattered throughout the empire. Still, both the empire and the idea of empire endured, as it had through 69 CE, the year of four emperors, the chaos of the early third century, the division into East and West in the 280s, the rise of Constantinople in the fourth century, and finally the tumultuous life of Galla Placidia. Things changed. But things always change.

It's hard to stand in Galla's small chapel in Ravenna and understand late Roman Christianity as solely a producer of dangerous passions. Christians did absolutely smash and murder. Galla herself was likely responsible for thousands of deaths. But Christians also built places of shimmering starlight. Galla Placidia, according to an inscription recorded centuries later, commissioned for her quiet chapel

in Ravenna a massive candelabra of gold, her portrait impressed into the center surrounded by the words, "I will prepare a lamp for my Christ." We'll find similar light in sacred spaces throughout the next thousand years, bouncing off the magnificent walls of Baghdad or streaming through the great rose window of Chartres. Fires like those of Rome in 410 are rekindled again and again, but artisans keep hanging new stars in the sky, in places where people can find a little quiet.

Forty years after the sack of the city by Alaric and his army, Galla was still calling Rome the "mistress of the earth" and returned to the city frequently, even as she wielded imperial power across the Mediterranean. Neither the presence of peasants nor foreigners occupying the seats of Roman power in this century—or those centuries that followed—signified collapse. Galla Placidia lay for at least another thousand years in an unadorned tomb in St. Peter's, the small silver casket of her first child by her side. She had brought her long-dead child home, to Rome, to rest.

THE GLEAMING TILES
OF THE NEW ROME

About ninety years after Galla Placidia was laid to rest next to her infant son, Romans returned to Ravenna. But these Romans were different from Galla and her son, the emperor; the army had come from a new Rome in the East, Constantinople, and were besieging the Western capital. A general named Belisarius had led the conquest of North Africa for Emperor Justinian (reigned 527–565), and with the siege of Ravenna was now on the cusp of completing his reconquest of much of Italy for the Eastern Roman Empire. The decades had not been kind to Italy in the years since Galla Placidia, as the various Roman rulers fought among themselves and new waves of invasions whittled away effective imperial control. Rome was sacked again by a group called the Vandals in 455. Then a new group of invaders, the Ostrogoths (a separate group of Goths from those discussed in the previous chapter), seized control of the bulk of the peninsula and consolidated their rule under King Theodoric in the early 490s.

Like other Romanized outsiders, Theodoric found value in connecting his regime to the imperial past. He generally maintained good

relations with Constantinople and served as an effective "client" of the Eastern Roman emperor. Indeed, Italy under the Ostrogoths at the beginning of the sixth century dutifully maintained Roman governmental institutions and so was arguably more "Roman"—thinking about art, bureaucracy, political ritual, and more—than other areas directly under the control of the Eastern Roman emperor. Continuity was arguably more characteristic of the early sixth century than change. Nevertheless, after Theodoric's death, dynastic disputes among the Ostrogoths erupted (though, in fairness, succession was almost never stable in the early Middle Ages) and his daughter was executed by the king who had seized power. In the 530s Emperor Justinian used this execution as a pretext to send his general to "liberate" Italy. Rome endured in both fact and culture, but the new political reality had left the peninsula decentered, with power now residing in a new Rome, far to the east, in a palace overlooking the Bosphorus.

As Belisarius sat outside the walls of Ravenna, Italy had almost entirely been reclaimed. The citizens within the walls of Ravenna were demoralized. A fire, set by treason, Belisarius's machinations, or a random lightning strike, had destroyed the grain warehouses, so the citizens knew they'd soon be hungry and couldn't hold out much longer. A relieving Gothic army descending from the Alps wouldn't get there in time. Moreover, and maybe more important, the mass of the citizens of the Adriatic city felt a kinship with the Eastern Romans and seemed ready to turn on their ruler, the Ostrogothic King Vitiges.

But surrender didn't go as planned. Two senators from Constantinople sent as imperial envoys had negotiated a deal in which Vitiges would leave Ravenna but keep lands north of the Po (a river that flows west-to-east across northern Italy). Belisarius, however, refused to ratify the truce, wanting both a decisive victory and the right to lead Vitiges as a captive back to the capital city in triumph.

Then it got even more complicated. The elites of Ravenna tried to surrender to Belisarius directly, bypassing the senators from Constantinople, instead offering Belisarius himself the title of Western Roman emperor.

He must have been tempted, even though Procopius—Belisarius's secretary, the chronicler of Justinian's works in the great city of Constantinople, and writer of a dirty book that accused Justinian, Belisarius, and their wives of all sorts of iniquitous acts—claimed that Belisarius never gave it a thought, merely pretending to seek the throne for himself. Procopius may well have been correct at least in this case, as when the city opened its gates, Belisarius seized it in the name of Emperor Justinian and the Roman Empire. Procopius marveled at the victory, writing in his *History of the Italian War* that as he watched the army enter the city without ever having to fight a battle, it must be a "divine power" at work rather than due to the "wisdom of men or other sort of excellence."

Let us imagine that Belisarius had accepted the offer from the citizens of Ravenna. What would that have meant for the realities of the sixth century but also for the modern myth about the decline and fall of the Roman Empire? With Belisarius, in this counterfactual, taking the title of Western Roman emperor, the year 540 would have witnessed a complete return to the status quo of the Roman Empire as it was under Galla Placidia. There would have been emperors in both east and west, collaborating and fighting and competing for power across the whole Mediterranean. As an emperor, Belisarius, himself already a successful general, might have taken full advantage of these circumstances and established a new dynasty in Italy that lasted years, decades, or generations. There's nothing inevitable in history. The slightest shift of political winds might force us to tell a very different story.

But of course Belisarius didn't accept the offer. He remained loyal

to his emperor and to Rome. Indeed, the political realities of the
early sixth-century Roman world, and the strategies employed by re-
ligious and political leaders in Constantinople to center that world's
imaginary geography on the Bosphorus, likely kept Belisarius loyal.
He owed his rise to prominence directly to the emperor's favor, by
winning victories over the Persians for Justinian and then massacring
thousands to save the emperor during the Nika riots of 532 (more
on that below). Maybe more important, though, would a real sixth-
century Roman want to rule from a marshy outpost on the Adriatic
when the new Rome glowed under warm sun on the Bosphorus? East
and west remained connected but Rome and Ravenna had been sur-
passed by Constantinople.

Once a backwater fishing town named Byzantion in the Roman
province of Asia, the city had been transformed by Emperor Con-
stantine I (reigned 306–337) when it became his seat of power and
was renamed "Constantinople" (*Constantinopolis*, or "the city of Con-
stantine") in his honor in 330. Over the next several hundred years,
the city became one of great public works, vast wealth, cultural dom-
inance, and tumultuous politics. Constantine began the process of
building by plundering other sites across his empire, bringing trea-
sure to his new city and constructing (or at least patronizing) new
churches. Subsequent rulers built in their own right, and the city
grew so quickly in just the few generations after its refounding that
new land walls—still standing in large part, and magnificent—had to
be built to expand the city's footprint and accommodate its roughly
500,000 inhabitants at its height. Within those walls grew a typical
Roman city with baths, fora, aqueducts, and monuments to its rulers
and prominent citizens. It was also a typical Roman city in its di-
versity as it grew, housing people who came from three continents,
spoke many languages, and practiced many different religions (and

versions of the same religion, especially important when it came to Constantinople's Christians).

The Romans ruling from Constantinople never called themselves "Byzantine," a characterization that became commonplace only in the sixteenth century. Although we'll use the term when we need to in order to distinguish the Greek-speaking Roman Empire in orbit around Constantinople from all the other Roman Empires out there, we must remember that the inhabitants of this empire that ruled from Constantinople called themselves Romans. Although Latin Christians in the later Middle Ages would sneer at them dismissively as "Greeks," their allies and enemies often simply called them Romans as well. They called the land they ruled over Rome, Rumania, Rumeli, and other terms that all indicate continuity rather than change. Still, in the late fifth and sixth centuries, culminating in the rule of Justinian and Theodora, these Eastern Romans worked hard to reorient the world around their city, completing a shift within the empire from center to periphery that had been evolving for centuries. Simultaneously, they were attempting to sustain a conceptual relationship with their pre-Christian Roman heritage and at once build something new.

The Byzantine grasp over Italy was fleeting and fractured. New Rome and old Rome remained connected but new Rome had to respond to emerging realities across the Mediterranean and the emperors' attention therefore drifted from west to east through the sixth century. Roman naval power from Constantinople would sustain Byzantine rule over the Adriatic Coast and the south of Italy, even as yet another group known as the Lombards took advantage of the turmoil of war to seize much of northern Italy. But the memory of Belisarius and his conquests lingered. New mosaics depicting the emperor and Empress Theodora would be installed in the Basilica of San Vitale, a recently completed sixth-century church barely a stone's throw from

Galla Placidia's tranquil mausoleum and her blanket of stars. These new imperial mosaics joined depictions of scenes from the Old and New Testaments to tell a story of Christian triumph and the restoration of empire. Those mosaics in Ravenna, alongside other Roman symbols in that city, would inspire centuries' worth of imperial pretensions in Europe at least into the 1300s, with famous rulers such as Charlemagne and Frederick I Barbarossa gazing upon their reflected splendor and shaping their own policies and actions to match. Those mosaics in Ravenna, it seems, accomplished their goal—reminding their audience of the continued connection between the two halves of the Roman Empire—but, more important that power now radiated from a new center, Constantinople.

HOW DO YOU MAKE A "NEW center" like Constantinople real? How do you convince masses of people to think differently about the world? Medieval mythographers face this challenge again and again throughout the Middle Ages as they try to assert the legitimacy of *their* city's or *their* church's or *their* ruler's appropriation of both the secular and religious legacies of the Roman Empire. In the case of Constantinople, conquering the city of Rome was one goal, but they needed to do much more to reshape the imaginations of their subjects.

So how do you rewrite the imaginary map of the world? Sometimes there are physical, tangible symbols of power that force us to shift our gaze—for example, churches and palaces, or sacred objects or crown jewels—while at other times that mental reality is more ethereal—a hazy refocusing that becomes clear only after some time. As the center of the Byzantine Empire, Constantinople became the mental center of the Mediterranean world—its gravity so strong that for a time it brought almost all expressions of religious, cultural, and political power to itself. Some of that work took place through massive buildings and church councils. But never underestimate the

power of a good story, particularly one that had been told for generations. Let's jump back in time, before Belisarius, Justinian, and Theodora, and consider, as an example, the case of Daniel, a fifth-century monk and later saint, who was told by an angel that Constantinople was the center of the world.

Sometime in the later half of the fifth century, this Daniel resigned his position as abbot of a small monastery near the city of Samosata, on the Euphrates, and walked to Aleppo. He wanted to visit a holy man named Simeon "the Stylite," so-called because he lived atop a large pillar, high in the air, never coming down, enduring the elements, separated (as best he could be in an urban setting) from other people. Both Daniel and Simeon were monks, a relatively new kind of Christian devotion that began in the fourth century in Egypt, spread to Roman Palestine, across North Africa, and eventually to Europe. At their core, monks tried to separate themselves from the world, to allow them to focus on spiritual matters—to save their souls—and avoid earthly distractions and temptations. Initially, these monks were hermits who lived "alone" in the desert, but slowly communities of ascetics began to form under the leadership of a guide, a leader, a father (an "abbot," from the Greek *abbas*, meaning "father"). Simeon was the former type of monk, while Daniel began as the latter but sought something stricter and so looked to Simeon for guidance.

When they met, Simeon urged Daniel to stay with him in Aleppo but Daniel was determined to continue onward to see Jerusalem, to see the sites of the Resurrection and then to retire to the desert as a hermit. But according to one of Daniel's followers, who wrote his hagiography, God had other plans. As he was on his way to Jerusalem, one day a "very hairy man," another monk, it seemed to Daniel, overtook him on the road. Daniel told the hairy man that he was going to Jerusalem but the old man replied, "Verily, verily, verily, behold three times I adjure you by the Lord, do not go to those places, but go

to Byzantion and you will see a second Jerusalem, namely Constanti-
nople." Perhaps understandably, Daniel wasn't convinced.

The two continued walking until evening had fallen and Daniel
made his way to a nearby monastery where he hoped to sleep for the
night. But when he looked back over his shoulder, the mysterious
hairy old man was gone. That night, the man—or rather angel, as it
now seemed he was—came to Daniel in a vision and told him again
to go to Constantinople instead of Jerusalem. This time he was con-
vinced. Rather than disobey a divine messenger, Daniel turned his
back on the city of Jesus's crucifixion, and instead went to the new
Jerusalem, the capital of the Roman Empire in the fifth century, and
the new center of the Christian world. Once he arrived in Constan-
tinople, Daniel would emulate Simeon and seek escape even in the
midst of a bustling metropolis, climbing a pillar, himself attracting
visitors and admirers, offering counsel, and serving as a public model
of heroic Christianity.

Just as Constantinople exerted its gravity over politics and cul-
ture in the sixth century, pulling Ravenna and Italy into its orbit, so
too even in the fifth century the story of Daniel the Stylite has God
Himself (through an angel) acknowledging a new religious reality.
Constantinople was at the time not just a new Rome, but a new Je-
rusalem as well—the home of the emperor and, soon, site of a new
temple that would outshine all others.

NEITHER THE PHYSICAL NOR THE INTELLECTUAL transformation of
Constantinople happened overnight. The city and the empire grew
slowly in both regards. But it was fortunate that the political situ-
ation remained relatively stable at the end of the fifth century and
beginning of the sixth. Unlike in the Western empire, which faced
a quick succession of several rulers after Valentinian III's murder, the
Byzantines had several long-serving leaders—Zeno (who visited

Daniel the Stylite and reigned until 491), then Anastasius I (reigned 491–518), and then Justin I (reigned 518–527).

Justin I, as with so many other Roman emperors, had been a talented military leader from a humble background (likely a peasant) who had made his way to the top of the palace guard. After Anastasius I died one summer night in 518, when Justin was nearly seventy, the old man neatly outmaneuvered his rivals and was himself acclaimed as emperor in the Hippodrome, the great racetrack that lay at the heart of the city's civic culture. Then the murders began.

Over the next few weeks Justin ordered the assassination of his former rivals for the throne, leaving his rule secure. He surrounded himself with men he could trust, including his family. One of those was his nephew Justinian, also from a humble background, and also a talented politician. Throughout this process, Justinian supported his uncle's ascension and within a few years seems to have been running much of the empire. In 527, Justin died of old age and Justinian did not throw away his shot.

Justinian climbed to the throne of the Caesars from the relative poverty of the Thracian countryside after his uncle's death. But just as significant for our story is that of his wife, Theodora. They had been married toward the end of Justin's reign, likely at about the time Justinian was taking over de facto control of the empire, and she had also emerged from modest beginnings. In her case, this meant she came from the capital's underclass of performers. At the time, chariot racing provided the chief entertainment of the city, organized around two major factions—the Blues and the Greens. The factions not only kept the horses, chariots, and racers, but provided entertainments throughout race days, including such diverse activities as bear-baiting and dancing. Theodora was born around 495 to a father who was a bear-keeper and an actress mother, both of whom worked for the Greens.

Theodora, also sister of a singer, herself took to the stage, it seems performing as a member of large troupes of mimes. Perhaps some of her performances were erotic—indeed, it's even likely—although the depths of depravity that her critics would attribute to her might well come from both sexist and classist scorn rather than any accuracy. She became the concubine—a kind of formalized semi-marriage that offered little stability in the long term, but was more significant than a mere lover, prostitute, or mistress—of a provincial governor, with whom perhaps she had a daughter, but then the relationship broke down. Still, somehow she maintained access to elite society and she and Justinian met, though we don't know precisely how. We do know that Justinian, coincidentally perhaps, facilitated the passage of a law legalizing marriage between former performers and the elites of Roman society and that by 523 the two were married.

What are we to make of this pair? Justinian and Theodora seem to have fallen genuinely in love, as certainly there was some political cost for Justinian as an up-and-comer to marry someone from the lower classes, even if she was literate and fiercely intelligent. Yet we need to acknowledge how our portrait is troubled by the complexity of their portrayals in works by the historian Procopius, the same secretary to Belisarius we met at the beginning of the chapter and our main source for the period. He wrote quite a bit. And in most of his texts, Procopius praised Justinian and Theodora as divinely mandated to rule. But elsewhere, in a work he called *The Anecdotes*, Procopius smeared Justinian as demonic and a lustful fool, while castigating Theodora as a whore (more on this in a moment). The temptation is to dismiss the formal histories as propaganda, identify *The Anecdotes* (also known as *The Secret History*) as Procopius's real views, and assert that the rulers' lower-class origins were a sign of instability, that it foreshadowed trouble to come for Byzantium.

But this might be looked at another way, outside of modern class

consciousness. Here were two individuals of clearly extraordinary talent and drive who, thanks to a flexibility in a great society near one of its peaks, managed to become two of the most powerful people in the world. As we have seen, one of the continuities of empire has been extraordinary people moving beyond their station. If read in this way, a sign of weakness then becomes a sign of vibrancy, of the brightness of a civilization reaching a new peak. The Dark Ages become a bit brighter.

And that brightness was not just metaphorical. In 532, Justinian and Thedora faced a rebellion that culminated in a mass demonstration in the Hippodrome. The rioters came from both racing factions—a moment of almost unheard-of danger, medieval or modern, when rival sports fans agreed on a common enemy. Allegedly shouting "*Nika!*" or "Victory!" they seized control of parts of the city and at one point supposedly appointed one of their own as the new emperor. According to Procopius, Justinian and his advisors considered fleeing, when Theodora famously said that she would not flee, because purple, the radiant color of imperial rule, "makes for a nobler shroud." Her words steeled their resolve. Justinian stayed. He sent Belisarius and another general to gather their men, then unleashed the full military force on the rioters in the Hippodrome, exacting terrible slaughter. In that moment, the brightness of the age came from the fires burning out of control, perhaps set by the rebels, perhaps set by the soldiers, but nevertheless including one that consumed the corpses of the citizens of Constantinople as well as the church of Hagia Sophia adjacent to both the Hippodrome and the imperial palace, the church's timbers crackling amid the screams and the slaughter.

In the aftermath, Justinian set about rebuilding the city and, in the process, revealing the complexities of trying to define and control Romanness in this bright, complicated land. One of his first priorities was to rebuild the Church of the Holy Wisdom. He called upon

two men, Anthemios and Isidore, brilliant scientists, inventors, and urban planners. They came from a class of professionals who were at once engaging the wisdom of the ancients—especially ancient Greek math and engineering—while pushing the sum of human knowledge forward. Anthemious is said to have made an artificial earthquake using steam power in order to study earthquakes (a persistent problem in the city), perhaps related to his efforts to develop better techniques for flood control. They brought this sensibility to the new church, Hagia Sophia (*sophia* is "wisdom" in Greek), as it's popularly known, erecting a massive dome that floated majestically above a vast space—the largest enclosed space in the Christian world at the time, and the largest constructed dome until the reconstruction of St. Peter's in Rome a millennium later. It captivated locals and pilgrims alike throughout the medieval period. Even today, its golden ceiling largely plastered over, the immensity of the space can leave visitors stunned. What's more, the church was built in a mere five years, an effort of unthinkable speed and precision.

And oh, the gold basking in the light. Some scholars estimate that at present more than half of the structure's original windows are covered, forcing into shadow a space that must have at times blinded. The marble on the floor, caught at a certain time of day, reflected the light in a way that mimicked the reflection of the sun off the Bosphorus at the same time. Whether in candlelight or sunbeam, Hagia Sophia must have gleamed.

Procopius wrote in his book *On Buildings* that light was part of the design: "Upon the crowns of the arches rests a circular structure, cylindrical in shape; it is through this that the light of day always first smiles. For it towers above the whole earth . . . and the structure is interrupted at short intervals, openings having been left intentionally, in the spaces where the perforation of the stonework takes place, to be channels for the admission of light in sufficient measure." Notice

not only the clever architecture, but notice, too, how he pauses to consider the relationship between earth and sun. He described the dome as "hanging in midair," the beauty calibrated so that a worshipper will find their "mind is lifted up toward God and exalted, feeling that He cannot be far away, but must especially love to dwell in this place which He has chosen. And this does not happen only to one who sees the church for the first time, but the same experience comes to him on each successive occasion, as though the sight were new each time." Certainly, all churches were total sensory experiences, but Hagia Sophia is different by an order of magnitude. The space would have been rich with sweet-smelling incense and smoke from candles, forming a miasma around the dome, even as the acoustics—which modern archaeologists have mapped and replicated—allow notes to reverberate and overlap; in the words of the art historian Bissera Pentcheva, to "flow."

Much as Constantinople became "the city," this became "the church," an assertion of dominance over and supersession of the temples in Jerusalem and basilicas of Rome, a statement that here, this church decorated with precious stones and gold from the Roman world and beyond, would be the center of the Christian cult. But supersession requires continuity, an acknowledgment that Hagia Sophia—like the city itself—pays homage to what came before but standing above it, surpassing it in every way. One of the surviving mosaics in the church makes this explicit, depicting the Virgin Mary, with Emperor Constantine handing a model of his city to her on one side, while Justinian hands her Hagia Sophia from the other.

We've focused on the church in all its brightness, but we might find similar stories in the Byzantine history of law, of theology, of education. Justinian initiated a legal reform, for example, his scholars pulling together fragments of Roman law into a single "digest" intended to lay out all the fundamental legal principles on which the empire

would run. At the same time, he closed the Academy of Athens, an august school of philosophy with its roots in antiquity. It's a move that modern historians—deeply invested in the legacy of Plato and Aristotle—have used to indicate the arrival of the Dark Ages. But we have to see the whole. There's always been intellectual tension about using polytheistic knowledge in a Christian realm, but that knowledge was still used, and here that tension led to adaptation and innovation, to a new legal system, a new technique for controlling floods, a new church soaring into the sky. Rome continues, but here—Justinian and his supporters would argue—the new Rome glows brighter.

What's more, Justinian and Theodora exported this brightness westward, seeking to spread their message of imperial Roman and Christian magnificence to the newly (re)conquered lands. The mosaics in San Vitale in Ravenna were part of that program. Even today, they still catch and hold the light as this pair of rulers and their retinues look down at the worshipper. To the people of the time the mosaics at Ravenna asserted that not only had the Roman Empire endured, but that in many ways sixth-century Constantinople, the second Rome, still thrived.

Imagined geographies come with real costs, though. All this construction and reconstruction, not to mention the wars around the Mediterranean and to the east, burdened the city and its people. The taxes Justinian levied transformed Constantinople and the Mediterranean world, not only supporting his building projects, but also convincing the mighty Persian Empire to the east to sign an "eternal" peace treaty. That peace lasted only as long as the payments did. Austerity brings a sword.

Inside Constantinople, the common folk of the city hated the taxes. Indeed, high taxes had sparked the Nika riots that almost brought his reign to its knees. Moreover, in a constant search for revenue the empire tended to sell access to high offices, sparking resent-

ment among the traditional elites, who were disgusted by the rise of commoners (such as Justinian and Theodora themselves). The risks to stability were many, and that's without even considering religious tensions among the many Christianities coexisting within the great city.

These internal and external tensions may, in fact, help to solve the enduring enigma of Procopius and his seemingly divided loyalties throughout his writings. Again, his official histories exult in the success of war and the transformation of the landscape, such as cisterns and sacred spaces, while also reveling in the emperor's bureaucratic and legal reforms. Justinian's law code would come, in time, to form the basis for much of continental medieval European law. In many ways, the bulk of Procopius's writings lie fully within Justinian and Theodora's imperial project. His pen served them well.

However, he of course also wrote his *Anecdotes*, a little book that eviscerated that same project. It somehow survived the centuries and exists in a sole copy now residing in the Vatican Library and rediscovered in modernity (though it was known in the centuries succeeding Procopius's death). *The Anecdotes* includes most of our details about Theodora's early life, while calling her a "whore" and ascribing to her endless enjoyment in public sexual performance, a lifetime of constant lust. He mocked Belisarius, the general he served for so long, as a cuckold. He dubbed Justinian as a devil in human flesh, the murderer of "a myriad myriad of myriad," which is to say ten thousand cubed or a trillion people (a salutary reminder to always be wary of medieval "data").

So was Procopius two-faced, with his formal work just paying the bills but the anecdotes revealing his true persona? He was from a more elite family than the monarchs, so we could see in him resentment, but another explanation may be to think of Procopius as not just a canny observer of politics, but a participant as well. Having

witnessed not just the glory but also the turmoil of Justinian's reign, he may have worried that, in the case of rebellion, he'd be judged complicit and suffer the fate of other collaborators. In such a case, Procopius's little book might have offered an insurance policy, a "secret history" that he could offer as evidence that he had never really been fond of the now-disgraced ruler. Yet that successful rebellion never came. Theodora died in 548 and Justinian in 565, both of natural causes. Procopius kept his apocryphal history buried in a drawer, to be discovered only after he died. Today, it offers us evidence that premodern people were just as complex and sophisticated as any who followed. They could try to play both sides, position themselves to protect their interests. But this also reminds us that people in the past didn't know the future. Too often, because we have the advantage of writing from our own present, from their future, we think of history as necessarily hurtling toward some predestined conclusion. But it never works like that.

Finally, the works of Procopius and the story of Theodora also remind us of the enduring power of patriarchal norms when it comes to depicting and attacking powerful women. The linking of sexual power to the rise of women appears again and again in literature and history, a testament to male fear. The fault, even then, was never the man's, but the demon-woman whose supposed sexual wiles had corrupted the ruler and his empire. Still, Theodora remains on the walls of Ravenna, having perhaps a last laugh despite it all.

Constantinople shone, its brightness both real and a political strategy. But we must remember that the rulers of Constantinople never called themselves "Byzantine" in their time. They called themselves Romans, as did their friends and enemies. But lots of people called themselves Romans. The rulers of Byzantium were shouting their supremacy into a world that shouted back in a thousand tongues, with a thousand other societies asserting their own primacy in their

own ways. Throughout the medieval period we need to think about Romes in the plural (and also Christianities, Judaisms, Islams, Frances, Germanies, and more), to parse the methods and motives of those who asserted connection and legitimacy, rather than seeking to discern the one true descendant of the classical empire.

But if Rome and Jerusalem came together in the imaginary geography promoted by these emperors in Constantinople, any claim that the Byzantines might have to full ownership of both the Christian and secular Roman past shattered. Justinian's hold over the Mediterranean territories would be fleeting not only because of new powers in the West, but also because just as Byzantium and Persia entered a new brutal conflict, a man named Muhammad in the faraway city of Mecca began preaching openly that he had been receiving sacred verses from God directly from the Angel Gabriel. He and his followers would offer a new story of both imperial and sacred power. The world would never be the same.

DAWN IN JERUSALEM

In the year 638 (or the year 16/17, depending on whether you locate the year zero with the birth of Jesus or the voyage of Muhammad and his followers to the city of Medina), 'Umar ibn al-Khattab, the second caliph, came riding toward Jerusalem on a white camel. His armies had swept through the weakened Roman forces in the region over the previous years and the city was his to conquer. As he approached, according to Christian histories of the time, Patriarch Sophronios of Jerusalem watched from the Tower of Solomon. "Behold the abomination of desolation," he reportedly said, "spoken of by Daniel the prophet." It was an apocalyptic statement, taken from the book of Daniel (12:11), and a warning of dire things to come. Sophronios, by quoting the phrase, was himself acting as a prophet in his own right, predicting the total destruction of Jerusalem and its Christian population. But as is the case with most prophets, Sophronius, it happens, was entirely wrong.

Instead, 'Umar and Sophronios reached an agreement that turned over the city to the conquering army but permitted the continued independence of Christians in Jerusalem. To be sure, Christians would be second-class citizens, but they would be under no pressure to convert as long as they paid their taxes. They retained their

churches, their leaders, their *religio*—the practices of their commu-
nity toward the divine. We tend to think about religion as timeless,
ignoring historical circumstance. We project backward a Protestant,
post-Enlightenment framework that privileges "belief" or "faith" and
ignores the lived experience of those from other traditions both
within and outside Europe. But certainly in the premodern world,
throughout almost all of the Bright Ages, it mattered what people *did*.
And here 'Umar was assuring the Christians that they could more or
less continue to do what they'd always done.

Jerusalem has certainly had a contested history among the three
great monotheisms but it's a mistake to see the city as a focal point
in a millennia-long history of a clash of civilizations. The focal point
of the Israelite cult, the city and its Temple, were destroyed in 70
CE by the Romans and then more thoroughly devastated by them in
140 after a second rebellion. Indeed, Jerusalem as a city didn't exist
for more than a century after, having been replaced by a new Roman
colonial city named Aelia Capitolina. Christians initially didn't place
much stock in the city. Part of that, of course, had to do with their
status as a minority and sometimes persecuted community, but it was
also an ideological position. The followers of Jesus believed they had
superseded Judaism, transcended the needs of an earthly kingdom in
favor of a heavenly one.

Constantine had other ideas. When he converted in the early
fourth century, he set about rebuilding a new Christian Jerusalem and
melded Roman imperial ideas with Christian supersessionism. New
churches were constructed to commemorate Jesus's life in the city,
and the Temple Mount, which had since around 150 featured a tem-
ple dedicated to Jupiter, was made into a garbage dump by Constan-
tine. His virulent anti-Judaism made the message clear that Jerusalem
was a Christian city now.

Take, for example, the stunning mosaic recovered from the sixth-

century church of St. George in Madaba, Jordan (then Roman Syria). This map, as with all maps at their core, is an ideological exercise but one that several centuries after Constantine still cements his vision in place. It represents not what Jerusalem was at that moment but what it was envisioned to be. Walls ring and define the city, with north to the viewer's left and a long street running from the northern Damascus Gate to Justinian's Nea ("New") Church at the right. At the center is the Church of the Holy Sepulcher, built by Constantine in the fourth century. The Temple Mount, which should be to the east (at the top of the image as viewed), simply doesn't exist here.

The Arabian conquests of the seventh century, like all conquests, brought destruction, death, and chaos. But contrary to popularly held belief they did not spark the eradication of preexisting peoples and practices. As new monotheists—a group we would soon call Muslims—spread out of Arabia and through much of the Mediterranean world and into central Asia, the agreements formed by 'Umar and other leaders who followed provided a framework for coexistence among diverse peoples. The historian Fred Donner has even explained that during the conquests, early Muslims seem to have celebrated their religion alongside the native Christian (and even perhaps Jewish) populations. For example, in Jerusalem their first place of worship was next to—or maybe inside—the Church of the Holy Sepulcher, while in Damascus the Church of St. John seems to have continued to be a site of dual worship for some time before Islam definitively split from its sister monotheisms and the structure was converted to a mosque. In fact, all around the Mediterranean and beyond people of varying religions and varying traditions within religions could and did live near one another, often more or less peacefully.

That coexistence was often uneasy and always unequal, but is at least part of the reason that Islam was able to spread so rapidly throughout large chunks of Europe, Asia, and Africa. Indeed, what

we see with the arrival of these new Believers is more continuity than change. Certainly, the coming of Islam brought subjugation and pressure to convert but also the attraction of intellectual continuity with Rome, and in any case, despite the protestations of certain Christians at the time, nothing approaching an "abomination of desolation."

THE ARABIAN PENINSULA MAY SEEM AT first glance like a distant periphery from a European, or even Mediterranean, perspective, but Arabia was anything but peripheral to the early medieval world. The peninsula thrived as a key node in ancient networks of exchange. Some overland routes across Asia might move north through Persia and toward Constantinople, or they might dip south toward Antioch or Acre or Caesarea, while still others could bypass Persia altogether and move straight through Arabia and up into North Africa. Routes that crossed the Indian Ocean, progressed up and down the coast of East Africa, and into the Red Sea, all flowed through Arabian ports—especially in the more fertile southern section. Though the center of the peninsula was desert, it was one that the inhabitants knew how to cross, and so could profit from bringing goods from one side of the urbanized periphery to the other, and north to the trading networks bordering the peninsula.

Both the religious and political cultures of the Arabian Peninsula in the late sixth century were organized around extended kinship networks (what white Western academics too often call "tribes"). These groups were in both peaceful and hostile contact with one another constantly, exchanging ideas, goods via trade and raid, and people through marriage or abduction and enslavement. The vast majority of these communities were polytheistic and worshipped a variety of gods, though (not unlike the Romans) often concentrating their worship on a single deity affiliated with their kinship networks, and often linking that god to a specific natural feature or object.

Following a very recognizable pattern across many religious traditions, sacred places became *haram*, areas in which violence was forbidden and thus somewhere that commerce could safely take place. In Arabia, where there was water and a core *haram*, cities grew. But monotheism also had a home in Arabia. A variety of forms of Judaism were common in some areas, but it seems almost certain that Christianity had drifted to the peninsula over the centuries as well. In any event, both Christian Romans and Zoroastrian Persians maintained military and commercial contacts among Arabs, even as Arab merchants and mercenaries traveled to the north. In other words, there was no hermetic seal between the monotheists of the empires and the polytheists of the peninsula. Historically, there almost never is. Communities near one another always intermingle in some way.

One *haram*, focused around a sacred black cube known as the Kaaba, lay at the heart of the city of Mecca. Situated just inland from the Red Sea on the western coast of the Arabian Peninsula, Mecca was one important city of one urban region, a place where diverse ideas and diverse peoples might mingle and a new religion would be born. In the late sixth century, the city was dominated by an elite group, the Quraysh, who held sway over the most important trade in the premodern world: basic foodstuffs. The Quraysh also benefited from long-distance trade into the area from the Indian Ocean and over the Silk Road. Into this combination of sacred and economic authority by a particular kinship group, a man of relatively humble origins named Muhammad began to speak about his prophetic visions.

The story of Muhammad's early life, marriage to a wealthy widow, journeys to meditate in the wilds outside the city, revelations, and emergence as one of the most influential people in history has been told ever since his own time. The history is at once well known and contested, his earliest years shrouded in oral tradition and mystery, and all of it too much for this chapter. He had to fight with the elites

of Mecca who saw his religion as a threat to their power. He either migrated or fled with his early followers to the neighboring city of Yathrib in 622 CE (eventually renamed Medina), an act that marks year zero in the Islamic calendar. There he developed the framework for a new society, governed by sacred law, often in tension with local Jews and other Arab communities but ultimately successful in unifying the city.

Muhammad then defeated his rivals in Mecca and brought them into his community of believers. Before he died, he laid down one of the mandates of Islam that forged a connection among the faithful no matter their tradition, their ethnicity, or where they lived. Although the believers started out by praying in the direction of Jerusalem, they now changed to pray toward Mecca, an Arabian city, and to emulate the Prophet in pilgrimage or the Hajj, so that the broader world is always present.

As ALL THIS WAS GOING ON in Arabia, Byzantium, and Persia, the great empires to the north were in the late stages of a brutal, decades-long (or even centuries-long, depending on how one counts) conflict. The rule of Justinian featured the hardening of identities among varying Christian sects, some differing in regards to the nature of the divine (especially Jesus), others focused on church authority. Conflict broke out frequently among these different Christianities as their leaders jockeyed for political and social influence. Byzantine orthodoxy, however, often won out, leading to tension and resentment across the empire. Zoroastrians in the Persian Empire were also not homogenous but were generally welcoming to non-orthodox Christians and Jews who had fled Byzantium. Among the former, the Nestorian Christians, losers of a doctrinal battle in the fifth century, would spread far and wide across Asia, with repercussions that would last throughout the medieval period.

The two empires were, therefore, both vast and fragmented culturally and politically. Both controlled far more territory than any of their rulers could reasonably oversee and both were exhausted from fighting among themselves and with each other. This led to opportunities for local elites, who pushed at times to expand their power both against one another and against imperial governments. And let us not forget the common people, who as always bore the brunt of domestic and external instability, whether it was poverty, disease, corrupt administration, or conscription for foreign wars. The cracks in these empires were many and ran deep, and an expanding Arab polity provided a lever that pried them apart.

One crack expanded as the Persians invaded in 614, seizing much of the eastern coast of the Mediterranean and Egypt. They played off the instability of Byzantine politics, which had witnessed a number of coups and civil wars over the past decades, as well as a deadly pandemic, to advance rapidly. On their march, the Persians plundered Jerusalem and even pushed to besiege Constantinople itself. But the Romans, led by Emperor Heraclius, regrouped and counterattacked. Heraclius and Byzantine observers framed this as a holy war. Supposedly, the Persian siege had been broken when the army paraded icons of the Virgin Mary around the walls of Constantinople. God, the Byzantines concluded, had returned to favor them, and this understanding was even more secured in their minds when over the next few years Heraclius and his army won victory after victory, not just retaking land that had been lost but pushing deep into Persian territory.

Persian military leaders had had enough and sued for peace, staging a coup d'état of their own by imprisoning and executing Emperor Khosrow II, then elevating his son to the throne. This was to be the final peace settled between Rome and Persia, two empires that had fought on and off for centuries. Heraclius capped off his victories by

celebrating a procession into Jerusalem in 629 with his recaptured relics of the True Cross and only then conducting a triumphal parade in Constantinople.

It seemed that around 630 Byzantium was at a high, having just decisively defeated its major imperial rival. But the Roman Empire of the seventh century was a multireligious and multiethnic society stretched thin. For example, Egypt provided great wealth to the empire in terms of both agricultural products and trade goods, but multiple forms of Christianity coexisted uneasily there and were divided by regional and perhaps racial or ethnic divides. These inter-Christian tensions were especially high in the regions around Syria and Palestine, where the local communities were none too happy feeling (from their point of view) Constantinople's thumb upon their necks. This became especially evident when Arab armies arrived in the region in about 632. The Byzantines rode to meet them but by 640 had been soundly defeated. In 636 at the Battle of Yarmouk, the Romans suffered perhaps their greatest loss ever, allowing the invaders to sweep north well into Asia Minor (modern Turkey) before they were finally stopped. Again, though, locals did not see this defeat of the empire as cataclysmic. Numerous reports have local Christian and Jewish communities celebrating Byzantine defeats and even at times opening their gates to the conquerors.

As Roman armies crumbled and new leaders filled the void left by a now-distant Constantinople, previously marginalized groups found opportunities for recognition under their new rulers, who were less concerned with the fine points of Christian theology than with the relative stability of conquered populations. In the wake of the conquest, Arabians generally took over the preexisting bureaucracy but kept most former officials within government structures in place, allowed most wealthy landowners to retain their positions, and promised noninterference on religious matters. The first great Islamic

empire, the Umayyad Caliphate based out of Damascus, was built on such pragmatism, and it, relatively seamlessly, wove itself into the fabric of the world of Late Antiquity, building connections among regions rather than severing them.

THAT BRINGS US BACK TO JERUSALEM after its conquest by Caliph 'Umar in 638, as it offers a good case study of the mutually beneficial pragmatism that Christian and Muslim leaders showed in the creation of the new empire. For Christians at the time, Jerusalem was the center of the world, except that it really wasn't. As we've seen, Constantinople was also the center of the world, or perhaps it was Rome. Even in the fourth century, when under Emperor Constantine a new Christian city was rebuilt (intentionally on the ruins of the old, intended to demonstrate the supersession of religions), Jerusalem remained a city of a sacred past but not necessarily a sacred present. Much of Europe, much of Byzantium, looked elsewhere for sacrality: to the Romes old and new or to local churches and shrines. Still, in the era of Heraclius, the loss and then reconquest of Jerusalem served the Roman rulers as a way to bolster their political authority and promote theological unity. This was, of course, not true for the Jews, who generally retained a strong attachment to the city throughout the medieval period. Though even this was complicated by the rise of rabbinic Judaism, in part an adaptation to the realities of life after a destroyed Temple and a diaspora across the Mediterranean, focused on the memory of sacrifice in a Temple at once lost and hoped for again.

For Muslims, Jerusalem is often popularly said to be the third most important city in the world. But again, it's more complicated than that. At least for a thousand years after Muhammad, places like Baghdad, or Damascus, or Cairo, or Cordoba, or any number of other sites might struggle among themselves for importance. For example, when

Jerusalem fell to an army of Europeans at the close of the eleventh century, the initial reaction of many Muslims—particularly those far removed from Roman Palestine—was a collective shrug. Still, for the religion of what would be known as Islam, Jerusalem had acquired a key role in the unfolding of sacred history according to the increasingly formalized traditions of the sayings and doings of the Prophet.

Here the switch to praying toward Mecca becomes critical. When in the earliest forms of Islamic daily prayer, practitioners were supposed to pray in the direction of Jerusalem, it was one of the ways that the monotheistic north—and the Jews of Medina—influenced the new religion's development. But then Muhammad shifted this practice to pray instead in the direction of Mecca and the Kaaba. Politically, this paved the way for the city's elites to accept Muhammad while maintaining their city's privileged status. 'Umar, the second caliph and the man with whom we began this chapter, in fact came from the Quraysh clan who initially so opposed Muhammad's leadership.

Still, despite the increasing importance of Mecca, Jerusalem maintained its status as a key holy site. Again the details are debated and the textual traditions confused—much was recorded orally and only written down generations later—but a story began to emerge in the seventh century about a miraculous night journey that the Prophet took from Mecca to Jerusalem. A winged horse carried him there in a single night, and then he ascended to heaven, leaving his footprint on a stone now residing on the Temple Mount, in order to pray with the prophets who came before him. It's a powerful narrative that binds Islam to its Abrahamic predecessors through sacred space. As Christianity claimed to have superseded Judaism by remaking Jerusalem, this story was helping Islam make the same assertion, linking generations of prophets and the specific sacred city to the new tradition of Muhammad.

And so it was with malleable, overlapping, but distinct traditions

involving the import of Jerusalem that the armies of Caliph 'Umar washed over the region. But that's the wrong metaphor because very little was, at least at first, "washed away." In 638, Patriarch Sophronios of Jerusalem surrendered the city to Abū 'Ubaydah 'Āmir ibn 'Abdillāh ibn al-Jarāḥ, one of the companions of the Prophet and the supreme commander under Caliph 'Umar. Abū 'Ubaydah led the conquest of greater Syria and the Levantine region, in each case offering major cities three choices: surrender and convert to Islam, surrender and agree to pay high taxes in exchange for safe conduct, or be destroyed in war. Once it was clear that no Byzantine army was coming to the rescue, the leaders of the region quickly chose option B. They surrendered and agreed to pay taxes.

But for Patriarch Sophronios, for reasons that we can speculate about but will never really know, that wasn't good enough. He agreed to surrender but requested to do so in person to the caliph. 'Umar rode to the holy city on a camel in February 638, camping at first outside the walls on the Mount of Olives and there meeting with the patriarch. History sat on a hinge, about to swing. The caliph and the patriarch signed an agreement and then 'Umar solemnly entered the city.

Together, patriarch and caliph toured the city until it came time for the caliph to pray. Sophronius led him to the Church of the Holy Sepulcher and offered him space there. But according to tradition 'Umar refused to pray inside and instead went outside the church and prayed there alone. According to the tenth-century historian Eutychius of Alexandria, a Christian prelate who wrote in Arabic some centuries after the event, 'Umar said to the patriarch "'Do you know why I did not pray inside the Church?' [The patriarch] answered: 'I do not know, Commander of the Faithful.' And 'Umar said to him: 'If I had prayed inside the Church, you would be losing it and it would have gone from your hands because after my death the Muslims would seize it saying: 'Umar has prayed here.'" Indeed, the

caliph ruled that the followers of Muhammad should never pray as a congregation even outside the church but instead only as individuals, protecting the rights of the Christians to their sacred site.

This history, of course, is suspect, because a Christian wrote it hundreds of years later with the clear agenda of protecting Christian control over their holy sites (and Islamic sources tell a slightly different story). Yet the anecdote demonstrates that religions don't exist in a constant state of coexistence or conflict. Between the conquest of Jerusalem in 638 and when Eutychius wrote some three hundred years later, Christians and Muslims warred and made peace, Byzantines struggled and traded and made alliances with both the Umayyad and Abbasid dynasties. Even here in the tenth century, our Christian author (writing in Arabic!) called back to a foundational moment of conquest to suggest a long tradition of coexistence.

Indeed, Christians largely did maintain control over their sites in Jerusalem, using the agreements between 'Umar and Sophronius as one template to guide a rough and unequal coexistence. Christian pilgrimages to the city remained consistent—and almost always welcomed—during the subsequent Islamic centuries. Certainly, just as Christian authors had done, Islamic writers crafted their own historical traditions out of these interactions, eventually codifying a "pact of 'Umar" as a core legal document at the heart of Islamic jurisprudence when it came to interacting with non-Muslims. These *dhimmis* (Arabic for non-Muslims living under Muslim rule) possessed specific rights, protections, and obligations. They were the majority within early Islamic society as the empire spread so rapidly. Solid historical evidence, for example, suggests that the majority of the population of Asia Minor switched from Christianity to Islam only several hundred years after that land's conquest, that they retained their *religio* for generations. The same was true of Iberia. Thus, perhaps largely out of necessity, and canonized within theological, historical, and legal

texts over the first few centuries after the life of the Prophet, the Islamic world created space for non-Muslims to both live and thrive.

And of course, Islam thrived too, spreading throughout a vast segment of the world. In 711, Arabs and newly converted peoples from North Africa conquered Spain, bringing Islam to the Atlantic Ocean. In 751, an army of the Abbasid caliphate (which overthrew the Umayyads in 750, then moved the capital from Damascus to Baghdad) fought an army of Tibetans and soldiers from the Tang dynasty in China, deep in central Asia at the Battle of Talas, as Islam began to expand eastward. We know that ships sailed back and forth from India throughout this period, driven by the trade winds, but perhaps Arabs sailed even farther during these early years. Around 830, a merchant ship sank off the coast of Indonesia. Its hold was full of Tang trade goods, including ceramics, coins, and star anise. At least some of the timber seems to have come from a species that grows only in southeastern Africa, which would solidify the Arabic origin of this vessel, evidence of merchant transport from the Arabian Peninsula to China and thus of a sea route that extended along the tendrils of Islamic culture far to the east long before the turn of the first millennium.

By then, followers of Islam not only lived along the Atlantic, as well as in Tibet and western China, but had also spread through conversion and trafficking in enslaved people (those from the steppes would be forcibly converted) onto the great central Asian steppes. And throughout, as all things do over time, the religion adapted to its new circumstances, morphed into a vibrant array of forms with multiple and contested theologies and political centers. Just as with the multiple Christianities we've hinted at in this chapter and will discuss in more depth in the next, we have to speak of the many Islams. The stories of these many Islams encompass all the many peoples who adopted it, those who lived under Islamic rulers, and the myriad forms of exchange across ethno-religious and political borders.

All of the Abrahamic religious traditions have roots in southwest Asia, at times focused around the city of Jerusalem, but with centers of devotion and power dotting three continents in the pre-modern era. From the eighth century to the twenty-first, but particularly during the Middle Ages, there is no moment in which large numbers of Muslims do not live, and often prosper, in Europe. There is no medieval moment in which ideas, peoples, objects do not flow from east to west and west to east. The early medieval world was connected both materially and intellectually, by peoples who passed through multiple ports, called many places home, followed different rulers, and worshipped one God but disagreed on how and why. The enduring legacy of antiquity moved across centuries and over seas, but always in the sixth and seventh centuries returned to Rome.

A GOLDEN HEN
AND THE WALLS
OF ROME

According to the historian-bishop Gregory of Tours (d. 594), the Tiber overflowed its banks in Rome in 589. Storehouses of wheat were spoiled and ancient buildings ruined. Then snakes appeared on the plain. They floated through the city and to the sea, where they were crushed by the waves. But they had brought plague in their wake, specifically a plague "of the groin" (almost certainly caused by the bacterium *Yersinia pestis*) that, Gregory lamented, ravaged the city and took its leader. But Gregory wasn't lamenting an emperor, Roman general, or Byzantine exarch; instead he was mourning the loss of the bishop of Rome.

We're yet a long way from talking about the (imagined) great and terrible medieval papacy, an individual who ruled an institutionalized, strictly hierarchical Church. That would come about six hundred years later. And yet, even here at the end of the sixth century, the bishop of Rome *mattered*. What's more, Rome around 600 still mattered as one key node in a perhaps diminished, but still active

network of ideas, goods, and peoples that flowed from the eastern Mediterranean through Italy and into far northwestern Europe. New states were rising and new forms of Christianity emerging, as kings, queens, and clergy traded words and golden sacred objects in their various quests for power, security, and influence. And though there was plenty of conflict, even among adherents of various forms of Christianity, we find overlap, accommodation, and collaboration.

Throughout Late Antiquity, at least after the conversion of Constantine in the early fourth century, bishops had filled a void that seemed from their perspective to have emerged in regional power networks, working closely in both West and East with Roman rulers, and serving as both imperial administrators and spiritual shepherds. This was true in Rome, too, even after the emperors moved to Ravenna and Constantinople. The bishop of Rome, however, was always special because that position derived power from the legacy of the apostle Peter, who had traveled to, and been killed in, the city. Certainly, the location of religious power across the empire was complicated by important bishops (called "patriarchs") in the new imperial center of Constantinople; in Antioch, where Peter first found his home; in Alexandria, with its intellectual legacy and connection to ascetic origins; and, of course, in Jerusalem itself. But Rome was, well, Rome.

So when Bishop Pelagius II fell to the plague in 589, the city turned to a man named Gregory (later known as Gregory I the Great, 590–604). He came from an old Roman senatorial family but had for a time been a monk, then the bishop of Rome's ambassador to Constantinople, before returning to his monastery until he was elected bishop in 590. The people all agreed that the plague was God's punishment on the sinfulness of the Romans and so, just after ascending to his new position, Gregory led a penitential procession through the streets. Lit by torches, the crowd prayed vigorously even as some of

them—allegedly—fell down dead along the route. Finally, according to a much later version of the story, as the procession neared its conclusion, Gregory looked to the sky and saw a vision of Michael the Archangel hovering above with a flaming sword, drawn and menacing. But as the procession neared, Michael sheathed his sword and disappeared. The people's repentance, led by their new leader Gregory, worked. The plague supposedly abated shortly thereafter.

While we can and should doubt the veracity of the vision, we can be sure that plague fundamentally transformed the sixth-century world. More than just ushering in a new (and deeply influential) bishop of Rome, the so-called Plague of Justinian that arrived in the early 540s severely hindered the Roman reconquest of Italy. Byzantium began once again to contract, facing severe depopulation and renewed external threats in the east, as we saw in the previous chapter—first from Persia, then later from Islam.

In the west, the Visigoths were reinvigorated and established a permanent kingdom in Iberia that would last until the early eighth century, while the Ostrogoths ceased to be players after their defeat by Belisarius and were then supplanted by a new group called the Lombards, who established their own kingdom in northern Italy. Rome became a backwater for the Byzantines as they focused their attention to the north of the Italian peninsula, deploying ships in the Adriatic to defend Ravenna.

The Lombards' own religious traditions circa 600 are a bit confused in the surviving sources because either they were written sometime later, post-conversion to Christianity, or they were produced by non-Lombards. The group seems to have been polytheistic but gradually embraced Christianity. Most of the other Germanic groups behaved similarly, moving from polytheism to Christian monotheism little by little sometime between 300 and 600. But the process of conversion is a bit more complicated than one might think, particularly

given that there were at the time multiple Christianities to choose from.

This is important because we have the tendency to think of ancient Christianity as monolithic, when it was anything but that. Historians now rightfully speak, rather than of one early Christianity, of the existence of multiple Christianities throughout the Roman East and West. Many of these theological controversies, which manifested in quite distinct cultural and social communities, revolved around determining the precise nature of Jesus—the relationship between His supposed godhood and manhood. One of the most enduring debates was Arianism (named after a priest from Alexandria named Arius). Whereas orthodoxy proposed that Jesus was equal parts man and god, Arianism said that Jesus was created by God the Father and so was not an equal partner in the Trinity. This was an immensely popular community throughout the Mediterranean world. The Visigoths and Vandals, for example, came into Roman territory as polytheists, converted to Arianism, and stayed that way. The majority of the Lombards, on the other hand, possibly after a brief flirtation with Arianism, moved largely from polytheism to orthodox Christianity. In all cases, the Arianism of the Germans brought them into almost immediate conflict with the native Romans, who by and large adhered to orthodoxy.

The tension between the various Christianities may have been entirely doctrinal, as a focus on Jesus's humanity definitely had emotional and intellectual appeal to its adherents. But there's also politics to consider. Religious conversion is often shaped by considerations of community and family, alliance and alignment, as we will see time and time again. Arian Christianity allowed Germanic rulers to enter the broader Christian world and gain access to intermarriage with other elite families, while keeping them free of doctrinal oversight from the orthodox emperors, patriarchs, and bishops. Orthodoxy,

on the other hand, allowed access to all those existing networks of power, as well as the intellectual heft of being able to claim "tradition." And one side could be played off against the other.

This is all-important in the case of the Lombards. The Ostrogoths were Arians, defeated by the Orthodox Romans (Byzantines) in the early part of the sixth century. When the Lombards swept in, they needed something to justify their conquest, something to legitimize their rule in the eyes of both the people they conquered and their potential rivals. They did so in part with religion, in part by trying to forge an alliance with one of the Romes that didn't fall, looking not east to the new Rome of Constantinople, but closer to home with the old city and its bishops.

The Lombards threatened the city of Rome but never sacked it, marching in 592 and again in 593 through the center of Italy, pillaging, enslaving, and killing, and bringing their troops to the walls of the city. They even paraded enslaved Italians in sight of the defenders as a threat to the Romans of what would happen if they didn't surrender. But the final assault never came. As leader of the Romans, the bishop of Rome (Gregory) managed to forge a peace with the Lombards that spared the city. Significantly, Gregory did so over the objections of the emperor in far-off Constantinople, who saw the Lombards (correctly) as a threat to Byzantine control in the region. The problem was that no Byzantine help ever seemed to come. So Gregory, more concerned with his city than with the titular claims of Constantinople, acted on his own as both spiritual and temporal protector of the city's residents and managed to achieve a lasting peace with the Lombards, in large part because he eventually found an ally in their queen.

Gregory didn't have armies or wealth or the ability to control the church outside his direct area of influence, but he did have the ability to write letters. He tried to extend his influence through writing, a

common pastime for people in his position, but Gregory was unusu-
ally prolific and was more than happy to share his ideas with any-
one and everyone who would listen (and even sometimes those who
weren't interested). The letters themselves reveal both the thoughts
of this unusual man and the ways in which ideas moved across the
early medieval landscape even in this time of imperial contraction.
In addition, these letters were rhetorical exercises—intended to con-
vince, to at least intellectually expand the old Rome's influence and
bring a wider world into the bishop's orbit. For example, he sent a
Rule of Pastoral Care (a kind of manual for how to be a good cleric)
addressed to the bishop of Ravenna but also sent a copy to Seville
and to Constantinople. *Pastoral Care* sketches out that the goal of the
shepherd is to care for his flock, rather than for himself and his own
worldly advancement, and that a proper education prepares the fu-
ture churchman to act as an effective and devout leader and teacher.
He was clearly talking about himself but it influenced others as well.
When he received a copy, Emperor Maurice in Constantinople was
so impressed that he ordered it translated into Greek.

In another work, *The Dialogues*, Gregory positions himself as the
vehicle to promote Italy's holy history. He opens *The Dialogues* with
the narrator (a "fictional" man named Gregory) telling a story in which
he feels melancholy and overwhelmed with worldly affairs, so he re-
tires to be alone with his thoughts. Gregory reveals that he's sad-
dened because he had been contemplating the lives of saintly Italian
men and found himself wanting. Gregory then tells story after story
of good lives, excellent behavior as a priest, and eventually saint-
hood and miracles. His examples led exemplary spiritual lives but
also managed to live in the world, fitting for a man who used to be a
monk but then was called to lead the Eternal City. Fitting, too, that
although this book made its way from Latin to Greek and around

the Mediterranean Sea, he kept one copy closer to home, sending it north to his ally, the Lombard queen Theodelinda (c. 570–628).

Theodelinda was the daughter of a Bavarian duke and descendant of an ancestral Lombard ruler. In 589, she married a Lombard king who had eliminated imperial control in much of the northern peninsula, pushing Byzantine power to the coasts, even as he adopted some Roman symbols and methods of governance. But he died just a year into the marriage. Theodelinda maneuvered this challenging position artfully, positioning herself against several competitors so she could choose her next husband and thus determine the next king. She chose Agilulf, the current Lombard duke of Spoleto, all the while corresponding with Gregory in Rome, maintaining her own lines of communication. When Agilulf died in 616, Theodelinda once again took the reins to lead the Lombards, serving as regent for her young son Adaloald.

Theodelinda, in other words, sits at the middle of a spider's web, skillfully traversing the strands of power in the Lombard world, astutely collecting allies to protect herself and her family in power. Part of that involved religion, as it's almost certainly not a coincidence that Gregory found such a staunch ally in this particular Lombard queen, nor is it coincidence that the first Lombard kings we can securely say were Christian are the three connected to Theodelinda. As we'll see in our next chapter, queens were often the tip of the spear in Christian conversion efforts in this period. But we shouldn't think of this as a purely cynical move. Modernity is comfortable dividing the world in ways that would be utterly foreign to the medieval world; during the Bright Ages, politics was religion and religion was politics. For example, consider that according to the eighth-century historian Paul the Deacon, Theodelinda built and funded churches such as the cathedral dedicated to St. John the Baptist in the city of Monza (just

north of Milan), which still stands today, albeit much embellished by artisans over the centuries.

The treasury of the church in Monza still contains objects associated with her: a votive cross that she may have commissioned for her son, a golden mother hen with chicks that perhaps (there's not a lot of surviving documentation) Pope Gregory sent to her as a metaphor for her role with her family and the Church, as well as small metal vials (*ampullae*) that contain dirt from Jerusalem and Rome. Together, the cross and statuary of the hen and her chicks stand as a metaphor for her reign as Lombard queen, linking her adherence to Christianity to her family's political fortunes. If Bishop Gregory did indeed send her the statue of the hen, he was acknowledging—even supporting— her power as a ruler in her own right, watching over her own "flock." Then there's the *ampullae*. These contact relics—objects that have come into contact with saints or Jesus himself and thereby contain some of their holiness—provided a mystical connection between the Lombard kingdom and the broader Christian world. But religion and politics connected; the earth was not just from the holy city of Jerusalem, but from Rome as well. The world of 600 CE is still very much dominated by the remembered glory of empire. When Theodelinda managed the succession of her son to the Lombard throne, she did so not in a church as one might expect from a Christian monarch, but in the Roman circus in Milan. Symbols of power are power, and at this moment church and state lived happily together.

Theodelinda's story doesn't end happily. Her son went insane and a civil war broke out, so her influence ebbed. Indeed, her son's reign lasted only as long as his mother remained alive; she died in 628, and he was murdered that same year.

BUT THEODELINDA MATTERS. ORTHODOXY DEFEATED ARIANISM and took hold as the dominant sect of Christianity in Western Europe

through clerics like Gregory and women like Theodelinda. Orthodox noblewomen married into polytheistic or non-orthodox ruling houses, raised their children into orthodoxy, and gradually pushed out other forms of Christianity. The frequency with which this happened must have been noticed by contemporary rulers, and perhaps raises questions about the extent to which many of them saw the variety of Christianities as significantly different from their own. It's easy for us to imagine an existential struggle between religions, as we've often been taught that this is a natural type of relationship, but that doesn't seem to have been the world in which these people lived. We saw that in the previous chapter and we'll see it again and again throughout.

Early medieval Germanic rulers were not fools, at least not the ones who lived long enough to have an impact. Although the Visigothic rulers of Iberia seemed to cling to Arianism as a way to differentiate the ruling class from populations north of the Pyrenees, other rulers used a shared faith as a way to bind conquered populations—and, via marriage, their elite families—together. Marriage was a traditional avenue for such separation and connection, and in almost every case, we need to remember that the women were not passive pawns in a political game. When we do get sources that describe these queens, we see agency—often to the dismay of the authors, almost all of whom were male clerics.

Under a people called the Franks, for example, the process of Christianization followed similar lines to what we just saw with the Lombards, though the Frankish story had begun much earlier. The Franks had fought under a Roman general in the late fifth century against the horde of Attila the Hun—the result of a mass movement of peoples from perhaps as far as western China, slowly rippling across Asia until an army of Turkic horsemen began attacking Europe. The Romans and their allies defeated Attila, but then a power play in Ravenna left the Roman general Aetius assassinated and the Franks at

once culturally bound to the Roman Empire, but also fundamentally on their own. They gradually expanded both the territory and the ways they talked about themselves as a people, transitioning from duly appointed rulers of Roman territory to kings in their own right.

According to the bishop and historian Gregory of Tours, the Frankish (at the time polytheistic) King Clovis married a Christian Burgundian princess named Clothilda (m. 493–511). They had two children and the queen baptized them, though the death of the first one after baptism led to Clovis's condemnation of the Christian god. Still, in a later battle with another group of Germans moving into the region called the Alemmani, Clovis cried out to his wife's god and promised to convert if he won. His foes fled. Clovis's people cried out en masse their desire to be baptized. "And the king," wrote Gregory, "was the first to ask to be baptized by the bishop. Another Constantine advanced to the baptismal font, to terminate the disease of ancient leprosy and wash away with fresh water the foul spots that had long been borne." In this story, although a battle is the proximate cause for the conversion of the king and his people, we see an author reaching back to Rome to justify a conversion in which the real mover was Clothilda.

But we cannot entirely trust Gregory of Tours here. The wife moving her husband to orthodoxy was an established literary trope by this time. Moreover, Gregory was no passive observer, but rather a deeply partisan player in both the church and Frankish royal politics (to the extent they can even be distinguished). He had rulers he liked and rulers he despised. For example, he was close friends with a queen, Radegund of Poitiers. When her husband murdered her brother, Radegund fled to Poitiers, just south of Tours. She entered religious life as a nun but maintained close contact with Gregory and literate elites throughout the kingdom, including the poet and bishop Venantius Fortunatus. She never regained her throne but eventually

became abbess of a religious house named after a relic of the True Cross given to her by the Byzantine Emperor Justin II.

Radegund soon developed another sort of power, one derived from her spiritual position instead of her political one. Imbued with the presence of the cross at her own house, she worked miracles of healing, according to her hagiographers. After she died, her nuns refused to accept episcopal authority over them for several years, asserting their independence and right of self-governance by telling her story, expanding Radegund's legend in ways that served this purpose. Gregory of Tours also told those stories. A blind girl regained her sight, oil from a lamp overflowed endlessly in the presence of the sacred wood, and a spark transformed into a beacon of light, revealing the sanctity of the object for all and illuminating this moment in sixth-century Poitou. Eventually, a tale in which Radegund turned away a dangerous serpent grew in stature, until the serpent became a dragon, the "Grand'Goule," which Radegund defeated with the presence of the relic and the power of her personal sanctity. God acted through her to defeat the monster.

The source of Radegund's power thus shifted from the temporal to the spiritual. We've seen this before, with Daniel on the pillar and other ascetics of the desert. Extreme asceticism—denial of the body and its worldly pleasures, including but not limited to food, wealth, and sex—can of course be found in many religions. In the eastern Mediterranean though, men typically swore to adhere to an individual path of rigor, even though they often lived in community among others. Solitary ascetics lived outside communities, serving as kinds of segregated spiritual celebrities or athletes, doing the sacred work by battling demons (through prayer, and sometimes visionary wrestling matches) on behalf of the broader community. But the Roman province of Gaul (roughly modern France) was not the same as Roman Palestine, and the sixth century wasn't the fourth. Ideas that

travel across time often need translation, and the Roman west found its ascetic translator in a man named Benedict of Nursia.

Benedict lived from around 480 to 547 in Italy, eventually founding multiple monasteries right in the same period as Goths and Greeks were fighting over the peninsula. His "rule" for which he's famous, a slim book describing how to live the best monastic life, is just one of many such attempts to create a pathway for an individual to dedicate their life to God, but what made Benedict's rule different was its emphasis on merging the individual with the collective, on taking the ascetic practices of the solitary monks of the eastern Mediterranean and then forming a single corporate identity in which the community would progress toward salvation with less pressure on the individual to be a demon-wrestling hero. Under the watchful eye of an abbot, life was to be cloistered away from the temptations of society, consisting mostly of daily readings from the *Rule* as well as other examples of holy lives, rules for meals and dress, prescriptions of silence, and how to both toil the land and venerate God. The emphasis of the *Rule* was on discipline, on the formation of a *schola*. The modern English word "school" is of course derived from this term, but in Latin it had another meaning as well, with the word reserved for a specially trained military unit within a Roman legion.

Benedict was trying to train an army, one specially trained to fight a spiritual war against the machinations of the devil in this world. Indeed, in Gregory the Great's *Life of Benedict*, he does just that, defeating the temptations of the devil by punishing his body, throwing himself into a thornbush to drive away his lust. Monks like Benedict and those who followed trained their bodies to pray for peace, to drive away the demons of the world that led people to sin, to discord, to violence. Sometimes those demons manifested in this world, such as with Radegund, but more often it was primarily a metaphorical battle directed toward ensuring that one lived properly.

When Gregory the Great wrote about St. Benedict's life in his second book of his *Dialogues*, he described not only miracles—exorcisms, cures, and one case of a monk meeting a dragon as a punishment for disrespecting the rule of the monastery (the monk promised to do better)—but also revelations about the pressures of running a religious house, with monks sneaking out to eat with women, a young monk renouncing his vows and going back to live with his parents (he died; the earth cast his body out when his parents tried to bury it), and constant pressures from the secular powers. In the stories of the saints, Gregory was, of course, not only promoting monasticism based around Benedict's ideas and the veneration of the Italian saint himself, but also sending a message about the aspirational role he thought Christianity should have. Despite modern and (sometimes) medieval protestations, the spiritual and the material were always intertwined, never separated, always more complicated.

Gregory's Rome stood between phases, no longer really a major city of a wide-reaching empire, nor the new hub of both political and religious sovereignty that it would become later. But still something important. Gregory's life and writings show both intellectual and political ties that stretched across the centuries and around the Mediterranean world. By the time of this death in 604, his world touched Asia Minor, North Africa, France, and even the far northern reaches of that world—Britain. Theodelinda's treasury in Monza attested that her world, even as the daughter of a Bavarian duke and wife to a Lombard king, stretched across the Rhine and beyond the sea to Jerusalem. Radegund's life in western France was punctuated by letters from Constantinople and relics from Jerusalem. And in all cases, religion and politics elided—often easily, as if they were one and the same—so that a bishop, a queen, and an abbess could at least intellectually connect the Roman world as easily as putting quill to vellum.

In 597, Gregory wrote to an abbot named Mellitus who was about to embark for Britain. The mission was about conversion of the peoples of that island, about casting down, in Gregory's words, "idols" and "the worship of demons." But, Gregory wrote, his missionaries weren't to destroy the polytheistic temples; instead they were to cleanse them with holy water and encourage the people they encountered to continue their religious rituals because "if they are not deprived of all exterior joys, they will more easily taste the interior ones." The point was not to punish but, as he'd done with the Lombards, to teach. The point of the mission was to use Christianity to lead a lost province—a lost people in Gregory's eyes—back into the orbit of an eternal Rome. But the varied peoples of Britain might have told a different story.

SUNLIGHT ON A NORTHERN FIELD

According to an early eighth-century account by the monk Bede, Mellitus wasn't the first to hear about Gregory's plan to send missionaries to Britain. Supposedly, one day (in the late sixth century) Gregory was walking through the streets of Rome and happened upon a market filled with merchants from distant lands. One stall caught his eye. It was selling enslaved people—mostly young boys brought south across the continent to be sold into bondage throughout Italy. The fact that there were slavers in Roman markets wasn't shocking (slavery was a holdover from antiquity that carried on throughout the Middle Ages), but Gregory was shocked to hear that they weren't Christian. He resolved to send missionaries to Britain to convert these people.

The story is apocryphal, deeply unlikely to be true. The monastic author of the account was writing about his distant past, seeking to connect Britain to Rome, and thus legitimize the presence of Christianity in his land. The general contours of that story have now worn smooth, been romanticized over centuries, and even deployed as a founding myth for white supremacist ideas about the past. It's a

story that sees a forgotten land reclaimed and yet always flourish-ing, paradoxically colonized by Roman Christians and yet forever independent, inhabited by a white, ethnically homogeneous group of Germanic polytheists just waiting for the triumph of Christianity to pave the way to (a millennium later) the British Empire. But that was a story told in the service of empires medieval and modern, a way for the tellers to promote themselves and justify their subjugation of other peoples.

There are other, better stories to help us think about this period and this place—ones that are more honest to the past. What if we instead start our discussion about Britain with other far-distant travel-ers, ones who were welcomed instead of imposed?

Archbishop Theodore of Canterbury (d. 690) arrived on the island in 669, originally from Tarsus, in the south-central part of modern Turkey. Soon after, he was joined by a man named Hadrian (d. 709), described as a "man from the people of Africa." Hadrian took up a po-sition as abbot of the monastery in Canterbury. Together they estab-lished a school to teach Greek and Latin, blending ancient learning with local knowledge. And it was wildly successful. Students flocked to Canterbury from across the land and would soon populate some of the most important posts across the various kingdoms on the is-lands. One of Hadrian's most famous pupils, Aldhelm, who styled himself a "disciple" of the North African and would himself later be-come an abbot and bishop, wrote Latin treatises and poetry, as well as a collection of one hundred riddles that inspired a whole genre in subsequent generations. But their influence was even greater. Holy men and women, particularly in the early Middle Ages, were often local personalities, with veneration for their sanctity limited to a par-ticular region. So the sudden appearance of saints from as far away as Asia Minor (modern Turkey) and Persia to the practice of religion in

Britain, and some of their subsequent acceptance, is notable for the influence of men like Theodore and Hadrian.

And this is just the beginning. Early medieval Britain was built by its connections to elsewhere. The seventh-century Wilton Cross, a golden pendant inlaid with garnets and intended to be worn around the neck, contains a Byzantine gold coin at its center, and likely dates to not long before Theodore and Hadrian arrived. But it's no outlier, simply one of the most brilliant of a multitude of both luxury and everyday objects with origins thousands of miles from where they ended up. Sixth- and seventh-century coins and gems have regularly been found in contemporary graves across Britain, originating in either Byzantium or even the Sassanian Empire in Persia. Shoulder clasps found in the famous Sutton Hoo ship burial in Suffolk, England contained garnets from, most likely, India or Sri Lanka. And people moved with these goods. Scientists can measure the oxygen isotopes in dental enamel to determine where in the world long-dead people were born. From the Bronze Age through to the medieval period, we're finding people buried in British graves who were born in Asia and Africa. That number peaked, unsurprisingly, during the Roman period, but never falls to zero throughout the Middle Ages.

We're in a moment in which scholars are radically reimagining early medieval Britain, one less in thrall to nationalistic myths and ultimately more honest to the past itself. Marshaling rigorous research across the arts, humanities, and sciences, these scholars have now peeled back the stories of early medieval Britain, and found that the island has never truly been an island. In the early Middle Ages, it was filled with people from at least three continents, with men, women, and children who likely spoke a variety of languages. Bede, for example, counted at least five languages there in his own time and seems to have assumed that multilingualism was common. The

people imported things and ideas from abroad, but it would also be a mistake to see the process as erasing what was already there; instead, local traditions amalgamated with the new in ways that made sense to them. They sometimes thought as much about lands thousands of miles away as they did about villages on the other side of the hillock. This is true of just about everywhere throughout the Bright Ages, but seeing Britain as part of a much larger community is relatively recent in the past few decades, a new model of development that emphasizes innovation and adaptability.

Reimagining Britain as a place of amalgamation can be done even with some of the most well-known objects and texts that once were used to support a simplistic, xenophobic story of early Britain. So let's turn our attention to a remote corner of a kingdom called Northumbria, where the eighth-century sunlight spread over a field and fell upon a giant stone cross.

The Ruthwell Cross is eighteen feet tall, was once brightly colored, and was constructed to tell the people of Britain a story about themselves, both their history and their future. Medieval people—not unlike those in our own times—built monuments to construct particular narratives about the past for their audiences, and this one was no different. It projected the viewer into the world to come, imagining a Christian Britain and, in the long run, salvation for all. But while at first the story of the cross seems to be a simple, top-down Christian history, there's something more complex and organic at work. Its design was shaped by and serves as evidence for that multilingual adaptable society, in contact with other British (and Irish) influences just as much as those from the Continent, and designed to speak to as many different people as possible.

One of the stories of the cross was designed to be read clockwise from west to south. These images, all vibrantly painted, illuminated the path to salvation. Reading upward, the original west side begins

with Mary's flight into Egypt, continues by showing a vignette from the life of St. Anthony and St. Paul of Thebes (two of those hermit monks from the eastern Mediterranean) breaking bread in the desert, then displays an image of Jesus demonstrating His mastery over the beasts of the earth. The west side concludes with an apocalyptic image of the apostle John holding a lamb. On the original east side is the Annunciation, followed by a miracle of Jesus healing a blind man, then Jesus with Mary Magdalene, and finally Mary and Martha together. All are surrounded by Latin inscriptions.

This monument, like all monuments, also told a story about the future, projecting the viewer into the world to come, imagining a Christian Britain and, in the long run, salvation for all. The east side offered a tale of salvation, how miracles were possible for those afflicted, how even Mary Magdalene could be raised up via her devotion to God. The west side was one for monks, about the ascetic life of the "desert," but also one about the liturgy, the mass, the story of the Gospel symbolically re-created, with Jesus's triumph over this world at its centerpiece. In both cases, the Latin around those images made their meaning clear, using the language of the priests sent from Rome at the urging of Gregory the Great so long before. But there are two more sides to the cross, because priests were never the only audience for monuments such as this. The story of early medieval Britain is not solely about people coming from the center and talking down to the locals, or Latin culture overwhelming local vernaculars, but about voices from all directions, often enough in conflict, but producing something of a polyphony, vibrant and complicated.

On the original north- and south-facing sides of the cross, among the vine scroll and animals, there's a text, likely part of a longer poem, carved in a Runic script so that one could read it out in Old English. Here, not in the language of Rome but instead in the vernacular (because without effective communication there would be no synthesis

to be found), the poem on the north and south sides tells of Jesus's crucifixion, one of our earliest non-Latin surviving versions, with similarities to the better-known eleventh-century poem "The Dream of the Rood." Again, moving clockwise, the north side begins the tale from the point of view of the Cross itself. It reads, "Almighty God stripped himself when he wished to mount the gallows . . . I dared not bow. I [raised] a powerful king . . . Men insulted the pair of us together. I was drenched with blood." The south side concludes the whole arc, Runic poem and artistic program, by saying once again in the Cross's own voice: "Christ was on the cross . . . I was terribly afflicted with sorrows. I bowed, wounded with arrows. They laid him down . . . looked upon the Lord of Heaven." As the west side culminates with the triumph of Jesus over the beasts and apocalyptic vision, the north side has Jesus mount the cross and reveal his humanity with an effusion of blood. Then the east side emphasizes His humanity, His birth, how Jesus offered sinners healing and salvation, and the story concludes on the south with the cross itself mourning Jesus's death alongside all mankind.

THE STORY TOLD BY THE RUTHWELL Cross, a monument sitting outside what may have been either a small church or monastery in what's now Scotland, far from any center of power, incorporates men, women, and children, merchants from far away, peasants, and kings. This story of a multivalent culture can be found on giant artifacts, but it can also be found in books, especially *The Ecclesiastical History of the English People* by a monk named Bede, a man who lived and wrote in the northeast of what is now England, at the abbey of Monkwearmouth in the Kingdom of Northumbria, and the very same person who preserved the story of Pope Gregory in the slave market (which, of course, indicates his agenda in looking for a smooth history despite all the bumps in his reality). Bede's story, like the monumental cross

just ninety or so miles directly west of where he wrote, binds the lives of non-Christians and Christians alike, including priests, monks, and—as several scholars have argued, given the imagery on the Ruthwell Cross—likely nuns. But perhaps this shouldn't surprise us. We have spent a lot of time so far in major cities and their hinterlands, in Rome, Constantinople, Jerusalem, but urban centers and peripheries remained connected throughout the medieval period. Some of the most important stories, the most revealing moments, occurred not just in cities but in fields, or even in swamps.

But permeability brings not only opportunity, it also brings conflict and tension, and that, too, resides in the voices that come down to us from early medieval Britain. South from Northumbria, but at the same time as Bede and the construction of the Ruthwell Cross, in the fens between Mercia and East Anglia a man named Guthlac left his life as an aristocrat and warrior in the kingdom of Mercia to become a monk. His path was not easy. He started his career at the monastery of Repton but allegedly found it wanting and decided to become a hermit, emulating the desert saints we met above.

According to the *Life of Guthlac*, written by a monk named Felix just after Guthlac's death in 715, the hermit experienced similar trauma to his model Anthony of Egypt. Not only (supposedly) was he carried off to the gates of Hell by demons and only rescued by the apostle St. Bartholomew, Guthlac was threatened physically by non-Christian peoples, wild beasts, and duplicitous fellow monks. But not all the danger came from the fens, the wilderness untouched by Christianity, as Guthlac and his biography moved between the high politics of two kingdoms. Felix's text was itself dedicated to King Aelfwald of East Anglia (713–749), the kingdom in which Guthlac had his hermitage, and we read inside that he was visited by a future king of Mercia named Aethelbald (716–757). Indeed, when Aethelbald returns to pay his respects after Guthlac's death, the future ruler

is treated to a vision of the hermit, now in Heaven, assuring Aethel-
bald that he will take the throne some day. Notice here that not only
does the periphery connect to the centers of political power, but can
in fact limit the center's options—the king decided not to drain the
swamp but rather to harness its power.

Bede, telling his story about Gregory in the slave markets of
Rome, was confident with the benefit of hindsight that Rome (and
Christianity) would return to Britain, but Rome's emissaries when
they arrived confronted an unruly world. Carved upon the Ruthwell
Cross, runes mingle with Latin letters, Gospel verses are sung with
the voice of anthropomorphic wood, vine scrolls intertwine with
apostles, the whole program speaking to educated monks and nuns
but also concerned with (from the church's perspective) an unedu-
cated populace. And as Felix's tale about the hermit Guthlac shows,
kingdoms and a network of Christian communities had been well es-
tablished, but the countryside was full of danger, one where demons
walked and commanded wild beasts, alongside pockets of threatening
non-Christian peoples. In both cases, in both stories, power resides
in unlikely places: "periphery," in other words, can readily become a
new center.

Throughout the history of Britain across the early Middle Ages,
we find this kind of patchwork of states and diverse peoples and be-
liefs. This was an inhabited land conquered with violence by the
Romans under Julius Caesar, then (at least partially) Christianized
first during the fourth century. More invaders came in the fifth and
sixth centuries and the inhabitants fought or made accommodations
with them, leading to the establishment of new kingdoms. Christian-
ity (mostly) returned again in the seventh century, forcing even more
political realignments.

Only a generation or so before Galla Placidia moved effortlessly
across the Mediterranean, in the early fifth century CE, and about

the same time the Goths sacked the city of Rome, Emperor Hono-rius (395–423) told the citizens of the province of Britannia that they were on their own. He had his own problems in Italy to deal with—no more troops would be coming to their aid. The Roman Britons nonetheless seem to have muddled through, sometimes in-dependently, sometimes working out agreements with other newly arrived communities from the continent. It was an island forged by immigration, collaboration, and war and that continued into the post-Roman world. But as power devolved to the local level, the is-land seemed to splinter. Kings arose. Kingdoms fell. Wars raged.

This is, in part, the world represented in the famous Old English poem *Beowulf*. Although the only version of the text comes from an early eleventh-century manuscript, its subject is of times past, a mo-ment of movement throughout Scandinavia and across the North Sea that locates its center far from the Mediterranean. The story con-forms to our stereotypical expectations of the medieval world writ large. There are kings and warriors, monsters, danger, and daring ex-ploits. But like the rest of the Bright Ages, it also confounds those expectations. The poem seems to want to talk only about men—their triumphs and follies—but the anonymous poet is clear that women are the skeleton giving this society its shape.

After Beowulf defeats Grendel, the current Danish queen, Wealh-theow, approaches Beowulf the man. She praises him, thanks him for his victory, brings him rich treasures from her and her husband, but there's an odd note in her speech; she consistently mentions her sons. She worries about Beowulf's intentions, that his fame and glory will supplant her family's. Her speech is a shot across his bow, a warning to be grateful and go home—to be the children's guardian but noth-ing more—a warning that everyone in the hall understands, the poet makes clear.

That very night Grendel's mother appears, "grief-racked and

ravenous, desperate for revenge." She tears apart the Danes once
more and leaves, taking her son's arm, a trophy taken by Beowulf in
his fight and then mounted in the Danes' hall, with her. When Be-
owulf chases her back to her home, he finds Grendel's body laid out
in the lair by a mother in mourning. But she will have no satisfaction
in this life. When she's defeated, she finally reunites with her son.
And this is a thread, a spine within the story, the power and power-
lessness of women like Wealhtheow and Grendel's mother, who all
share the same world.

Even in the other, more formal and ecclesiastical sources from
the eighth century mentioned above, we pull back just a bit and see
how these stories of men doing heroic deeds—fighting monsters in
a swamp with swords or Psalms, for example—continually reveal the
agency and authority of women. The triumphal carvings of the Ruth-
well Cross are divided between holy men and holy women who move
sacred history forward. Repton, the house at which Guthlac became
a monk, was a double monastery of men and women, one founded
with close ties to the Mercian royal family and led by an abbess. In-
deed, Guthlac maintained a close connection to the abbesses of Rep-
ton, writing to Abbess Ecgburh (daughter of King Aelfwald of East
Anglia, to whom Guthlac's *Life* was dedicated) just before his death
to request she send a lead coffin and burial shroud. The funeral itself
was then performed by Guthlac's sister Pega. Guthlac learned to be a
monk because he was trained by a woman and ensured his legacy by
entrusting it to his spiritual superiors, two women. The "Dark Ages"
imagines a world of violent men and subservient women, a world that
conforms to stereotypes; the Bright Ages, attentive to the sources
themselves and not our own preconceptions, finds something much
more nuanced.

So then what would the story of early medieval Britain—of the
early Middle Ages generally—be if it were told by pulling back these

layers? The heroic narrative of this chapter that began with Gregory the Great sending missionaries off to the far north, with Guthlac braving the fens, with Beowulf conquering monsters, would be quite different. We must dissolve this nostalgia into air and see a more human, more diverse world beneath it.

We might tell the story of early queens in the southeast of Britain. Rather than ascribing the reconversion of Britain to Christianity to Roman bishops and local kings, we should pay more attention to Queen Bertha (d. ca. 606), the Christian daughter of a Merovingian Frankish king, who married the polytheistic King Aethelbert of Kent (589–616) on the condition she could keep her religion and bring her confessor-bishop with her across the Channel. It was she who paved the way for Gregory's missionaries from Rome to arrive in 596–597 and likely pushed Aethelbert to convert and allow further proselytization. Bertha's son King Eadbald (616–640) was still a polytheist when he succeeded his father, though, and it took another marriage to another Frank—Queen Emma (d. 642)—to bring himself and the kingdom fully, and finally, to Christianity.

We might also tell a different story of the Synod of Whitby in 664. This famous event, in which the king of Northumbria observed a debate over whether to follow Rome or the traditional Irish practice when it came to the date of Easter, was argued among men. The king judged, the abbot of the monastery of Ripon argued against the bishop of Northumbria, and other very important men consulted and conspired. But the event itself was held at the monastery of Whitby, under the care and gaze of Abbess Hilda (d. 680). Converted to Christianity in 627 after her father married into the family of the same King Eadbald of Kent, she lived a primarily political life until her thirties. She then had to flee the north when her father fell in battle, but soon found refuge with her stepmother's family. She returned north only later, when she was appointed abbess in Hartlepool before

helping found Whitby as a double monastery for monks and nuns in 657. Although she was on the losing side of the Easter debate, she remained so powerful and important that the Northumbrian king who ruled against her position at the synod was still buried in her monastery, and she seems to have been instrumental in getting her debate opponent, St. Wilfrid of York, removed from his bishopric shortly before her death in 680.

Not only do we find a more complicated situation when it comes to gender and power, we also find connections that stretch across continents. By the end of the eighth century, King Offa of Mercia (757–796) ordered a gold coin minted. In the middle, his artisans slapped the Latin words "Offa the king" (*Offa rex*). Around the edge of the same coin, though, we find a jumbled Arabic that seems to reflect the *shahada*, the basic profession of Islamic belief. This coin, perhaps despite our assumptions, doesn't say anything about Offa's religious commitments (the Arabic, for example, is upside down). Rather, they were clearly working from a model—specifically a gold dinar minted around 773–774 by the first Abbasid caliph al-Mansur (754–775). But the coin's itinerary reveals even more about early medieval connections across vast regions and among diverse peoples. It was discovered in modernity in Rome, perhaps part of a tribute sent to the bishop of Rome, and so we can trace the ideas—and perhaps the gold itself, shining brightly in the light as it passed from hand to hand—from Baghdad to Britain to Rome.

Goods were not the only things to leave the island. Just as people and ideas from across the medieval world made their way to Britain, Britain reciprocated. Not long after Hadrian's death, the monks of Wearmouth-Jarrow produced a lavishly illustrated Bible so massive that it had to be carried by cart. Perhaps like Offa's dinar, the manuscript, known as the Codex Amiatinus, was intended for the bishop of Rome. Britain began to send missionaries back across the channel.

Both men and women traveled to the continent, missionizing to poly-theistic groups such as the Frisians. Another traveler, a monk named Alcuin, made his way to Rome on behalf of the king of Northumbria. But he never returned to the north, instead installing himself at the court of a foreign king named Charlemagne and leading his palace school. Even in early medieval Britain, a space often characterized as the most remote, the "darkest" of the "dark ages," they felt themselves a part of a much wider world.

IF WE RETURN, HERE AT THE end of the chapter, to that multicolored cross in a field in far Northumbria sometime in the early part of the eighth century, we look upon it differently now. It's not as isolated as we might have earlier thought. To the east, a massive Bible is being finished to be sent to Rome, and missionaries are crossing the channel now in reverse, to bring Christianity to a different "periphery" on the continent. But in that field, we now stand alongside a population that was perhaps Christian and non-Christian, flexible in their use of lan-guage and in what identities they might claim, varied in terms of their status in life—but including people bound to labor for the king or even the local monastery, because we can't look away from the long history of slavery. And of course there were the nuns and monks, per-haps mostly from the surrounding community but maybe some from much farther afield, perhaps from as far as Hadrian of Canterbury's home across the seas.

Medieval art hasn't always lived in a museum. Monuments and other objects lived in the world, with people. They were, in the words of the art historian Herbert Kessler, meant to be "felt, kissed, eaten, and smelled." So, first, the crowd looks upon a monument that towers above them, reading upward a heroic story of salvation. The story begins with a flight to safety, then a conquest of the beasts of the world, and concludes with a revelation of God's will. But we look

behind that, and on the other side we see the women who underpin that story, beginning with the Virgin Mary and the Annunciation, Jesus's relationship with Mary Magdalene. A metaphor, if ever there was one, for the Bright Ages. Some step forward and touch the donkey, kiss the Virgin, as the earthen smell of the stone enters their nostrils.

Here, in the early eighth century, in the north of Europe, at the far edges of a northern kingdom, the sun broke over this field and upon this cross. The vine-scrolling on two sides was perhaps covered not just in paint but moss. The stone was taken from nature, reshaped, and now slowly given back. The carved birds offered perches to real ones. Perhaps the cross itself now seemed to sing.

The assembled crowd consumed a monument that told them a particular story. The story had been told on the island for centuries, but here with Latin verses and runic poetry, a conglomeration of artistic styles that evoked the complexity of its world, that story was reframed to its particular context. Here, this monument told them that they were part of a larger world still, one that had perhaps never ended but rather had managed to adapt and innovate and continue to welcome people to their shores. This monument told the assembled crowd about a Jewish refugee from the eastern Mediterranean who once crossed into Africa, but who had now come to this island where He sat comfortably, nestled into the natural landscape, among them, with them, part of them.

A TOWERING
IVORY TUSK

In summer 802, a strange—but not unexpected—visitor arrived at Aachen, home of Emperor Charlemagne (768–814). That Charlemagne would receive a visitor wasn't the odd thing; he had been crowned emperor in Rome two years earlier and so held power over peoples stretching across all of Europe, from beyond the Pyrenees in the south to Denmark in the north, and from the shores of the Atlantic in the west to the banks of the Danube River in the east. But this particular visitor had come a rather long way.

He began his journey (most likely) somewhere beyond the Sahara, perhaps starting in Cameroon or Congo, ventured northeast to Baghdad, then across nearly the whole of North Africa before embarking for Europe from somewhere in Tunisia, perhaps even from the ancient port of Carthage, a city that once led his ancestors into war. After arriving in the southern part of the Italian peninsula, the visitor made his way north, through the Alps, finally to what is now western Germany and Charlemagne's palace at Aachen. Charlemagne had sent for him about four years previously, and Caliph Harun al-Rashid had assented shortly after that. But this visitor, named

Abul-Abass, was slow and tricky for his chaperones to manage. After all, the visitor Charlemagne had sent for likely weighed more than three tons and was a glorious African elephant.

We know very little about what became of Abul-Abass once he arrived in Germany. He seems to disappear from the sources almost immediately, only resurfacing in a record for 810 when it was noted that he died suddenly and was mourned by the Franks as they prepared for a military campaign into modern Denmark. We can only wonder what the journey itself was like, what an elephant would have made of northern Europe, what hardships and abuse he experienced, and also what his handlers must have endured to goad him across more than three thousand miles from Congo to modern Germany. What we do know is what it meant for this to happen specifically under Charlemagne and Harun al-Rashid, what it meant for an elephant to move those thousands of miles at that time and between those places, and what it meant for visitors to Charlemagne's court to be confronted by the glinting ivory whiteness of an elephant's tusk. As the elephant thundered and his tusk came into sight, it reminded all its viewers of the east and, from the Franks' perspective, of a connection between equals—between a Christian "Roman" emperor and an Islamic "Persian" caliph.

Charlemagne's dynasty (the "Carolingians") came to power in 750, after Charlemagne's father, Pepin the Short (750–768), seized power from the Merovingians, a dynasty that had ruled the Franks for nearly three hundred years. The *Royal Frankish Annals* (RFA), a year-by-year account of events written by someone close to Charlemagne's court, said that Pepin sent a delegation to the bishop of Rome to ask a (loaded) question: who should rule a kingdom, those who held the title by birth or those who wielded "actual power"? Pope Zacharias (741–752) astutely read the room and answered that, of course, it should be the latter and that Pepin should become king.

The delegation returned happily to Francia and, according to the *RFA*, Pepin was "peacefully" elected king and the former king Childeric sent to a monastery to live out his life in contemplation. But then the source falls suddenly silent.

The *RFA* is not a work that we today might immediately recognize as "history." The manuscripts are often a more-or-less bullet-pointed list of events marked off by the year. Some entries are longer and some are shorter but the point is their completeness, the author of this genre (the "annal") showing that the years moved successively and that some were marked by momentous events worth recording. Here, this annal of the Carolingians details every year in succession between 741 and 829, beginning with the death of Charlemagne's grandfather and ending with Charlemagne's son (Louis the Pious, 814–840) holding court at the city of Worms, appointing Count Bernard of Septimania as his chamberlain, spending the fall hunting, and wintering back at the palace at Aachen.

Well, actually, that's not entirely accurate. The *RFA* omits two years—751 and 752, the ones immediately after Pepin's ascent to power. Then it suddenly resumes (as if nothing happened) in 753. The omission of those two years is both obvious and cleverly hidden in plain sight, a moment that alerts us to something important about the transition of power, reminds us that this was a coup d'état, and almost certainly a violent one at that. What we see in the *RFA* is a perfect encapsulation of the path the Franks took to dominate Europe, to force themselves onto the world stage as one of its major players.

The Franks were prolific record-makers, often focused particularly on their own recent history. But all history writing is subjective (not the same, of course, as "false") and, particularly in the Middle Ages, was deployed to convey what the author thought was a deeper truth. The original version of the *RFA* is a catalog of triumphs, a litany of successes that reveals the "truth" that the Carolingians deserved to

rule. Let's here pay close attention to what happens just before and after the lacuna. In 749, the Franks sent emissaries to the pope and got his support. In 750, Pepin the usurper was "elected king" and the current king sent to a monastery. Then, in 753, King Pepin attacks and defeats the Saxons on his northeast border, hears that his rebellious brother has died, and pledges military support for the papacy against the Lombards.

The entry in the annal solves the problems of the transition. Pepin is now, according to the text, the unquestioned king, with the previous king out of the picture and even Pepin's rebellious brother dead. The new king defends the Franks' borders against the Saxons. The new king upholds the Church by protecting the papacy. Although quid pro quos can end the reigns of some rulers, this one worked out well for Pepin and his successors. Coming out of a messy (but narratively hidden) civil war, the Franks wagged the dog's tail, turning outward to fight against an external, non-Christian enemy (the Saxons) at the same time they were forging a special relationship with the institutional Church. The Franks certainly didn't invent the idea of writing the history they wanted, nor of marrying religion and violence, but they did use both to great effect.

Pushing outward from the Frankish heartland around the modern Low Countries, they fought constant wars, including those against the polytheistic Saxons to the northeast, the Christian Bretons to the west, the Christian Aquitanians, Christian Gascons, and Islamic Ummayyads to the southwest, and the polytheistic Pannonian Avars to the southeast. The Franks of the late eighth century also fought the Christian Lombards and Byzantines to the south, two groups that had been menacing the prerogatives of the papacy and so were, in part, the reason the popes were eager to help Pepin's dynasty to power.

This constant warfare required campaigning every spring and

summer, which wasn't just about fighting, but was also a political strategy. An early medieval king could remain a king only because his aristocracy allowed it. After all, Pepin himself had been a high aristocrat when he seized power. Every successive Frankish ruler remembered this and indeed endured at least one serious rebellion from the aristocracy. Threats, both potential and real, were everywhere. What kept the nobility in line (the Frankish kings hoped) was plunder—lands and honors given out as spoils after the Franks won a victory. When the Avars were finally conquered in 796, for example, the *RFA* reported that plunder was sent to Charlemagne, who in turn sent "a large part of [the treasure] to Rome. The rest he distributed among his magnates, ecclesiastic as well as lay."

This is a particularly revealing anecdote in a number of ways. It directly states that the Frankish king shared his spoils with both those who fought for him (lay magnates) as well as those who prayed for him (ecclesiastical). This was important because the logic here was circular. The Franks conquered other peoples, which meant (to them) that God was on their side, and because God was on their side, they could conquer other peoples. To do so, Charlemagne and the Franks needed both soldiers to fight and churchmen to pray. Religion and violence were two sides of the same coin here. Indeed, it seemed to work for them. Charlemagne's power, after all, extended across Europe to an extent unlike anything seen since the height of Rome. They won victory after victory.

If we look back a bit further in the *RFA*, we see that this war against the Avars, for example, began in 791 "because of the excessive and intolerable outrage committed by the Avars against the holy church and the Christian people." The *RFA* credits victory in that case to "Christ [who] guided His people and led both [Frankish] armies without harm into the Avar strongholds." In other words, this campaign was waged against the Avars not simply because they were

threatening Frankish political power (even if they were doing so in Bavaria), but because they were a threat to Christians as a whole. In addition, the annal recounts that the Franks won their campaign because God protected "His people." Charlemagne rewarded all his magnates, churchmen and lay, because both were under his care as king—a fact, the *RFA* asserted here, that even God Himself recognized.

Charlemagne and the Franks didn't invent the idea of Christian rulership. As we've seen in earlier chapters, the position of a ruler within the hierarchy of Christianity was relatively ill-defined, which meant both that kings had to find ways to grow their authority rather than having it handed to them, and that there also were relatively few limits on what authority kings might claim. Christians moved rather rapidly from an outsider community in the Roman world to one that found itself at the highest levels of power during the fourth century. We might be tempted to look at the Byzantines, for instance, and see emperors ruling unquestioned, but from the time of Constantine, Roman emperors had battled with bishops of different stripes, including patriarchs of Constantinople and bishops of Rome, to clarify who was "really" in charge. Charlemagne and the Franks claimed Constantine's mantle for themselves, asserting the ruler's position atop the hierarchy of the church (again, a term to be understood here as a community of all followers).

This wasn't, it must be emphasized, a cynical move—this wasn't about "manipulating" real Christianity. Christianity in the early Middle Ages was an idea in development, adapting constantly to continuously different historical contexts and geographic idiosyncrasies. There is every indication that Charlemagne took his charge as a religious leader seriously, and that he was deeply concerned about the spiritual as well as the material well-being of his followers. For

example, he championed monastic reform throughout his reign, freeing monks from interference from local bishops and other secular nobles, and making the monasteries subject only to the Frankish king. Why? Certainly, the king got something practical from the relationship, namely agents of royal power in far-flung locations across the continent. But more important, he also got prayer. Charlemagne was creating a reciprocal relationship between the monks and the kingdom as a whole, via the avatar of the king. Monks used their special relationship with God to pray for the safety and prosperity of the king and all the Franks, thereby combating the devil, who worked in the world to sow discord and confusion. These monasteries, "islands of sacrality," acted as bastions of the resplendent heavenly Jerusalem here on earth.

And Charlemagne not only cared for his monks; he cared for his bishops, even the bishop of Rome. The papacy in the eighth and ninth centuries was not the institution it would become toward the end of the medieval period. As we saw with Gregory the Great, the bishops of Rome were political as well as religious leaders of a city, but ones with pretensions that extended across Europe and the Mediterranean. But those pretensions were sometimes simply no more than that. After Gregory's death, the bishops of Rome turned more directly to face Constantinople, while always conscious of the Lombards to the north. But a break came in the early eighth century, at the same time that the Byzantines embraced iconoclasm, moving away from the use of images in Christian religious practice. Western Christians roundly condemned the practice, which led both Romes to pull away from each other. The Lombards, sensing a power vacuum, stepped in and seized Roman land in central Italy. The popes needed new allies and so looked to the Franks. Pepin had, after all, come to power by making a specific quid pro quo agreement with the

papacy; the papacy would provide legitimacy to his new dynasty and the Franks would push back against the Lombards and Byzantines who threatened the bishop's power in central Italy.

And that worked for both parties. In the early 770s, Charlemagne invaded Italy at the behest of the pope and conquered Pavia, deposing the Lombard king and taking for himself the title "king of the Franks and Lombards." During that campaign, Charlemagne visited Rome himself and was welcomed with a procession as a liberator. But a sterner test awaited. In 799, Pope Leo III (795–816) was attacked by his fellow Romans and imprisoned. He escaped and made his way north to Paderborn, seeking help from Charlemagne.

Charlemagne immediately sent an army to Rome to reinstall Leo, then followed it across the Alps the next year. The pope was exonerated of the charges against him and the perpetrators of the attack were found, tried, and exiled. But while wintering in Rome, before Charlemagne returned north to Aachen, two important things happened. First, late in 800 Charlemagne received a diplomatic mission sent west by the patriarch of Jerusalem, bearing gifts including (according to the *RFA*) "mementos of the Lord's Sepulcher and Calvary, as well to the city and mountain [which is unspecified] along with a relic of the true cross." Then, shortly afterward, amid the flickering candlelight of a mass held on Christmas Day 800, Pope Leo III crowned Charlemagne "emperor" and the assembled crowd immediately hailed him as such.

We have to read these two events in tandem. First, the geography is important. Rome and Jerusalem were two locations critically tied to the history of Christianity—Jerusalem, of course, as the city of Jesus, and Rome as the city of St. Peter and the foundation of the *ecclesia* in the succeeding centuries. The gifts from the bishop of Jerusalem symbolically granted Charlemagne power over the locations of Jesus's death and resurrection, as well as to the gates of the city,

all accompanied by a relic of the Cross itself. The patriarch quite directly—if symbolically because Charlemagne was nowhere near Jerusalem—handed him control of the famous city. Essentially, the pope did the same via the coronation. With the Byzantines estranged, the patriarch and the pope looked to the great orthodox ruler, a new Roman emperor, for support.

After having demonstrated his concern for the good of the people of Rome, Charlemagne was made emperor by the pope and people of the city. This is not, it should be noted, the beginning of the "Holy Roman Empire." That came much later, in the late twelfth century. Instead, Charlemagne's coronation integrated him with the succession of Roman emperors that led back through Justinian and Theodosius, to Constantine, and even to the first emperor, Augustus himself. But because the acclamation and coronation happened with a bishop, and linked to both Rome and Jerusalem, the event was tying Charlemagne to an even older lineage—not only a coronation of a secular ruler, but also the anointing of a holy king such as David and Solomon, the biblical kings of Israel.

This synthetic rulership—Roman, Christian, Israelite—isn't a case of historians trying to read too much into opaque sources; the medieval Franks weren't subtle. A 789 law code has Charlemagne calling himself a new Josiah, the king of Judah who had purified the chosen people of their pagan practices. Saint-Germigny-des-Prés, a Frankish church just southeast of the city of Orléans, had an early ninth-century mosaic above the altar, with two angels watching over the Ark of the Covenant. This image allowed this ninth-century Frankish church to stand as a representation—a re-creation—of the Temple in Jerusalem. But it also reminded its audience that the ark, carried by the Israelites into battle in the Christian Old Testament, a symbol of God's protection, now protected His new chosen people in Francia.

In this sense, Charlemagne's elevation to Roman imperial status wasn't considered by contemporaries to be a "new" thing. It was the continuation of an older thing, one tied to how the Franks thought of themselves, with their ruler as an avatar of the collective. They were successors to the Israelites, inheritors of the Romans. Once again, even as late as 800, they were still justifying their coup and working with a matrix of religion, culture, and politics to do so.

Perhaps there's no better illustration of this interpenetrating ideology than the palace chapel at Aachen, right at the heart of Charlemagne's empire. Begun in the 790s but completed and dedicated in 805, this octagonal building, awash in (now lost) mosaics and marble veneers, and covered by a dome, at first approximates San Vitale in Ravenna, the very site where Justinian and Theodora look down on the worshippers from their radiant mosaics. The shape of the palace chapel, then, links to Justinian and so represents Roman imperial power. Indeed, to ninth-century Franks, San Vitale was remembered as an ancient building in the Roman style, ideologically connecting the Franks back to centuries of Roman imperial glory.

But then the architects in Aachen added something else. The circumference of the interior octagon measures 144 Carolingian feet, the same length as the walls of the Heavenly Jerusalem described in Revelation 21. For the iconographically sophisticated consumers of symbols in the early Middle Ages, the Heavenly Jerusalem was an image of the terrestrial Jerusalem. In other words, an invocation of the Heavenly Jerusalem would conjure not only the book of Revelation but the city in Roman Palestine, rebuilt by Constantine, evocative of the Temple that once witnessed the reigns of David and Solomon.

It meant something and everything. It was Rome and Jerusalem, just like at the moment of Charlemagne's imperial coronation. It was emperors and kings, evoking Justinian, Constantine, and Solomon. It was heaven and earth, a meeting point as described in the Christian

Bible. It was a parish chapel, not just a private enclave—thus projecting power outward toward the many publics who would walk through its halls. And the Franks and their king sat at the nexus of it all. The glittering multicolored marbled interior in Aachen, the way candlelight would have reflected off the golden mosaics, the warm glow Charlemagne himself must have seen and felt as he entered his chapel to pray; all of this called to mind past, present, and future. The Franks were saying in text and in stone that the Israelites had once held God's favor in the terrestrial Jerusalem, but that favor passed to Rome, then to Aachen and the Franks, who would carry it to the very End.

And into this world came an elephant.

Charlemagne had sent for the great beast before he became emperor, but certainly after he started thinking about claiming the imperial title and well after the palace complex at Aachen had begun construction. Abul-Abass thus arrived into a world that the Franks had fully formed. One author wrote in the 820s, looking back, that "everyone in the kingdom of the Franks saw an elephant during the reign of the emperor Charles." And what they saw was not simply an elephant, it was a host of ideological associations. They saw a ruler who tamed a great beast, a ruler who stood as a new biblical David, a new Emperor Constantine. They saw the Islamic Abbasids, based in their new golden city of Baghdad, the preeminent power in the East, sending gifts in recognition of the Franks' power, considering them as (at least) equals. It was not just King Offa of Mercia who knew that to project power, one needed to appropriate the symbols of the caliph. The mammoth animal, the whiteness of its tusks as it towered over everything around, was a living, breathing representation of the Frankish sense of self. As its trumpet bellowed into the octagonal dome of the resplendent chapel, God did seem to favor his new chosen people.

BUT GOD'S FAVOR IS ALWAYS CONTINGENT.

Charlemagne's only surviving son, Louis the Pious, succeeded to the throne on Charles's death in 814. But losses began to mount and the ruler, again serving as an avatar for the Franks' relationship to God, was blamed. Louis was deposed briefly in both 830 and 833, both times by his sons. So it's perhaps little surprise that when Louis died in 840, civil war broke out. The eldest, Lothar I (840–855), claimed the imperial title and wanted to keep the empire together. His brothers, Charles the Bald (840–877) and Louis the German (840–876), wanted their own independent kingdoms.

This finally erupted into violence in 841 at Fontenoy, a village just southwest of Auxerre in modern France. The leaders sent emissaries back and forth, trying to avoid conflict, but battle broke out at dawn on June 25. As we've seen throughout this chapter, the Franks were no strangers to violence, even as Christians killing other Christians. This was, however, more than that. This time, Franks fought against Franks. This time, the leaders of the opposing armies were all grandsons of Charlemagne. This time, the armies were literally composed of brothers.

One of the participants, a partisan of the eldest brother, Lothar, wrote a poem about the battle just afterward. "The common people call the place . . . Fontenoy, / Where the massacre and bloody downfall of the Franks [took place]: / The fields recoil, the woods recoil, the swamp recoils." We note that the very earth reacts to the slaughter, that he hopes the battle fades from human memory. Then, at the end, Angelbert takes on a prophet's voice, using verses from Jeremiah to lament what he had seen—positioning the battle within sacred time, another instance of the chosen people's sins in the eyes of God. This was unlike earlier victories by the Franks, where good and bad were certain. This civil war within the new chosen people was more

unclear. The fate of the fallen's souls were in doubt. All that remains, Angelbert concludes, is for everyone to pray.

After Fontenoy, Charlemagne's empire remained divided. Lothar I was emperor and controlled a swath of territory stretching north–south across the continent, from southern Denmark to central Italy. Louis the German controlled the eastern portion, while Charles the Bald took the western. The brothers continued to struggle against one another until 855, when Lothar died and Charles and Louis carved up their brother's land between them.

The sources we have from this period of civil war strike a very different tone from the ones of just a generation before. Hope for the future was now all but gone. Sometime between 841 and 843, a noblewoman named Dhuoda wrote a *Handbook* for her son William, who was at Charles the Bald's court. If we remember, the *RFA* ended in the year 829, with a note that Louis the Pious had appointed a new chamberlain named Bernard of Septimania. Bernard sat out the Battle of Fontenoy but, after the result, sent his son William (as hostage) to Charles the Bald as a sign of Bernard's support.

Dhuoda's book is one that looks both forward and back. It's a deeply learned treatise, a guide about how to survive and thrive at court, about the nature of power, about the Franks as a people and their relationship to God, and about how brightly her love burns for her son. More specifically, Dhuoda offers moral and political instruction for the various scenarios William might encounter at court. She wants to ensure that her son act properly before their king but also before God—the former in some way an extension/agent of the latter.

But that exhortation is as much lament as advice. Dhuoda makes it abundantly clear that, even on the borders of the empire in what is now far southwestern France, she understands the disorder of the

times, the politics that have taken her family from her. Indeed, as the work progresses, as it nears its end, Dhuoda despairs for her health and seems to acknowledge that she'll never see William again. Gone are the practical pieces of advice about life at court, about navigating the complicated machinations of the nobility. She seems to have lost hope, ending her book with "Farewell, noble boy, and always be strong in Christ . . . [T]he handbook for William ends here in the word of the gospel: It is consummated [John 19:30]." Dhuoda ends with Jesus's dying words in the Gospel of John, words He utters after having looked with love upon his mother and another disciple. It is a fitting conclusion in some ways—Jesus looking at the very end upon those who loved Him most in this world, Dhuoda calling that image to mind as she ends her own labors.

Echoing Dhuoda's lament, and writing in the early 840s at the same time as Dhuoda, Nithard (himself a descendant of Charlemagne) looked back sadly upon what the Franks had lost. He wrote, "in the times of Charles the Great of good memory . . . peace and concord ruled everywhere because our people were treading . . . the way of the common welfare, and thus the way of God." Now, however, in Nithard's own time there is violence and deceit, selfishness and plunder. The Carolingians had, via a coup d'état, forged a dynasty that elided religion and politics as self-reinforcing ideas behind their victory. But now that alliance had eaten itself. The earth itself had turned upon the Franks. The very last words of Nithard's chronicle relate an eclipse and a massive spring snowstorm: "I mention this because rapine and wrongs of every sort were rampant on all sides, and now the unseasonable weather killed the last hope of any good to come."

Dhuoda finished writing in 843, perhaps dying shortly afterward. Her husband, Bernard, was executed for treason by Charles the Bald in 844. Her son William was similarly captured and killed in 850,

perhaps (according to at least one historian) carrying a copy of Dhuo-
da's book on him at the time, for trying to avenge his father against
King Charles. Nithard's lament about disorder and civil war played
out with tombstones. Nithard, too, died around 845 of violence. But
this was a violence unforeseen, an invasion by a new threat from the
north. In a pattern we've seen again and again, taking advantage of
internal disorder, a group of raiders swept in to add to the "rapine and
wrongs of every sort." These Northmen swept in, burning monaster-
ies and pillaging the countryside. The Age of the Carolingians was
coming to an end; the Age of the Vikings had begun.

A SHIP AFLAME
ON THE VOLGA

It's 793 in Northumbria, and raiders from even farther north are about to sack and plunder the burial site of St. Cuthbert, one of the most important sites in early medieval Christendom. A monastic chronicler mourns the "rapine and slaughter" of the attack, writing of dragons, of ill wind and famine that accompanied the invaders.

It's 921 along the Volga River and an Islamic jurist perhaps originally from Arabia marvels at the physical prowess of the Rusiya, a group of northern merchants and warriors. He recoils at their filthiness, though, and dispassionately records the ritual rape and human sacrifice of an enslaved girl as the Rus mourn their fallen leader, a ritual that ends with the leader's body and those he'd held enslaved burning along with one of their longships.

It's 986 in the city of Kiev and Prince Vladimir of the Rus receives missionaries from Muslim Bulgars, Jewish Khazars, and Christian Germans, but it's the Romans of Constantinople that convert him in the end. He and his people are baptized, binding his hybrid Scandinavian-Slavic kingdom to the New Rome.

It's 1010 near the Gulf of St. Lawrence and the indigenous people

of North America seek to trade for weapons with the Greenlanders who have set up camp. They have to settle for cow's milk, still a treat for the residents of a continent with no domesticated dairy animals. But later fighting breaks out and the interlopers flee—all except a woman named Freydis, who frightens off her attackers by baring one breast and slapping a sword against it.

It's 1038 in Sicily and an exiled prince from Norway named Harald Hardarada fights in a Byzantine army alongside Norman allies against the Muslim rulers of the island. Later, he returns to Constantinople, kidnaps a Roman princess, flees to Kiev, fights for control of Norway, and dies trying to conquer England, traversing thousands of miles in his fifty-one years.

VIKINGS SEEM TO HAVE DONE EVERYTHING, been everywhere. They rampaged through the remnants of Carolingian northern Europe, raided into the Mediterranean, fought in (and against) Byzantine armies, and traded with Native Americans and Caliphs. They loom large in the modern imagination, the subject of popular television shows and video games, caricatured by far-right groups for their violence and supposed misogyny. But the Bright Ages are more complicated than that, and the Vikings are no exception.

To look upon the scope of the world occupied by those that we often call "Vikings" requires both narrowing and stretching our gaze. The term "Viking" itself is a limiting one, something akin to "pirate," and so not applicable to all groups at all times in its historical context. Like "Byzantine" and other terms that have traveled far outside their original context over the centuries, we'll use it for simplicity's sake. But when we talk about what's often known as the "Viking Age," we absolutely must expand our field of vision, for this is a time and set of activities that move all the way across continental Europe, the Mediterranean, Asia, the islands of the North Atlantic, and even North

America. Few peoples traveled so far, so quickly, and with such last-ing consequence, positive and negative, for those they encountered. The texts recording these encounters are written in Greek, Latin, English, Arabic, Slavonic, and Icelandic, among others. For several centuries, they engaged the British, Franks, Slavs, Rus, Byzantines, North Africans, Arabs, and even the First Nations of North Amer-ica. They traded and fought against and alongside believers in all the Abrahamic monotheisms, as well as adherents of countless other re-ligious traditions, and those stories have stuck with us for more than a thousand years. But as even these vignettes show, while the Vikings were capable of extraordinarily terrible violence, they also partici-pated in transregional trading networks, colonized land they thought uninhabited (and both traded and fought with Inuit and other First Nations when they discovered they were mistaken), and built new kingdoms and other states that quickly moved into formal diplo-matic relationships with their neighbors.

Indeed, within a few centuries the northerners had mostly con-verted to Christianity and become just another set of powers and peoples in the hyperconnected medieval world. The "Northmen" became Normans. Meanwhile, greater Scandinavia became a site of cultural, artistic, political, and economic innovation as these peoples altered but preserved their linguistic and cultural traditions even after they converted to Christianity. Icelanders loved democracy and lit-erature, even as they told stories of (and participated in) brutal blood feuds and murder. The Danes constructed an empire—a small one, but clearly an empire in the way it stretched across kingdoms and peoples—in the North Sea. Viking craftspeople built the best ships in the medieval world, at once oceanworthy yet capable of sailing inland on rivers. Their society featured significant gender parity, at least in key parts of society. Their cities were vibrant hubs of mercan-tile exchange. Their men were extremely snazzy dressers. And as we

see with Harald Hardarada's personal itinerary, a single Viking could be a vector of connectivity and exchange, even as he also chased and sparked violent conflict everywhere he went. When the Vikings found wealth and weak political structure, they raided. When the Vikings found transregional trade routes, they traded. When they found strong leaders seeking soldiers, they served. And when they found empty land, they farmed.

The story of medieval Scandinavia, its peoples, its incursions, then inclusions in the broader medieval systems, requires a kind of dual vision, looking first at the arrival of Vikings on the various frontiers of medieval societies and the ways they permeate and reshape those frontiers. Then, we need to look inside Scandinavia, marking transformations as a result of their expansion and examining the new syncretic cultures that emerge.

LET'S GO BACK IN TIME TO the island of Lindisfarne just off the coast of Northumbria in Britain, a sacred site for resident Christians and one that the Vikings raided, looking for plunder, in 793. Their arrival in Britain and the sack of Lindisfarne is recorded in, among other places, a collection of annals written in Old English. Not unlike the *Royal Frankish Annals* that chronicled the Carolingians, the so-called *Anglo-Saxon Chronicle* that was produced in the British Isles also provided a year-by-year record of events, a common way for institutions such as monasteries to keep track of basic economic, meteorological, clerical, and political details. These types of texts are often quite boring, listing deaths, titles (who got made an abbot or bishop, who inherited a crown), and comings and goings of notable people. Sometimes, though, as in 793, things get exciting—or, perhaps better, horrifying. According to the unknown author of that year's record, "dreadful fore-warnings [came] over the land of the Northumbrians, terrifying the people most woefully: these were immense sheets of light rushing

through the air, and whirlwinds, and fiery dragons flying across the firmament." Famine followed the dragons. Not long after, "heathen men made lamentable havoc in the church of God in Holy-island," killing as they went.

Yet the next forty years or so do not mark drastic change in the annals. Bishops take office. Kings battle other kings. Local prelates hold synods. The arrival of these "heathens" was an eruption, but one that passed—at least until 832, when "heathen men overran the Isle of Shepey" in the southeast, and then in 851, when "The heathens now for the first time remained over winter in the Isle of Thanet," no longer returning to Scandinavia when the raiding season ended. Read carefully then, the text reveals the new reality that the arrival of the Vikings was a regular occurrence. By 865, the Vikings arrived not as raiders, but an army, and were there to stay, as the author wrote that they "fixed their winter-quarters in East Anglia, where they were soon housed; and the inhabitants made peace with them."

For a long time, historians—particularly modern English ones—retold this story as one of invasion, of the Great Heathen Army overrunning good English kings. But more recently there's been a reevaluation, as there are other ways to read this text and other sources—including artifacts—that can help us. Yes, the kings of early Britain fought Vikings and generally, if not always, lost. The British, however, found they could often buy peace with horses or other forms of plunder and coin, encouraging the Vikings to move on. But then the Northmen began to settle, groups of them dominating most of the island except for the Kingdom of Wessex. Its king, Alfred the Great (871–899), defeated the raiders (mostly from what's now Denmark), preserving his independence, but was also forced to sign a treaty acknowledging the new reality of Danish rule over most of the eastern part of England. On the other hand, the Danish raiders agreed to convert to Christianity as part of the deal. Thereafter in

Britain, political powers would rise and fall but the Vikings never left. Vernacular Old English adopted Scandinavian words, power structures shifted to incorporate Danish overlords, and the Vikings converted to Christianity.

Danes in Britain began to convert to Christianity in the late ninth and early tenth centuries, but, as we've seen before, real movement happens when rulers convert and bring their subjects with them. King Harald Bluetooth of Denmark (958–986), also later king of Norway (970–986), was converted by missionaries from farther south not long after he took the throne. To commemorate his and his people's embrace of Christianity, he ordered the erection of a painted Runic stone, depicting Christ and touting Harald's achievements as the unifier of a new Christian kingdom. Today the stone is weathered and gray, but for the Danes of his own time it had a vivid brightness of color. Much like the Ruthwell Cross, the Jelling Stones combined what we might call "pagan" and "Christian" imagery—a clearly recognizable Jesus on the cross embraced by vine-scrolling and animals in a Nordic style. The permeability of religions, cultures, and geographies, demonstrated with such grace in paint and stonework here, was institutionalized soon after. Harald's son and successor, Sweyn Forkbeard, became king (albeit briefly) of Denmark, Norway, and England in 1013.

But there are many other stories of conversion to tell. In 1000, the Althing, the Icelandic democratic body, voted to Christianize the island, perhaps the only story of conversion by democracy in medieval history. More typical was what happened in Denmark and, much earlier, in Normandy. Around 911, a Norwegian war chief named Rollo was ceded the lands around the mouth of the Seine River by the Carolingian King Charles "the Simple" (898–922). The Seine had been a point of access for other raiders, and the remnants of the Frankish kingdom had suffered for decades at their hands. Now, astutely, the

Frankish king bought off his enemies, and Vikings would become Christian and receive lands in exchange for defending France on behalf of the king. The buying off, however, didn't go too smoothly, according to one chronicler. As he was turning over the land rights to Rollo, the king demanded Rollo kiss his feet to signify his submission. Rollo demurred but finally agreed—having his men turn the king upside down so that Rollo wouldn't have to bend the knee. Although the story is almost certainly not true, it does reveal a tension that would last for generations. This land of the Northmen, of the Normans, would become Normandy, and Rollo's successors, as dukes of Normandy, would be a persistent thorn in the king's side especially after Rollo's descendants became kings themselves (of England) after 1066.

FAR TO THE EAST, BUT AT about the same time the Danes were settling in Britain, different groups of raiders and traders were engaging other polities and peoples. The story in western and central Asia plays out very differently than in western Europe because the pre-Viking situation there was so distinct. Instead of fragmented states and wealth hoarded in easily raidable religious institutions, Vikings found themselves on the northern edges of scattered settlements within vast trading networks that stretched from China and India to the Mediterranean. Constantinople offered one node; Baghdad another, with perhaps hundreds of cities providing connections across steppe, mountain, desert, and forest. The centralized power and military might of these cities and civilizations did not preclude frequent raiding, but made collaborative economic exchange the much more profitable option.

From their position in the north, Vikings could sail their ships on western Asian rivers such as the Dnieper and Volga, carrying them over short portages, or building new ones as required. As we approach

900, these settlements become ruled by families that connect their origins to legendary founders from Sweden such as Rurik, founder of Novgororod. They built connections with the growing kingdoms in Scandinavia, while pushing to the south, once again both raiding and trading. In 860, for example, the Rus raided the Byzantines and besieged Constantinople, catching the Byzantine forces off guard and savaging the suburbs of Christendom's greatest city at the time. But they also built alliances with the Khazars, a steppe people whose rulers converted to Judaism (and then later in the tenth century, Islam) and who dominated the territory between the northlands and the Black Sea. And because the Silk Road ran through Khazar lands, the Vikings participated in the great trading networks of the world's most prized luxury goods, such as silk, spices, incense, precious metals, fur, weapons, and enslaved people. But also, traversing the great rivers, they themselves brought fur, timber, and enslaved people from the north and collected for their return metal works, beads, and silver dirhams, the coin of the caliphate. Indeed, dirhams have been found in Viking burials and hordes stretching from Novgororod, across Scandinavia, to the Isle of Skye in Scotland, to Iceland.

On one such trade delegation, early in the 920s, the Abbasid Caliphate in Baghdad sent a diplomat with the Rus on their journey back north. We don't know much about this traveler, Ibn Fadlan, just that he took notes on the people he encountered, and then produced a quasi-ethnographic narrative of his journey, although only the record of his outward journey survives. This type of text wasn't all that unusual among Arabic literati, for whom this kind of travel writing became embedded in Arabic culture over the centuries. He wasn't even the only author to describe the Rus in Islamic lands. A roughly contemporary geographer and tax official named Abdallah Ibn Khurradadhbih described the Rus coming down from the "land

of the Slavs . . . with beaver and fox pelts, as well as swords." They traded with the Byzantines and the Khazars, but sometimes went into the region around the Caspian Sea, exchanging their ships for camels, and using those camels to bring their goods on the long journey to Baghdad, where enslaved eunuchs, formerly of Christian lands, interpreted for them. These camel-riding Vikings would pretend to be Christian, so as to pay a lesser tax than polytheists. As we've seen, Islamic states had carved out a distinct, protected if unequal position in society for Christians, but not for the pagan northlanders. So the Vikings faked it.

But Ibn Fadlan's tale captures the imagination in part because even as he describes in a deadpan voice, generally without apparent emotion, the world he encounters there are moments when the humanity of his subjects—in all their glory and horror—becomes visible in these early medieval encounters. For example, he clearly had conflicting reactions as he learned more about the Rus on his journey. On the one hand, he said he had "never seen bodies more perfect than theirs. They were like palm trees. They are fair and ruddy," and heavily armed. The women wore fine jewelry, perhaps brooches of some sort and torcs around their necks. Yet even as Ibn Fadlan admired their beauty, he condemned them as "the filthiest of god's creatures . . . like wandering asses," recoiling at their practice of washing in the morning with a single bowl, blowing their noses and spitting in the water, before handing it back to a serving girl who would pass it to the next man.

Beyond hygiene, one of the most disturbing elements of Ibn Fadlan's encounter is his description of the ritual burial of a Rus leader, which focuses on an enslaved girl being drugged, serially raped by the elite men of the group, and then ritually murdered on a ship, next to her master. The ship, which also contained luxury goods,

the bodies of enslaved people and sacrificed animals, and the finely dressed corpse of the ruler, is drawn onto a woodpile on the shore and set alight. "The fire enveloped the wood, the man, the girl, and all that there was on the boat. A violent wind began to blow and the heat of the fire intensified." One of the Rus laughs at Ibn Fadlan, telling him, "You Arabs are fools because you put the men you love most into the earth, where the worms eat them. We burn them so that at once they enter Paradise."

The comment reveals a peculiar encounter, one in which both sides seem to understand differing cultural and religious practices. The Rus interlocutor knows about Islamic burial practice, just as Ibn Fadlan is learning about the Rus. But the focus of the passage is the fate of the enslaved woman, a fate that doesn't seem to bother the Arabic narrator, even if it should absolutely disturb us. Slavery was relatively common across the early medieval world, as we've seen, and Viking society was no different. Vikings trafficked humans, sometimes captured in war or raiding, throughout their routes, right along with timber, fur, and other goods. Indeed, certain Viking settlements were set up as conduits for sex trafficking, with raids dedicated to killing men and taking women for sale (or as gifts to followers) elsewhere. Even within Viking society, various kinds of legal judgment could reduce someone to thralldom (unfreedom). Being unfree could and did mean different things in different places and times, with many enslaved peoples living and working with considerable legal protections. And yet we cannot—can never—deny the reality of enslaved people's existence. They suffered and were subject to the whims of their masters or lords. Even if this particular rape and ritual murder may have been an extreme case, it was well within the realm of the horrifying reality, so it's not unthinkable to say that Ibn Fadlan was writing exactly what he saw that night by the Volga River.

Still, it would be a mistake to encounter that poor murdered girl

and think she stood in for all women in Viking society. Enslaved peo-
ple suffered, but Norsewomen enjoyed what perhaps might be a sur-
prising amount of parity with men. Although the sagas and histories
are full of gendered violence, medieval Scandinavian law typically
allowed for divorce, initiated by either party. Women owned prop-
erty. Women fought in both reality and story. When the men went
traveling, women often sailed along with them, even as far as the
shores of North America. The graves of Norsewomen are filled with
all the implements of their lives, which often means jewelry or do-
mestic goods, but also might mean swords, so perhaps some women
even went on the raids—or "on a viking," as the Norse described such
activities (although that's debated). There are just too many images,
literary depictions, outsider complaints, and archaeological evidence
of women who fought, ruled, and exercised agency in their lives.

Take the example of a woman named Freydís, the sister of Leif
Eriksson, both of whom lived around the turn of the first millennium.
Leif is perhaps best known for the records of his exploits that survive
in heroic sagas, wherein he sails west from Greenland to raid and
trade, eventually reaching the Americas nearly five hundred years be-
fore Columbus. We have no surviving stories from the indigenous
perspective, but the two Viking sagas that mention Vinland (unclear
where precisely but likely northeastern North America) are reveal-
ing. In both, Vikings were quick to resort to violence but also willing
to trade with local inhabitants; the locals seem to have felt similarly
willing to fight or trade as the circumstances merited. In both, Freydís
played a leading role. At one point, under attack, the pregnant Frey-
dís shouted at the men, "Why do you flee from such pitiful wretches,
brave men like you? If I had weapons, I am sure I could fight bet-
ter than any of you." Her claim came true when she came upon a
dead Viking warrior, picked up a sword, "pulled one of her breasts
out of her bodice and slapped it with the sword. The Skraelings [a

derogatory epithet that the Vikings used for the indigenous peoples]
were terrified and fled back to their boats." In the other saga, as the
Viking colony collapses because of infighting, Freydís herself leads
an expedition to Vinland. It doesn't go well. Freydís starts a fight
between two factions and murders several with an axe. The colony
disintegrates and the survivors return to Greenland.

Indeed, the Viking presence in North America, although in-
disputable now, seems to have been relatively short-lived. But that
shouldn't surprise us. The Viking movement westward across the At-
lantic was one of island-hopping in the early Middle Ages, and then
retrenchment and retreat toward the end of the period. The Faroe
Islands, far to the north of Scotland and far to the west of Norway,
were a stepping-stone to the much bigger landmass of Iceland, and
both were uninhabited when the Vikings arrived. Here the voyag-
ers turned to agriculture, fishing, hunting, and animal husbandry. By
930, the Icelanders had established an island-wide parliament, whose
chronology supports modern Icelandic claims to be the world's oldest
democracy. But the Vikings continued to move west, this time later
in the tenth century to Greenland, where ultimately thousands of
Vikings moved, seeking better land and wealth. Greenland opened
the sea lanes to North America.

Then, just as quickly as it started, the Viking world all began to
fall apart. The North American lumber and trading posts (and likely
small settlements) were abandoned early in the second millennium
and the inhabitants fell back to Greenland, as noted in the story of
Freydís. Those Greenland colonies in turn began to wither in the
fourteenth century, perhaps because of a drop in the demand for
walrus ivory caused by population decline due to the Black Death.
By the middle of the fifteenth century, both major settlements on
the massive island were gone. Although there is a record of a ship

arriving in Iceland in 1347 after having gathered timber in Markland (likely Labrador in Canada), by that time Iceland had become less of a waypoint and more of a terminal destination in movement across the North Atlantic. That ship had simply been blown off course and was making the best of a bad situation.

IN SOME WAYS, THE ERA OF the Vikings as feared outsiders came to an end due to cultural change rather than military action. Mostly, as we've seen, the Vikings converted to Christianity, albeit slowly and often with great conflict, and so the stories they told about themselves and that others told about them changed. A few years after the turn of the first millennium, a new Norwegian king, Olaf II Haraldsson (1015–29), sought to unite the divided chiefdoms of Norway into a single Christian kingdom under his rule. He seems to have been converted when traveling in Normandy years earlier, and even though he was later known as St. Olaf, scholars emphasize that he was no pious leader. In fact, he doesn't seem to have been that great a leader at all, having lost enough influence that his lords welcomed the invasion of King Cnut of England and Denmark in 1029, and Olaf died at the Battle of Stiklestad in 1030.

Olaf's brother Harald Hardarada was fifteen when he fought beside King Olaf at the Battle of Stiklestad, but fled to Kiev afterward and served in the army of Grand Prince Yaroslav. Later, according to the saga recording his life, Harald went to Constantinople and joined the Varangian Guard, a group of Norsemen who served as a kind of bodyguard and mercenary troop for the Roman emperors. This was a common enough path for mercenaries and adventurers. Look hard enough and you'll find graffiti of runes carved into the stones of Hagia Sophia, saying, "Ári made these runes." Another preserves the name Halfdan. Harald himself fought in Sicily and southern Italy,

then returned to Constantinople and became deeply involved in the political intrigue of the city in the 1040s. This was a decade of civil wars and short-lived emperors, and so Harald's fortunes fell as quickly as they'd risen. He fled the city by ship and returned to Kiev, married Yaroslav's daughter, then set about taking the Norwegian throne for himself.

By 1046, he'd done so and ruled for twenty years, until 1066 when he was invited to England to take that throne as well, reuniting kingdoms that had been linked just a generation before. But the Norwegians fell in battle to the English army under King Harold II near the current Scottish border. Harold II's victory was short-lived, though, as he was then in turn defeated by Normans invading from the south. And although periodic raids continued from time to time, perhaps this is a good place to bring the Viking era to a close, here in 1066. Between September and October of that year, Duke William of Normandy (descended from Rollo's Vikings who first settled in Francia under the Carolingians) defeated King Harold II Godwinsson (descended from Danish Vikings on his mother's side), who had previously defeated Harald Hardarada (the Viking king of Norway).

It's useful to draw a line between the era of Viking expansion and medieval Christian Scandinavia as the first millennium turned into the second. The Vikings didn't go away but the nature of the relationship between the kingdoms of the north and their neighbors shifted. We followed the Vikings east, down the rivers of Russia and into the Caspian Sea, riding camels, raiding and trading with the Abbasid Caliphate for silk as opportunities offered themselves. With them we went west into the North Atlantic, hunting walrus in Iceland, raising cattle in Greenland, or sailing all the way to the fertile lands of the North American coast. We turned south down the Atlantic, raiding across French rivers and even through the Strait of Gibraltar into the western Mediterranean. The ends don't quite meet, with these

raiders in Spain in the 800s finding the Norwegians fighting for Rome in 1040 Sicily, but the circle nearly connects. Indeed, the Vikings seem to be a quintessential medieval phenomenon, capable of great violence, equally able to interact peacefully in pursuit of commercial gain, and always vectors of permeability.

A GOLDEN GIRL
IN FRANCE

Early in the eleventh century, deep in what is now southern France, a soldier named Gerbert came upon three captives held by a brutal man named Guy, a local ruler of a castle who reveled in violence and often kidnapped locals for ransom. Gerbert, filled with mercy, helped the prisoners escape, but they were quickly recaptured and through torture confessed that Gerbert had aided them. Gerbert was seized and Guy ordered his dastardly henchmen to cut Gerbert's eyes from his sockets.

Gerbert despaired of his fate and wanted to die. "His plan was to drink goat's milk, for people say that if anyone who has recently been wounded drinks goat's milk the person will be undone by death on the spot." Luckily, no one gave him goat's milk. So instead Gerbert decided to starve himself to death. But on the eighth day, he had a vision. A ten-year-old girl appeared to him, clothed in gold, suffused with light, and beautiful beyond description. She regarded him closely, then stuck her hands into his sockets and seemed to re-implant his eyes. Gerbert awoke with a start to thank the girl, but no one was there. His vision began to return slowly.

Stories about saints and miracles, or hagiographies, offer useful windows into the worlds of their composition. They describe a natural landscape upon which the supernatural operated, the boundaries within which men and women lived their lives right alongside the divine. As such, these types of stories reveal not only localized religious belief and practice, of course, but also provided a canvas upon which medieval people painted their hopes and fears about all aspects of life. These were acts of rhetorical persuasion. In Gerbert's case, the story of his golden girl is our pathway into the perception of crisis around the turn of the first millennium.

The traditional story is that in the aftermath of the Carolingian collapse of the later ninth century and the Viking incursions, with North African pirates raiding the coasts of France and Italy, and the Magyars—a people who migrated out of central Asia—pushing into eastern Europe, we left behind a "Carolingian Renaissance" and plunged right back into the darkest of the Dark Ages. The disruption might well have seemed total to people in Charlemagne's former empire as we emerge into the eleventh century, not unlike in the fifth, when Rome was sacked, when Attila and his Huns raged across Europe, and new kingdoms began to emerge in Roman provinces. Such moments did not in fact signify total collapse, but they still threatened the equilibrium of the people who perceived chaos around them. For all the ways in which we, as modern historians, might point out that some aspects of Rome remained as we emerge from the fifth century and that this kind of violence had been going on since the third, this would have been cold comfort to Augustine or Jerome as they tried to explain why God let Rome be sacked. So, too, with Gerbert and many others in this later period: they were looking for a new meaning, a new structure, a new stability. But even when we turn our attention to post-Carolingian France, to an elite experiencing deep anxiety about the shape of their society and the

state of their souls, we find that rich human complexity we've come to expect in our Bright Ages. And out of that complexity, embedded within the stories they told, we find a pathway of new ideas about how to work toward peace.

AFTER HIS VISION OF THE GIRL, Gerbert's eyesight started to return and he went back to his life as a warrior, but he was conflicted about his old lifestyle after his miraculous experience. He confessed his concerns to Theotberga, the wife of a powerful count. She convinced him to go to the monastery of Conques, to escape the turmoil of the world and become a monk. He did just this, spending the rest of his life in devotion to that monastery's patron—an energetic saint who was martyred as a child, Ste. Foy (Saint Faith).

The story doesn't end there though. Gerbert and Guy's story reappears in a collection of miracles related to Ste. Foy, with Guy finally getting his comeuppance in the end. According to this story, when Guy heard about the miracle that restored Gerbert's eyes, he responded with disbelief and slandered Foy as a false saint. But when Guy died sometime later, the stench of his corpse became unbearable and a snake suddenly appeared in his bed, covering him in slime before vanishing. Those around him concluded that these were both indications that Guy had been punished for his sins: the snake was a demon that had been his teacher, and the stench was a sign that his soul had been transported directly to hell.

Gerbert's story is relatively triumphant (in the sense of good vs. evil), but is still laden with the uncertainty of the time. Guy wielded raw power to terrorize the people around him. Gerbert showed mercy and was mercilessly punished. Guy gets what's coming to him (eventually), but that justice is reserved for the next world. There's no king to appeal to for justice, no Charlemagne or his heirs to exercise authority; no court within which to try the wicked. But there is hope,

and in both these stories and sometimes in reality, wisdom, stability, and vengeance come from women—the countess Theotberga and the long-dead ten-year-old girl, Foy. They right the ship; Theotberga pushing Gerbert to do the right thing, Foy rewarding Gerbert for his act of mercy and punishing Guy for his transgressions. Even when she seemed to intervene at the moment of Guy's death, this golden girl was thanking Gerbert for being a friend.

And when we dig into how the story is told, we see even more ways in which the people of this period were looking for stability. We know about Guy and Gerbert in large part because of Bernard of Angers, an early eleventh-century churchman who studied at the cathedral school of Chartres (southwest of Paris) and then became a teacher himself at Angers, in the Loire Valley. In Bernard's *Book of Sainte Foy*, he reports hearing of "strange" miracles and a "strange" saint and so decides to investigate for himself. He first went in 1013 to the town of Aurillac, where he saw a statue of a certain St. Gerald, resplendent in gold. Bernard, however, was initially unimpressed, thinking the Cross the only appropriate image for proper Christian worship. He continued farther south. At the monastery of Conques, he encountered a golden girl. That relatively small statue reliquary of Ste. Foy still survives today, still at Conques, often on display just near the main altar to the monastery church. The saint sits enthroned, her eyes serene, a statue entirely clothed in gold, encrusted with jewels, sparkling with gems, radiant in the sunlight.

Bernard at first mocked the statue, thinking it no better than a false idol—something like the golden calf of the Hebrew Bible. But he wrote that he soon came to understand the difference between veneration and commemoration. Through conversations with those who'd experienced the saint's miracles, Bernard learned that the relic, the remains of the girl within, connected heaven and earth. The statue was simply art that called the saint to mind. But it was more

than that. Its beauty acted, Bernard describes, as a pale reflection of the glory of heaven, allowing people here on earth a way to focus their prayer and therefore access divine power. In this way, the statue of Foy was according to Bernard "more precious" than the Israelites' Ark of the Covenant.

Bernard recounts miracles like the restoration of Gerbert's eyes in order to tell a story about the power of the saints, the importance of monasteries, and the necessity of lay devotion to them both. Yet he was also telling a story embedded in biblical history, a narrative intended to reveal "truth" much more than "fact." *The Book of Sainte Foy* is an attempt to make sense of a world that didn't seem to make sense, a moment of crisis. For Bernard, this was a world in which men with castles at times seemed more powerful than the pagan gods and just as amoral, a world in which God through His saints needed to intervene directly to set things aright.

The story of Ste. Foy and her adherents is really about the rise of the new aristocracy, a class of petty elites whose battles, patronage, alliances, religious devotion and concerns, and more would reshape the structure of medieval European society. After the Carolingian kingdoms splintered and external pressure from the Vikings, Magyars, and Arabs mounted, the biggest winners were the aristocracy. Successfully playing sides off one another, they bargained and negotiated for land grants and concessions to expand their prerogatives. Kings and higher nobles needed troops to both repel external invasions and suppress internal rebellions, sparking the rise of a new class of soldier—the *castellan*, literally meaning "one who has a stronghold" (or "castle," *castellum*)—in the land. These are the bad guys of Bernard of Angers's text, men like Guy, the tormentors of the people of Conques.

But they didn't rule the massive stone castles we often envision when we think of the Middle Ages. It's too easy to hear the word "castle" or "knights" and grab images from Hollywood of giant buildings

and men encased head-to-toe in armor. These new aristocrats instead raised wooden structures called motte-and-baileys, which consisted of a building on an artificial hill with a few supporting structures below, surrounded by a wooden palisade. These weren't glamorous settlements, but they did offer protection, a place from which to raid out into the countryside and to which the castellans could retreat if they encountered trouble. They were relatively cheap and easy to construct. They produced income, usually from agriculture produced by peasants or other unfree laborers, which could then be parceled out among strongmen in ever-shifting networks of alliances. Local aristocrats would divide up revenues so that a given lord might have small shares of many castles' wealth, replicating on a small scale what Charlemagne had done to keep his nobles placated (and at peace) centuries before.

In this case, though, rather than breed interdependence, this complex economic and political arrangement generated a constant drone of small-scale disruptive conflict. These fortifications didn't require royal or high noble permissions to construct but simply the initiative and resources of an individual. In the absence of royal and ducal power, they sprang up just about everywhere across France.

We see hints of the disruptive consequences of the rapid spread of proto-castles in *The Book of Sainte Foy*. Conques was surrounded by independent castellans, sometimes loosely tied to one another or some greater noble, but often functionally independent, and each of them prioritized their own aggrandizement. For example, Bernard relates the story of a castellan by the name of Rainon who wanted to attack one of the monks of Conques and take his horses. Rainon met an unfortunate end: his horse threw him as he charged at the monk, breaking his neck in the process and proving the young saint's ability to protect her people. Ste. Foy also defended her land from the nobleman Pons, who desired to seize some land promised to the

monastery for his own. He was struck by lightning and killed as he was planning more mischief. These examples could be multiplied many times over, not just in *The Book of Sainte Foy* but also in other texts from all over Europe, although sometimes without the slimy snakes and regrown eyeballs.

Chronicles and annals from the period are replete with the hum of constant warfare, raids on churches, and general disorder. There was no king, no emperor to keep the peace. To the authors of these texts, centers and peripheries have now almost entirely destabilized, with large chunks of western Europe now divided into fragmenting segments fraught with low-grade but constant strife. No one was ultimately responsible to anyone else, and it seemed, at least to many observers, that might simply made right. Justice could be administered only with the sharp end of a sword. Neighborhood bullies flexed their muscles.

But if we look a little deeper, the authors of this period also show that the bullies were not unopposed. For every Guy, Rainon, and Pons, there were other castellans who supported monasteries and churches, and petty nobles who took it upon themselves to fill in the vacuum in the absence of royal justice. Bernard tells of a monk named Gimon, formerly a castellan himself, who kept his fighting gear with him even after he joined the monastery of Conques, and charged out to battle his former compatriots who would challenge the saint's rights. This melding of monastic profession and actual combat was not unheard of in the eleventh century, but it wasn't common (yet). Most warriors in early medieval Christian storytelling who renounced their military ways stayed peaceful. We remember that St. Guthlac of Crowland (in Britain) in the late seventh century famously renounced his warrior ways, "converting"—his word, not ours—not to Christianity (since he was already Christian) but to monasticism since he feared the impact of his violent acts on his immortal soul. Even more

famously, St. Martin of Tours—who served as a model for generations and whose tomb became a wildly popular pilgrimage destination—had in the fourth century renounced his role as a Roman soldier and issued his desire to be a hermit by saying, "I am a soldier of Christ; it isn't lawful for me to fight."

But by the early decades of the tenth century, things had begun to change. Odo, the abbot of the monastery of Cluny in Burgundy, wrote about a local nobleman from the region of Aurillac by the name of Gerald. This nobleman had lived a particularly praiseworthy life. He protected those in need, avoided sin, lived chastely, and listened to monks, priests, and bishops. But still he led his army into battle against those who broke the peace, even if he fought only with the flat of his sword and never drew blood. In one instance, Gerald went to his bishop and asked to join a monastery. The bishop refused his request but did allow Gerald to be secretly tonsured as if he were a monk. Gerald supposedly never touched his sword again.

The bishop's response was well within the mainstream of Christian tradition, going back several centuries to our old friend Augustine of Hippo. A convert to Christianity and then bishop in North Africa in the late fourth and early fifth centuries, Augustine argued that warfare could be justified, could be acceptable to God, if it were waged defensively and with the goal of bringing peace. This was his theory of "Just War." First and foremost a Roman, Augustine lived at a time when his world seemed under threat, when it seemed like the borders of what he thought to be the civilized world were closing in around him. But his ideas were easily adapted to subsequent centuries when Christian rulers still controlled the levers of political power, when the administration of justice and maintenance of peace seemed to require violence. And here we are in the tenth century.

What was once for a fourth- and fifth-century bishop like Augustine something to be applied to the whole of the Roman Empire

could now be applied by a regional monk in Burgundy to a local castellan. Truth was manifested in results. The power of God allowed Gerald to win all his battles, forcing many castellans to simply surrender rather than face Gerald's justice. All this, Odo concluded, suggested Gerald's sanctity, his closeness to God. After his death, monks like Odo hailed him as a saint and built a golden statue to house his relics. One hundred years later, Bernard of Angers would see St. Gerald's statue above an altar in Aurillac while on his way to Conques. So the story of Gerald, later St. Gerald, is also the history of political (and thus economic and social) stabilization, of a people looking to the presence of the divine in their world to return peace and order.

TEXTS LIKE ODO'S *LIFE OF GERALD of Aurillac* or Bernard's *Book of Sainte Foy* may seem triumphant, but in fact betray deep layers of uncertainty in the lives of both the authors and their subjects. Aristocrats, particularly castellans but also the monastic authors who were almost always related to the nobles they wrote about, were effectively new money, a new class, having used the hyperlocalization of power in the wake of the tenth-century invasions to carve out a space for themselves in the ordering of the world. Their brothers populated monasteries, their uncles and cousins controlled neighboring and often rival castles. They shared a culture and lineage that stretched back through the disorder they saw in the world around them, through the breakdown of empire, all the way to the time of Charlemagne. Even here around the year 1000, they remembered their legacy as God's new chosen people. But they also thought they saw how far they'd fallen. They themselves weren't kings or emperors. If the surety of the chosen people was shattered by Frank fighting Frank, Christian fighting Christian at Fontenoy, then weren't castellans warring with one another doing the same? Were they trapped in a cycle of sin? Were they the baddies in the story of sacred history?

There were no easy answers to those questions, no recognizable royal or imperial bureaucratic structure to work within, so understandably they worried about their souls. Stories of saints like Martin and Guthlac told the castellans they had to abandon their lives. Gerald told them it was okay to remain in society, as long as they disavowed violence. In any case, they seemed to know they needed some closer connection to God. Just as they needed allies in waging wars for their land, they needed allies in the war for their salvation. They needed friends like Foy and connections to where those saints lived—monasteries like Conques.

Sometimes these castellans used what was familiar to them, falling back on Carolingian models, donating land or money to monasteries and providing protection in exchange for prayers on their behalf. Others simply founded their own monasteries, aping royal power in the absence of those figures. And in still other instances, they brought monks in from these newer monasteries to reform existing churches, creating networks that spanned the continent and united now-disparate areas through their religious communities.

The path to salvation did not just lie through monasteries, but more specifically emerged through their patrons, the saints. As with Foy, the saints remained present in the real world through their relics in their glittering reliquaries. The inscription above the tomb of Martin at Tours read "Here lies Martin . . . of holy memory, whose soul is in the hand of God; but he's fully here, present and made plain in miracles of every kind." The saint remained active on earth, tethered in some way to his final resting place. But that wasn't a permanent state. The saints could leave, could withdraw their sheltering hand if that reciprocal relationship soured—if chastisement was warranted to bring the saints' charges (monk or castellan) back into line.

Odo of Cluny, the one who wrote about Gerald of Aurillac, was asked by a local nobleman to reform another monastery, at Fleury-

sur-Loire, not far from Orléans. When he arrived, he found the gates locked to him, the monks of Fleury on the walls, warning him away by hurling stones. They were not so keen on the promised "reform." Nevertheless, he persisted. After three days outside the walls, Odo awoke to find the gates open and the monks awaiting him, begging his forgiveness. Pleasantly confused, Odo asked what had happened. The monks of Fleury told him that one of their own had had a vision that night of their patron, St. Benedict. Benedict had screamed at the monk, telling them to stop being so obstinate, to let Odo in and accept his reform. If they didn't, Benedict would abandon Fleury and its monks. He would withdraw his protection. The monks didn't want to risk it and opened the gates at dawn the next day.

Knowing the saints' (or God's) wishes wasn't always so easy. It required astute observation and interpretation, with potentially deadly consequences to getting it wrong. God and the saints manifested both pleasure and displeasure through war and peace, violence and prosperity. To that end, to try to divine what God wanted of them, councils of churchmen were convened to discuss how to put the world back together. These convocations led to a phenomenon now known as the "Peace of God." At these councils, religious leaders would gather to decide on a set of actions to keep the peace. It's important that they did so under the watchful eyes of the saints.

As described in one instance by Bernard of Angers: "The most reverend Arnald, bishop of Rodez, had convened a synod . . . [and] to this synod the bodies of saints were conveyed in reliquary boxes or in golden images by various communities of monks and canons. The ranks of saints were arranged in tents and pavilions in the meadow . . . The golden majesties of St. Marius . . . and St. Amans . . . the golden reliquary box of St. Saturninus, and the golden image of holy Mary . . . and the golden majesty of Sainte Foy especially adorned that place." It was here, under the golden light of an autumn sun, amid the golden

wheat of southern France and the golden reliquaries of the holy mar-
tyrs, that bishops and monks, peasants and nobles, men and women
all worked together to try to understand God's plan for the world.

Most often, the results of these councils were oaths to keep the
peace and promises to protect those in need. Transgressors were threat-
ened with excommunication from the Church, eternal damnation.
Those who stole from churches or priests, those who took livestock
or crops from the poor or from women, would suffer eternal punish-
ment. But let us think on these crimes for a moment. Centuries be-
fore, these were things dealt with by royal justice. No longer, though.
Another power was needed to step into this void. In other words,
these councils were standing in for the king. They stood in for an
absent ruler, attempting to fill the gap in temporal power with super-
natural power—the threat of the vengeance of saints like Foy. People
believed generally in divine intervention as a real force in their world,
one that could offer some solace in the face of oppression, because
medieval people did not want to live in a society racked by constant
violence. They were looking for a better way. Whereas in the past,
God seemed to work with and through the king or emperor, He now
had to work directly in the world with those rulers' absence.

Sometimes, however, these councils took things into their own
hands.

Later in the eleventh century, near Bourges in central France, an
army gathered under the leadership of the archbishop of that city.
After convening a council of local bishops, the archbishop decided
to gather all men of fighting age and bind them by an oath, not only
that they wouldn't break the peace, but also that they'd band together
to wage war against any recalcitrant peacebreakers. The chronicler
Andrew of Fleury reported that the army so terrified those with ill
intentions that it did indeed keep the peace for a time; it seemed to
at least one contemporary chronicler that this region had become

like a new Israel, beloved by God. Alas, greed crept in. The army was finally undone when the archbishop led the peacekeeping army against someone who didn't deserve it, massacring women and children. Then God revealed His displeasure. At the next engagement, "a sound was made heavenward [indicating that the bishop's forces should] retreat, since they no longer had the Lord with them as a leader. When they made no sign of following this advice, an enormous globe of flashing light fell in their midst. Thus it came to pass, as it is said, 'Flash forth the lightning and scatter them, send out their arrows and rout them!'" (Psalm 143:6). And it came to pass. So many in the archbishop's army died that it dammed the Cher River and is said to have created a bridge that men could walk across.

The point in all these examples, from Gerbert's regrowing eyeballs to the destruction of an army, is that the people of this era were certain that God still intervened in the affairs of the world. Surely many people found it reassuring that God hadn't abandoned His new chosen people, but this served to reinforce the cultural anxiety of the moment by reminding the Franks of their responsibilities to the progress of sacred history and how they had, so far, fallen down on the job. That realization was particularly pressing when put into a wider perspective. After all, sacred history always hurtled toward something inevitable: Revelation and Apocalypse.

In sermons contemporary with the archbishop of Bourges's ill-fated army and with Bernard's account of Ste. Foy's miracles, another monk described that inevitable end. When the Apocalypse finally arrived, Ademar of Chabannes explained, the saints would be arrayed to observe and ultimately judge the souls of all Christians. This last judgment is a familiar scene for many, one carved in stone throughout the twelfth century on the west fronts of cathedrals across Europe, and thus familiar to anyone who passed through church doors.

Judgment did not have to be paralyzing, but rather could be

motivational. This is another version of the vision of gold in Ro-
dez, the councils of the Peace of God that assembled throughout the
period—good Christians coming before the saints to ask for their
help before God. At the turn of the first millennium in Europe, the
resplendent beauty of a reliquary and an image of expectation crafted
from limestone were their best reminders that this world was only
an approximation of the next. For now, at the turn of the first millen-
nium in Europe, the hope of justice, of peace here on earth, seemed
to live elsewhere—in the heavens, at the end of time. Over the next
century, that anxiety would lead petty lords from all across Europe
to action, to redeem their status as the new chosen people, to repent
and spur history forward via their actions by attempting to retake
Jerusalem.

THE BRILLIANT
JEWELS OF THE
HEAVENLY
JERUSALEM

As the attackers entered Jerusalem in the middle of July 1099, their journey seemed to be at its end. After several failed assaults on the walls, one had breached the city's defenses and opened the gates to the assembled Franks. They poured in, killing as they went. One participant, a priest named Raymond d'Aguiliers, in a chronicle of the events written some years later, recounted that in the "Temple of Solomon" the killing was so great that the soldiers rode through blood up to their knees, up to the bridles of their horses. This, the writer continued, was God's justice and intended to cleanse this holy place with the blood of the blasphemers. Paganism had been cast down and Christianity exalted. This, Raymond continued, "is the day the Lord has made; we will rejoice and be glad in it" (Psalms 118:24).

Medieval Christian traditions of religious violence, especially holy war, pass into modernity as one of the darkest moments of a dark age,

and we're not going to argue against the horror. In fact, too many in the modern world try to excuse the campaigns at the end of the eleventh century as a legitimate defensive reaction in 1099 to the Islamic conquests across the Christian Mediterranean some four hundred years beforehand. This thinking transposes modern sensibilities, an acceptance of an existential "clash of civilizations" that serves modern politics. Instead, we need to see the practice of Christian holy war through (as much as possible) medieval European eyes so that we can understand these conflicts as part of the messy, complicated human past. In doing so, we'll see how wars like this were not eternal or inevitable, no matter how often medieval people—and sometimes modern historians that followed—tried to locate their ephemeral moment in a cosmic timeline.

Without any doubt, there was a massacre in Jerusalem in 1099. All sources agree that thousands were killed. But the language in this one famous account is peculiar. Blood to a horse's bridle in the Temple? Several feet deep? Scholars often recount it as hyperbole, indicative of the scale of the slaughter. That's likely true. But this specific set piece reveals more; it reveals a biblical reference, language lifted almost verbatim from the book of Revelation. There, in chapter 14, the book recounts the salvation of the righteous and how the rest were given one last warning to forsake evil. Those who refused were confronted by an angel, who emerged from the Temple with a sickle, who reaped the earth, and thrust them into the winepress of the wrath of God. Blood flowed from the winepress up to the horses' bridles (Revelation 14:15–20).

Raymond was describing a moment in which heaven and earth seemed to meet, when sacred history became visible to onlookers. Read this way, it then makes sense that Raymond followed the evocation of Revelation with one from Psalms (about the "day the Lord had made"), verses mashed together by the author to demonstrate that

he thought he understood God's will. God was at work in the world, there in Jerusalem, as an army of Christian Franks slaughtered those they considered unbelievers. This was an instance of the long-sought apocalypse, a continuation of sacred history played out—pushed into being—by the new chosen people.

WE TEND TO THINK OF "APOCALYPSE" as meaning "the end" but it might be better understood as "transformation." The Greek term ἀποκάλυψις ("apokálypsis")—from which the English derives—simply means "to reveal" or "make seen." Something that was once hidden, that was perhaps truer than what we knew before, can now be seen and the world is different afterward. In Revelation, for example, the world is transformed repeatedly before John's eyes, as God makes the final truth of sacred history visible. That truth has always been there but now, again, John sees. This is the paradox of apocalypse, of things hidden and things seen, the paradox of fear vs. anticipation, of paralysis in the face of that coming change vs. vigorous activity to make that change happen.

We've seen this before, in previous chapters focused on the Byzantine and Latin Christian worlds. Christian writers throughout antiquity and the Middle Ages tried to locate themselves within the arc of sacred history, somewhere between Creation and Last Judgment. But they never agreed where they were on that timeline and so, too, did the work they thought was required in their own life to get there. Context mattered. What they did agree on was that glittering jewels illuminated their final end.

Revelation 21, just at the end of the book, opens with a world transformed. Heaven and earth have passed away and been replaced by a new heaven and a new earth, one connected by a new Jerusalem. The city descends from the sky, shimmering, adorned with jewels that sparkle, walls of pure gold so bright as to seem like glass, and

gates that will never be shut. The city has no need for the sun or moon because its brilliance generates its own light.

But to get to the light, one had to pass through darkness. The New Jerusalem appeared only after the final cosmic war between good and evil, after the plagues, the persecutions, the death, the destruction. The New Jerusalem, the transformation of the world, the vindication of the righteous, would be the reward only for the chosen people, those who took the side of God and the saints and angels against the machinations of the devil. And that battle would play out here on earth, the same earth to which the Heavenly Jerusalem would descend, enveloping and surpassing the old. The key, the hope, was to make this world as much like the next as possible, paving the way, bringing close the appointed time for the apocalypse, for the transformation of the world.

The eleventh-century Franks did try to see their actions on a larger stage, as they attempted to draw the worlds close. European Christians through the eleventh century seemed to think they had a better sense of how sacred history moved, how God acted through the saints. Theirs was a battleground between good and evil, between God's chosen people and those who made them suffer, the "soldiers of Christ" (*milites Christi*) against the "enemies of Christ" (*inimici Christi*). Such a cosmic war was not a new idea, but in this period operated in a different register and animated Christians' minds for very specific reasons at this very specific time.

The idea of Christian holy war has been present since the earliest centuries of the religion. There is clear evidence of early followers of Jesus being in the Roman army, and in the fourth century CE, moreover, the apparatus of the Roman state melded quite easily with the existing Church. The god under which Roman legions conquered was quite easy to swap out for a new deity, it seems. Certainly, this wasn't a necessary or foreordained development. Plenty of early

followers of Jesus were ambivalent about, if not outright hostile to, the idea of people killing other people. But Romans and Israelites were part of the same Mediterranean world, a culture in which officially sanctioned violence was simply a part of life—a way of exercising political power, a way of navigating certain parts of society. The army was a path to wealth and social advancement, both for the lower and upper classes.

Augustine of Hippo's influence on the development of intellectual culture in medieval Europe is hard to overstate. His ideas related to "Just War," how warfare was allowable if it was waged defensively and with a goal of bringing peace, were by the eleventh century canonical across Latin Christianity. Augustine, of course, lived in a very different time, consumed by nostalgia, wanting the power of Rome to be as it once was, to bring peace across the Mediterranean. True peace might exist only in Heaven, but Christian rulers had a responsibility to stop the "barbarians" at the gates.

That idea—that responsibility—was carried by European Christian kings and emperors through to and beyond the ninth century, walking the halls of and inhabiting the courts at Aachen alongside the ivory-tusked Abul-Abass. The power of old Rome was taken up by their inheritors in the Franks, made particularly evident after Charlemagne's coronation as emperor in 800. But then, in the tenth and eleventh centuries, ideology moved alongside power, away from the seemingly distant kings. After all, hadn't all of this been foretold?

A mixture of idealized Roman-Christian power with Frankish nostalgia—longing for an era of political stability and the certainty that they were the chosen people—seems to have been some of the primary motivation behind those who walked more than two thousand miles to Jerusalem, to fight a people they had never seen and almost certainly had barely heard of. Many scholarly accounts of the beginnings of this event, the so-called First Crusade, focus on one

singular moment—when Urban spoke to an assembled council of warriors and churchmen in a field outside Clermont in November 1095. And there's good reason to do so. There's a dramatic visuality to the moment, one recounted by several contemporaries, some of whom likely even attended the council.

They tell a story of a pope thundering in a sermon, the acclamation of the masses, people tearing their clothes to make crosses and vowing to march to Jerusalem. What's more, the ensuing campaign was even more dramatic, with great armies gathering; some from the Rhineland, some from what we today call northern France, some from Aquitaine, others from southern Italy. They moved slowly, independently, toward the East. On their way, they slaughtered and forcibly converted Jews and pillaged the countryside, sometimes skirmishing with their fellow Christian Byzantines. Before the massive walls of Constantinople, more than six hundred years old, the armies begin to converge. From there, the story turns even more improbable, providing even more evidence to contemporaries of the divine nature of a campaign that stumbled from Turkey to the Armenian city of Edessa, stalled outside the massive walls of Antioch, but then in 1098 one of the Christian leaders managed to bribe a defender of one of the city's gatehouses and the besiegers poured in, forcing the defenders to retreat into the citadel. This was good timing, as a large Muslim army from Mosul arrived just a few days later.

Hungry, desperate, trapped between the army in the citadel and another outside the walls, the Christians marched out against the Islamic leader Kerbogha. Somehow, the Christians won and began the final push south to Jerusalem.

The siege of this city lasted only about a month. Its walls had been broken just a year earlier by another army, the Fatimids, who took it from the Seljuks. On July 15, 1099, several ladders clung to the wall and the Christians gained a foothold, forcing the defenders

to retreat. The gates opened. The Christians poured in. The Temple ran red with blood, and the exultant victors celebrated a mass at the Church of the Holy Sepulcher, a sanctuary supposedly built over Jesus's tomb. What happened during this campaign is not heavily contested by historians; what it meant at the time, what it means today—these matters remain subjects of bitter and sometimes violent dispute.

THERE'S LITTLE TO DEBATE ABOUT THE "whats" and "whens" of the taking of Jerusalem in 1099; what's more open for discussion and debate are the "hows" and the "whys." Our sources are trying to place the events within a history that spans from Creation to Apocalypse, more intent on conveying a spiritual (or, at times, allegorical) meaning than a simple recounting of events. We are a long way from the *Royal Frankish Annals*. For example, we honestly don't know—can never know— what was in Pope Urban II's mind or on his lips when he spoke from that rostrum in a field outside Clermont. The five versions we have, reprinted endlessly, often repeated breathlessly, were written some ten to fifteen years after the speech itself, all written after the taking of Jerusalem and the "success" of the expedition. All of the authors were writing the beginning by starting from the ending, seeing a miracle worked by God, and projecting backward an "appropriate" prime mover.

All of the event's chroniclers, educated churchmen, knew at the time, as we should know now but too often forget, that there was no one singular cause for the holy war. They also knew that they operated within a particular intellectual tradition, one that stretched back well past what had just transpired, through the actions of their glorious ancestors at Aachen, dwelled in the forums of Constantinople and Rome, and found purchase in the Israelite Temple. As such, they had to make the enemies the aggressors, show that there was

a precedent for avenging these wrongs, and ensure that the battle to come was framed within the overall arc of sacred history. And so those authors portrayed Jerusalem and all of Christendom as under immediate threat, evoked the victories of the Franks themselves in generations past, and filled their accounts with biblical references and claimed that the actions of the Christians on the march were fulfillments of prophecy. The authors weren't necessarily describing what they'd seen or what they'd been told but rather creating an intellectual architecture to justify and explain to contemporaries how this supposed miracle had occurred.

These contemporary authors all agreed that the enemies had stolen Christian land. They were committing atrocities, murdering women and children, and defiling churches, the chroniclers said. The Byzantine Empire had been dismembered and was on the verge of collapse. But great predecessors such as Charlemagne had vanquished the enemies of Christ, had heeded the calls of those in need. Charlemagne had even gone to Jerusalem himself, some of the authors said (he hadn't). Addressing their audience directly, they said to remember who you used to be, the sin that had caused your people's fall, and what was required to reclaim God's favor. And this was the appointed time to avenge those wrongs, the authors concluded. Indeed, this was the moment spoken of in Scripture, in Testaments both Old and New. Sacred history looped. The Franks of the eleventh century were the new Maccabees, they were the new Israelites escaping Egypt, the new armies of kings David and Solomon. The prophets Isaiah, Daniel, Amos, and others were speaking to this moment right here. One of the authors, a monk of the abbey of St-Remigius of Reims, said that the events he described were the greatest miracle since Jesus's resurrection.

The cosmic struggle between good and evil had moved to this earth, and God used His agents against the servants of the Devil. This

is a more complicated explanation of medieval holy war than simplistic and cynical accusations that they were in it for the money, were just bloodthirsty fanatics, or (worst of all) that they were making a sober, militarily justified defensive decision in response to an unprovoked attack. But that's the way of the Bright Ages, even when the brightness comes from the fire of burning buildings amid the screams of a conquered city, we have to work from the inside of these all-too-human medieval people, try to see the universe as they saw it, and ask "how" and "why."

As such, from their perspective, we can now see how the consequences of this Christian victory didn't end in 1099. With the taking of Jerusalem, that struggle seemed to have entered a new phase. God's plan for the world had been made manifest, plain for all to see in the actions of the Franks. As these medieval chroniclers wrote, a Christian king sat on the throne in Jerusalem. A new form of religious warfare, soldiers acting on God's behalf, under the leadership of the Church, seems to have been vindicated. The arc of sacred history was bending up, the blood of the Temple cleansing the city and its new residents, making visible the glittering jewels of the Heavenly Jerusalem on the horizon.

But that was *their* explanation for why this all happened. It doesn't have to be ours. Often, this summary of the sources has been read a bit too naively, as if they were a transparent window into the past, rather than as the theological—and polemical—texts they are. For example, the events leading to the sack of Jerusalem in 1099 have been seen as a particular flashpoint in a "clash of civilizations," an unending war between Islam and "the West" (which really means "Christianity") that began in late antiquity, continued through the Middle Ages, reformed itself during colonialism, and extends into the twenty-first century. These conflicts at once embody the darkest of the Dark Ages for those who see nothing but religious hatred in

the moment, and the brightest of causes for those who would pursue religious violence in the here and now. This is the siren song of political pundits selling war in the Middle East, jihadis calling for war in return, and also far-right nationalists and white supremacists exhorting and practicing domestic terrorism. We see it used to justify ISIL terror attacks, then screamed across social media in their wake, emblazoned on homemade wooden shields at the white supremacist rally in Charlottesville, Virginia, scrawled on the gun of a murderer in Christchurch, New Zealand.

But, again, the story told by extremists doesn't have to be ours, because having unfolded the grounds for why this particular conflict happened when it did happen, we can also see that coexistence was possible. We saw it before the eleventh century, through normalized diplomatic relations between Byzantine emperors or Viking warlords and Abbasid caliphs, even through the gift of a thundering elephant that made its way from Baghdad to Aachen. And, even not long after the massacre that took place in Jerusalem, we'll see a possible world open up for them again.

IN THE EARLY 1180S, A SYRIAN nobleman wrote a book. More a series of anecdotes than a sustained narrative, the *Book of Contemplation* by Usama ibn Munqidh portrays a world in which he had only known a Christian Jerusalem (the city was taken when he was four years old). In this world, he both fights against some Franks and counts others as his friends. He recounts one incident, during a visit to Jerusalem, when he prayed at a small mosque adjoining Al-Aqsa on the Temple Mount. Facing south toward Mecca, he was accosted by a Frank who had just arrived in Jerusalem. The Christian Frank, interestingly, didn't object to this Muslim praying but rather tried to tell the Syrian he was facing in the wrong direction—Christian churches are oriented east–west, with the altar to the east. That's the direction in

which the Christian thought Usama should be facing. Usama was taken aback, flabbergasted. But he was quickly rescued by his friends, who escorted the Frank out, apologized for his behavior, and stood guard so that Usama ibn Munqidh could complete his prayers.

It was, of course, fortunate that Usama's friends were nearby but it's also not surprising. Al-Aqsa Mosque, known as the "Temple of Solomon" to the Christians, was where the Knights of the Temple—the Templars—called home. Here, an Islamic Syrian nobleman, who throughout his career fought and killed Christian Franks, was in this case worshipping in a mosque in a Christian Jerusalem, when he was protected by a Christian religious-military order—a collection of knights vowed to holy war against the enemies of Christ.

So what can we take from this anecdote? In short, holy war was never a permanent state. Christians and Muslims in the eleventh and twelfth century were sometimes enemies, sometimes friends, but in all cases lived together. The history of these wars, peoples, kingdoms, and religions along the shore of the eastern Mediterranean, like the whole of the medieval past, was messy, complicated, and human, no matter how often medieval people—or moderns—tried to graft it into simple narratives of good vs. evil, East vs. West, Christian vs. Muslim, to place it within the confines of a cosmic war at the end of days.

THE SUN-DAPPLED TOWERS IN A CITY OF THREE RELIGIONS

In the 1140s, a traveler went south. He was no ordinary traveler. Peter the Venerable, the abbot of the powerful monastery of Cluny in Burgundy, the (at least informal) head of a network of more than a thousand religious houses spread across the continent, ventured across the Pyrenees out of necessity. Although Cluny had one of the largest libraries in Europe at the time, with a still-surviving contemporary catalog listing nearly six hundred distinct manuscripts, he needed a book—a new one that would provide an answer he needed to settle a score. But no one in France, Italy, or Germany had it—it had never been translated into Latin. It was the Quran.

This story, like so many others from the Bright Ages, is not simply a straightforward tale of intellectual inquiry, but a symbol of a complex interaction among diverse cultures that reflects the drive toward both coexistence and violence.

Peter's predecessor as abbot at Cluny had established connections between his house and the king of Léon and Castile, and at the

center of that kingdom sat the city of Toledo, southwest of modern Madrid. One of the monastery's former monks actually held office as the archbishop of Toledo. And in and around the city's new cathedral, a structure that used to be the central mosque, the archbishop fostered a culture that attracted translators, groups led by Mozarabic (native Iberian) Christians who spoke Arabic but had learned Latin, as well as northerners who spoke Latin but had come south to learn Arabic. The man Peter eventually found, Roger of Ketton, was one of the latter. Roger was originally from England but had come to read Arabic treatises on algebra by al-Khawarizmi, as well as Arabic translations of the work of Aristotle.

When Peter returned home, he again crossed the Pyrenees, but this time with the first Latin translation of the Quran in hand. It was not a literal translation, but rather one that seemed to Roger to have captured the sense of the text. All translations are interpretations, of course, but what was different here in the twelfth century was that he didn't make these decisions on his own but worked in a team, one almost certainly composed of Mozarabic Christians, Muslims, and Jews. Roger, the Latin Christian, was an immigrant. The others, men of three religious traditions, had called this region and this city home for several centuries. If the Bright Ages consists of vast numbers of overlapping networks of contact and change, creating endless potential for cultural permeability, the nodes in those networks are found in cities like Toledo and specifically institutions like the cathedral to which Peter the Venerable traveled.

Peter's motivation matters. His was only a generation past the conquest of Jerusalem, only a bit more than a decade past the Council of Troyes, which formally recognized the Templars—a formal class of warrior-monks. The monks of Cluny generally, and Peter specifically, had been avid supporters of Christian holy war both in Iberia and in the East. Ultimately, Peter wanted the Quran to better under-

stand the "errors" of Islam so that more Christians could be encouraged to fight it with words, ink, and swords. This translation, made in a workshop of Muslims, Christians, and Jews working together, was intended as a weapon in the holy war.

Violence and coexistence, together at the same time. We saw this with the paradox of Usama ibn Munqidh's friends, the Christian holy warriors, who protected him while he prayed in a mosque in Christian Jerusalem. And here this tension played out across a sea, 2,200 miles to the west, in a very different set of circumstances.

IBERIA HAS ALWAYS SEEMED TO HAVE an odd place in the European imagination. It's inside and out, often written about both as a part of Europe and something apart from Europe. This is true also of how the European Middle Ages have been studied and how medieval people themselves conceptualized their world. Understanding historically contextualized relationships among medieval Iberian Muslims, Christians, and Jews—and diverse groups within those religious traditions—requires looking back to its relationship with the broader Mediterranean over the centuries.

Previously a province of Carthage, the Iberian Peninsula was absorbed into Rome beginning late in the third century BCE, but was only really Romanized about two hundred years later, around 19 BCE. Thereafter, the region became known as the province of *Hispania*, with new cities founded, roads established, and the population integrated into the empire. In fact, the emperors Trajan (98–117), Hadrian (117–138), Theodosius I "the Great" (379–395), and of course Empress Galla Placidia (d. 450) were all of Hispanic origin.

But Iberia suffered the same fate as the other provinces in the fourth and fifth centuries. As the centralized authority in the empire contracted, the legions were pulled out and the Romanized locals had to fend for themselves, making sometimes uneasy alliances and

accommodations. In the case of Iberia, this eventually resulted in a united Visigothic (again, meaning "Western Goth") kingdom during the late fifth and sixth centuries.

The Visigoths, pushed and pulled southward from their initial settlements in Aquitaine, established a kingdom that by the beginning of the seventh century spanned most of the Iberian Peninsula, with Toledo as its capital. Visigothic Iberia remained part of the connected early medieval Mediterranean world, in contact and frequently in conflict with the Basques and Franks in the north and Byzantines in the south. They ruled Iberia for nearly two centuries, until 711, when Arabs and other peoples of North Africa arrived and ended the Visigothic royal line. The North Africans and their allies, like a wave, rolled northward across the land, then over the Pyrenees, until the wave ran out of steam about twenty years later not far from Tours in what's now France.

Although textbooks have long elevated the 732 Battle of Tours (sometimes called the Battle of Poitiers) to world-historical significance, often portraying it as the battle that "saved Europe/Christendom," very little of that characterization has to do with the battle itself. The Franks defeated a raiding party, nothing more; and the stakes of the battle were about who controlled Aquitaine, a squabble between different Christian lords with Muslim soldiers from Iberia recruited by and fighting for one Christian side against another. That's the reality of the past. But the story of the battle, why we even know about it today, is because it became something more in the hands of Islamophobic and nationalistic eighteenth- and nineteenth-century European historians. They used it as a moment to construct a grander narrative about the formation of the nation-state or, later, a bogus "clash of civilizations." These historians wanted to fit the event into larger narratives that served their contemporary political purposes, to ensure audiences saw the Islamic world as distinct and

non-European, another "barbarian" at the gate needing to be repelled by valiant white European powers.

On the contrary, contemporary medieval sources thought no such thing, instead suggesting that, in the decisive battle at Guadalete against the Visigothic king in 711, the armies from North Africa were reinforced by Christian Visigothic supporters of a rival claimant to the crown. Indeed, one of the most useful sources for the events of the early eighth century comes from the *Chronicle of 754*, which frames the conquest as a sort of punishment against the Visigothic usurper, with the North Africans working alongside one of the rival claimants to the Visigothic crown, and in some ways bringing closure to a civil war. This text was written in Latin, almost certainly by a Christian governmental official working for the new Islamic rulers of Córdoba. But even sources in Arabic, such as the (admittedly, much later) *Narrative* by Ibn 'Abd al-Hakam, tell a very similar story.

That relationship between Muslims and Christians on the peninsula, a place that had been called Hispania under Rome but for the next seven centuries would be known as al-Andalus, was always fraught, always complicated, always messier than we might like to imagine. When talking about this place and this period, we must remember that we're not just talking about Christians and Muslims. In Iberia, as opposed to many other regions, there was also a substantial Jewish population, present since Rome (and perhaps before), a group persecuted heavily by the Visigoths at times, then remaining to find an uneasy abode under Islamic rule.

The relationships among these three peoples, living with and next to one another on the Iberian Peninsula throughout the Middle Ages, has long been known as "Convivencia" (meaning literally, "living together"). The history of Convivencia, however, lies entangled with "Reconquista" (meaning "reconquest"). The history of medieval Iberia in the popular imagination has tended to waver between imagined

worlds—real harmonious coexistence interrupted by religious vio-
lence on the one hand, and on the other, real religious persecution
that was stopped only when Christians reclaimed the land that was
"rightfully theirs." But these are extreme positions, categories of un-
derstanding made even more blunt by a rather naive understanding of
some medieval Latin sources that was mainstreamed by nineteenth-
and twentieth-century Spanish nationalism and contemporary Roman
Catholic reactionism, and then embraced by Franco's fascists just be-
fore World War II.

The edges between the two terms sharpened because of twentieth-
century conflicts. Convivencia was portrayed as symbolic of medie-
val weakness, with Christians "forced" to be tolerant because they
couldn't do otherwise. Reconquista for Franco was more real, more
authentic—a way of drawing a rainbow connection between him-
self and the past. He relied on blunt categories to legitimize his own
power. According to Franco's authoritarian nostalgia, just as medieval
Christians fought against Islam, so he fought to retake the country
once more, this time from republicans, anarchists, and Communists.
Unsurprisingly, this framing remains prevalent to this day, with the
term "Reconquista" still used in approving ways by the far right across
the West. Also unsurprisingly, in part as a reaction to the right's ap-
propriation of Reconquista, Convivencia was transformed by the left
into a liberal value in the late twentieth century—its supposed multi-
culturalism, that Christians, Jews, and Muslims lived next to one an-
other, seen as a historical precedent for the uniqueness and strength
of a modern, republican Spain.

The problem with these framings is that they are indeed blunt
categories, more often than not serving a modern agenda that cares
little for the actual past. Both terms rely on a particular understanding
of politics and religion, a conceptualization that ultimately distances
the one from the other. In this way of thinking, religion was some-

thing internal, all else, all actions, were politics. That made sense to white Europeans who lived after the religious changes of the nineteenth century, when their own view of religion was projected outward, at first geographically onto the colonies then chronologically into the past. They looked for things that felt familiar—whatever scanned like "faith" mattered more in categorization than "practice." Religion was portrayed as internal and supposedly timeless, independent of any external historical change.

But as we've seen throughout the Bright Ages, this isn't how those categories worked in the medieval world. Things were quite different in Hispania, in al-Andalus, in the kingdoms of Navarre, Léon, Castille, Aragon, and later Portugal, across nearly a millennium. When Visigothic soldiers helped the North African army defeat King Rodrigo in 711, or when El Cid moved easily back and forth in the eleventh and twelfth centuries to fight for and against Christians and Muslims, or when thirteenth- and fourteenth-century Muslim *jenets* from Granada joined the kings of Aragon in their Reconquista, or when Catalan Christian mercenaries traveled to North Africa to serve as the bodyguard for Hafsid sultans, these all complicate our complacent—and all-too-modern—categories of religion, politics, and culture. These are neither eruptions through a static state of amiable coexistence, nor are they deeply indicative of an unending hostility between different communities.

So, to untangle the multiple, overlapping categories of analysis and get to the lived experience of those on the peninsula, let's return to Toledo, the site of Peter the Venerable's visit around 1140—a city that once served as the capital of a united Visigothic kingdom, but that fell to the people from North Africa in 711, and then to King Alfonso VI of Léon and Castile in 1085.

After the fall of the Visigothic royal line, Toledo was at first simply part of the wider Umayyad Caliphate ruling from Damascus.

But when the Umayyads were massacred and overthrown by the Abbasids, and the capital of the caliphate moved to Baghdad in the middle of the eighth century, al-Andalus resisted and separated itself. When centralized power in al-Andalus began to break down during the eleventh century, Toledo became a fully independent *taifa* (Arabic for "sect" or "band," but essentially meaning "kingdom").

Across those three centuries, amid the internal political struggles of al-Andalus, Toledo began to look north, which means that by the time Alfonso VI conquered it in 1085, or Peter the Venerable arrived there in the next century, the connections were generations old. Despite, or perhaps in response to, a significant pattern of persecution by the Christian Visigoths, the Jewish community of Toledo blossomed to a population of several thousand by the tenth century. This in some ways mirrored the growth of Jewish communities across al-Andalus, though no singular figures in Toledo rose to the prominence they would have in Córdoba or Granada in the tenth and eleventh centuries. In Córdoba, poets and artists flourished and individuals such as Hasdai ibn Shaprut (early tenth century) were councilors to the caliph and appointed to prominent bureaucratic positions. In Granada, Samuel ibn Nagrela (early eleventh century) and his son Joseph were viziers to the ruler, not only acting as advisors but commanding Granadan armies in the field. Nonetheless, especially during the eleventh century under the rule of al-Mamum, Toledo leveraged its place in the middle, becoming a haven for culture and political exiles.

But this had almost always been so. A substantial Christian population had remained in Toledo since its conquest in the eighth century, significant enough and still connected to the intellectual world north of the Pyrenees that it attracted serious attention during Charlemagne's reign when the city's Archbishop Elipandus espoused a theory of Jesus's nature (called "adoptionism") that was the focus

of several Carolingian councils around 800. Indeed, Toledo during this period continued to look north, though not always as far north as Aachen, and the city's rulers maintained a (sometimes uneasy) relationship with the Christian rulers of Léon, Castile, and Navarre, appealing on several occasions for military aid against other *taifas*.

This is the context in which Toledo came to Alfonso VI in 1085. Upon his father's death in 1065, Alfonso as the second son inherited the kingdom of Léon, while his brothers divided between them the separate kingdoms of Galicia and Castile. Perhaps predictably, civil war shortly ensued. Alfonso helped his brother Sancho II of Castile take Galicia from their younger brother but then the two eldest soon found themselves at odds. Alfonso lost and fled in early 1072 to the safety of Islamic Toledo, where he remained for several months, returning to Léon only after Sancho's death later that same year, at which time Alfonso in short order seized and united all three kingdoms once more.

Opportunistically, he struck out against the neighboring Christian kingdom of Navarre, but Alfonso's main focus was to the south. In Toledo, his protector during his exile, al-Mamum, had died in 1074 and a struggle for the city was under way. Alfonso took full advantage, picking away at the borders during the turmoil, supporting al-Mamum's grandson, named al-Qadir, and extracting concessions in exchange for that support. By 1085, al-Qadir had had enough, unable to pacify the local elites and still facing external pressures. He wanted out and handed Toledo and its surrounding territory to Alfonso in exchange for the king's support in establishing al-Qadir to the southeast, in Valencia. The Islamic elites in control of the city opened the gates and welcomed Alfonso in.

In the immediate aftermath of the Christians' arrival, not much changed. Synagogues and mosques would not, Alfonso promised, be converted into churches, and each community—Muslims, Jews, and

Latin-rite Christians—was granted the right to be governed by its own legal codes. But this didn't last. Although the Jewish community remained fairly stable for a time, the native Mozarabic Christians, culturally Arabized citizens of the city who still celebrated with a liturgy derived from the Visigoths in the early eighth century, were simply excluded from this arrangement. And although some stayed and a few converted, most of the wealthy Muslim inhabitants fled the city for the south, and by 1087 the city's mosque had been seized and became its new cathedral.

This slice of time, just a few years, shows the problem of modern categories such as Convivencia projected back onto the medieval past. A Christian ruler conquers a city, but that city was actually given to him by its Muslim inhabitants. A city of three religions is living together, but with tension when that ruler converts the mosque to a cathedral and all three of those communities lose protections they were promised.

Scholars have often blamed the hardening of attitudes against non-Christians in Toledo, as we move forward in time from 1085, on Queen Constance, Alfonso VI's wife, and her confessor, Bernard. Bernard most recently had been the abbot of the monastery of Sahagún in León, notably a location where Alfonso had spent some of his exile, on the run from his brother after the death of their father, and incidentally where he'd eventually be buried. But the more important link was that Bernard was originally a monk at the Abbey of Cluny and had likely crossed the Pyrenees around 1080 with Constance when she was Alfonso's bride-to-be. She was a daughter of the duke of Burgundy, niece of the abbot of Cluny, and directly descended from the Capetian kings of France. Given these connections, it shouldn't entirely shock us that Bernard was appointed bishop of Toledo just after Alfonso took control in 1085. Bishops were political positions as much as spiritual.

Laying the blame at the feet of these two wades into the either/or framing of Convivencia and Reconquista, blaming outsiders for fomenting interreligious conflict. That's perhaps fair to a degree but the suggestion that "outside agitators" are to blame for eruptions in civic life are almost always politically motivated. In this case, both Constance and Bernard had been deeply embedded in Léon for several years. What's more important to remember here, often forgotten in discussion of these events, is the fact that when Bernard was raised to the bishopric in 1085 he displaced someone already in that seat!

Toledo had maintained a substantial Christian population continuously through the caliphate and *taifa* periods, a population complete with ecclesiastical hierarchy and practicing the same liturgy in the same cathedral they'd been using under the Visigothic rulers. The native Mozarabic Christians were not particularly pleased by Alfonso's takeover, since to them the Léonese who arrived in the city in 1085 were the interlopers, bringing with them different cultural practices, a different language (Latin) and practice of worship (a liturgy linked to Rome).

The appointment of Bernard as bishop in 1085 must therefore be understood alongside the conversion of the mosque into a cathedral in 1087, both aimed as much, if not more, at the native Christians as the Muslims of the city—not only removing the leader of the indigenous Christian community but relocating their sacred space as well. The moves, taken together, cemented Alfonso's control over his new capital by allowing the king to install his own people in positions critical to the governance of the city itself, literally replacing power. At the same time, the moves created a chain of associations, linking Toledo intellectually and materially northward via Bernard and the new cathedral, past the Pyrenees to Cluny, and through them, south over the Alps to Rome and the papacy. This is, then,

a messy relationship of communities living together, but one spelled out within a clear hierarchy.

This is the Toledo that, at least for the next century, became a meeting point between languages, religions, communities—but a meeting point in which it was terribly clear from whence power flowed, and from whence it would never flow.

CONVIVENCIA, MUCH LIKE THE IDEA OF the Bright Ages, should be understood as complicated and human. They both involve people making choices, sometimes to understand and work with one another, other times to hate and harm. Where we see collaborative blossoms we also find the roots of ideological hatred, and we can't ignore the fragrant blooms nor the horrors that followed. By the late twelfth century, formal translation studios had sprung up in and around the new cathedral of Toledo, mirroring the power relationships of the new cathedral itself—together in partnership, but with a clearly defined hierarchy. Michael the Scot, one of the most famous translators active during the 1220s, partnered with a Jewish scholar named Abuteus Levitaso and likely employed Mozarabs, Muslims, and Jews as well. Their skills were in such demand that Michael was swept up to Palermo and the court of Emperor Frederick II because he was thought to have been a sorcerer and astrologer—using dark arts to move between languages. He's perhaps most famous for translating into Latin the works of Ibn Rushd, known also as Averroes.

Ibn Rushd, born in Córdoba in 1126, stood in a line of exceptional thinkers. His primary work was a response to an early twelfth-century work by al-Ghazali (Latin: "Algazel"), who was in turn responding to an early eleventh-century treatise by Ibn Sina (Latin: "Avicenna"). Ibn Rushd sought to reconcile the monotheistic god of Islam with that of Greek philosophy, thereby defending and expanding upon Ibn Sina.

As a part of that program, Ibn Rushd penned commentaries on the works of Aristotle.

These would have a momentous effect north of the Alps in the following century. Even within a generation of Ibn Rushd's death, beginning just outside, or certainly within sight of, the still-under-construction cathedral of Notre-Dame, students at the University of Paris were so enamored of his work that, at the beginning of the thirteenth century, the Church administration was worried the school had been taken over by "Averroists." Indeed, Thomas Aquinas could not have completed his late thirteenth-century *Summa Theologiae* (*Summary of All Theology*) without the "new" Aristotle, without Ibn Rushd and his contemporary the Jewish-Islamic thinker Maimonides. All of these men were part of a grand international cross-cultural multi-generational, multilingual, and multireligious network of intellectuals fixated on Aristotle and one another's commentaries on the ancient philosopher.

But the papacy and bishop of Paris weren't happy with all this Aristotle and Averroes, with what they saw as the infiltration of pagan learning into Christian discourse. They certainly didn't like the university asserting its independence, its ability to set its own curriculum. So the papacy acted.

From his *cathedra* ("seat" upon which the bishop sat, the basis for our word "cathedral"), Bishop Stephen Tempier of Paris carried out the papacy's demands, investigating what was being taught at the university in 1277. He found 219 propositions as unorthodox, hence no longer to be taught. The works of Aristotle, Ibn Rushd, and even some by Thomas Aquinas himself were banned—a ban on the saint's work only partially lifted about fifty years later, when Aquinas was canonized in 1323. Some were threatened by this intellectual "living together," about the perceived softening of boundaries between

religious traditions, and so worked to reharden them by crushing collaboration under their thumb. The motivations behind the exchange and movement of ideas matter, and often enough medieval people learned about the other only to refute them. Yet ideas and peoples did move.

DIVINE LIGHT
REFLECTING OFF
THE NILE

A round the year 1170, a Jewish jewelry merchant named David left Egypt to go trading in Sudan. The voyage was long and difficult, first south up the Nile and then by caravan over the desert, but despite all the hazards, the expected profits from purchasing goods in the Red Sea port of 'Aydhab were great. David's elder brother Moses, back in Cairo, had given him clear instructions to go no farther, but upon reaching the port, David found that new shipments from India had not come in recently. So David wrote a letter back to his brother, explained the situation, and told his brother that he would take ship to India. He asked Moses to calm his wife, "the little one," and his sister, and be reassured that after the dangers of desert travel, a sea voyage would be safer.

David and his family were originally from Córdoba, then lived in Fez in Morocco, and had only relatively recently settled in Egypt. But as this family of Iberian Jews set out to trade in southern Asia, David had reason to think the voyage was a good idea. Merchants

had throughout the Bright Ages traversed the wine-dark seas, moving easily between different polities and religious communities. Not too long before David's journey, another Jewish merchant named Benjamin left the Christian-ruled Iberian town of Tudela and recorded his journey across the whole Mediterranean. He moved first to the coast at Barcelona, then traveled through southern France and all of Italy, visited Constantinople, Jerusalem, Damascus, and Baghdad, then circled the Arabian Peninsula before arriving in Alexandria and Cairo, then making his return journey to Iberia via Sicily. Everywhere he went, he found Jewish people, willing to aid him on his journey, living alongside Christian and Muslim communities. People traveled and often safely returned home to tell their tale.

But not everyone was so lucky. David drowned on his way to India, never reaching his destination. Moses would later call it the greatest misfortune that had ever befallen him, writing that David's death left him bedridden and sick for a year. It also hurt Moses financially, pushing him to commit more fully to the practice of medicine. He was a good doctor, though, and eventually the chief vizier (head administrator) hired him as the doctor to the court of the Islamic sultan of Egypt, Saladin.

The tension of coexistence in a multireligious world was not confined to Iberia but lapped upon shores touched by the Arabian and Mediterranean seas, as well as the Indian Ocean. During the Bright Ages, objects (such as David's jewels) and ideas (Aristotle and Ibn Sina's philosophy) moved constantly toward horizons east and west. A Persian could explain Aristotle to the world. An Englishman could study math in Iberia and help a French monk read the Quran. A Jew from Córdoba could end up serving the sultan in Cairo. And his books could travel the world.

Yet, as we have seen, these interactions were by no means always peaceful, but often accompanied by violence and persecution.

A Persian's books could be burned in Paris. A French monk's reading of the Quran could inspire bigoted polemic and murder on crusade. A Jew from Córdoba could be driven from his home by Muslims seeking a return to their understanding of the pure fundamentals of their religion. Sometimes movement is anything but voluntary. In collaboration and violence, these are the tensions—and uncertainty—of permeability in the Bright Ages.

IT'S MOSES, NOT HIS LOST BROTHER David, who has come down to us as one of the important figures of the Middle Ages, or indeed of any age. This Moses, better known to us today by his family name, Maimonides, was the author most famously of the *Guide for the Perplexed*, a philosophical treatise in which he applied Aristotelian logic to explain the nature of God, the structure of the universe, the function of prophecy and time, and how—given all this and the scriptural commandments—to be a correct and moral person. But he was also deeply engaged in the complexities of the world as a merchant and physician. He sought to harmonize religious and secular knowledge, to deploy logic as a tool to make sense of a confusing world—one in which his brother might set off across the ocean and never return. He found answers in the philosophy of the ancient Greeks, as well as in the works of more contemporary thinkers who, like him, tried to apply the teachings of Aristotle to their current conditions. The work of these thinkers and the lives they lived embody an age that connected past and present, East and West, and Islam, Judaism, and Christianity.

Moses was born in southern Iberia, specifically in Córdoba in 1138, the son of a Jewish judge and a resident of the briefly ascendant Almoravid Empire. The Almoravids ruled from Marrakesh in what's now Morocco, and extended their influence from sub-Saharan West Africa up to the Strait of Gibraltar, and then across into Europe, profiting from long-established trans-Saharan trading routes to create a

massive state. In the stories we're telling, we may not get to spend much time south of the Sahara, but that region had its own bright ages of gold, nation-building, intellectual life, and conflict. And given that Europe had almost no gold of its own, every ruler who minted a golden coin and every worshipper who gazed on a golden chalice garnered, in some way, the fruits of African and Asian trade.

Not long after Maimonides's birth, the Almoravid Empire began to collapse. Sustained pressure from the Christian kings of Léon to the north, alongside a crusade that captured Lisbon and established the Christian kingdom of Portugal, and a new Islamic religious movement among the peoples of southern Morocco all combined to refigure the political landscape of southern Iberia.

The Almohad Empire's origins lie in the words and deeds of a North African Islamic preacher named Abu Abd Allah Muhammad Ibn Tumart. He was a prophetic figure who, around 1120, established his independent rule in the mountains of Morocco, offering a semi-messianic vision of Islam as a rallying point for supporters, who quickly spread outward after his death around the year 1130, attacking their Islamic coreligionists the Almoravids first. The Almohads conquered Morocco, then moved rapidly across North Africa and over the Strait of Gibraltar into al-Andalus. In 1148, they conquered Maimonides's city of Córdoba. By around 1170, the Almoravids had effectively been replaced by the Almohads.

That political upheaval came through religious innovation is not particularly unusual but it does speak to the diversity of medieval Islam and its manifestations in multiple forms among medieval peoples. As we have seen repeatedly, the practitioners of medieval religions existed in fluid, living traditions in which new ideas and modes of practice constantly emerged. Sometimes new ideas were adopted by local religious authorities as orthodox. At other times orthodoxies tried to smash or exile groups they deemed deviant or heretical,

or groups organized around a religious innovation that would over-throw the status quo and become the new orthodoxy. In still other instances, diverse religious traditions found short- or long-term mod-els of coexistence within a single polity. The Iberia and North Africa through which Maimonides moved embodied all of these possibili-ties at one time or another.

The North African preacher Ibn Tumart and his followers spe-cifically rejected an anthropomorphic (humanlike) vision, insisting instead on the ultimate unknowability of God. In addition, as a re-former, he was ascribed messianic attributes by his followers. Most Muslims follow some idea of time as fundamentally linear, with an end point (much like most practitioners of the other Abrahamic reli-gious traditions). In addition, although the idea of some sort of mes-sianic figure was new to Islam in the late seventh century, it became much more common later. Shi'a Islam, for example, predicts the re-turn of a final imam, a leader who will bring justice to the world, but Ibn Tumart engaged with a different messianic tradition when he re-vealed himself (according to his biographers, who of course were tell-ing an official story of the dynasty founder) as the *mahdi*, or divinely ordained lawgiver and spiritual leader who appears before the final days and converts the whole world to Islam. Critically, the followers of Ibn Tumart reasoned that if the *mahdi* had arrived, there was no need to sustain the *dhimmi* system that had protected the positions of non-Muslims within Islamic society. Therefore, although practice be-came something a bit different, the official policy of the conquering Almohads was that Jews and Christians had to convert or die.

Both medieval northwest Africa and southern al-Andalus, prior to the Almohads, were polyglot multiconfessional societies benefiting from both intercommunity and transregional economic and cultural exchange. As we've seen, though, interreligious coexistence can cre-ate the conditions for conflict across religious boundaries, even as

at the same time conquest does not necessarily result in wiping out difference.

We don't really know how many Jews were actually forced to convert. There's some evidence that life went on more or less as before, with Jewish merchants (who left us letters, bills of sale, and other both personal and commercial documents to verify this) crossing borders and not worrying that colleagues would be forced to convert, be killed, or be exiled. Indeed, it may in fact have been worse at this time for Muslims in Iberia than for Christians or Jews. Those who didn't comply with Almohad beliefs during the period of expansion, branded heretics because they were outside a new Islamic orthodoxy, seemed to have been considered a greater threat than "non-believers" to Ibn Tumart and his successors. Moreover, it seems that after the initial conquest, the new rulers settled into a traditional set of Sunni beliefs and practices as regards the continuation of *dhimmi* status for Jews and Christians.

In the end, although scholars disagree about the extent to which the Almohads actually forced conversion on Jewish residents across the realm, they seem to agree it must have been a plausible scenario or perhaps happened at least reasonably often, because many Jews abandoned their homes and fled into exile. Indeed, there's evidence that some were killed. A great Iberian Jewish scholar, Abraham Ibn Ezra, wrote a lament about the takeover by the Almohads, naming city after city and mourning the loss of life, faith, and beauty in each. He wrote, "I shave my head and bitterly keen for Seville's martyrs and sons who were taken, as daughters were forced into strangeness of faith. Córdoba's ruined, like the desolate sea, its nobles and sages have perished in hunger." Poetry, of course, cannot be absorbed as straight evidence of what happened, but does speak to the crafting of memory of the conquest. Ibn Ezra ended up leaving Iberia after the conquest, spending time in both France and Italy, perhaps traveling

as far as Baghdad, and leaving his legacy not only in the works of biblical criticism, science, and grammar, but by choosing to continue to write in Hebrew rather than in the Judeo-Arabic (Maimonides's language) of al-Andalus and North Africa.

Maimonides's family fled too, first traveling south across the Strait of Gibraltar to the Maghreb and eventually to Fez, where they took up residence. It seems likely that he converted to Islam under pressure for a time after the family's flight to North Africa, though whether he did so is hotly contested both by scholars and modern religious practitioners, in part because the actual evidence is unclear, but also because various contemporary groups want to claim his legacy for themselves.

We have to concede that we'll never know the specifics of his experience. If he didn't convert, at the very least he must have encountered many Jews who chose to do so when faced with Almohad demands. It is perhaps telling that he did think and write about forced conversion. Toward the end of his life, Maimonides wrote to the Jews in Yemen, who also experienced similar chaos when rival Muslim factions battled there. In the 1170s, a Shi'a rebellion against Saladin led to persecution of the Jews (as well as the Sunni Muslims there— these upheavals almost always strike hardest the coreligious groups that deviate in doctrinal identity). Some Yemeni Jews converted, but a certain faction of rabbis argued that it was better to choose martyrdom than to falsely profess Islam. Maimonides disagreed, writing that it was better to pretend to convert than to die or to truly abandon Judaism. A false conversion would not, he argued, bar you from returning to the fold once the crisis had passed or you had escaped to less hostile territory. So we have to wonder if, in writing about the Yemeni Jews, he was also writing about Iberians from his past, including himself.

Maimonides eventually left Morocco and made his way in the

late 1160s to Egypt, which at that time was a bit of a mess, with the Fatimid viziers (rulers) paying tribute in gold to the Christian king of Jerusalem, after that king had captured both Cairo and Alexandria. Only in 1169 did things start to settle, when the Islamic general Saladin took power and transformed the world. Saladin is a well-known figure, most famous perhaps for virtually destroying the Christian Crusader states and retaking Jerusalem for Islam in 1187. A Kurd from around Mosul, Saladin was indeed an extraordinarily talented ruler and general who rose through the ranks of armies associated with rulers out of the city of Aleppo, and then Damascus. Saladin was sent to help calm (well, pacify) Egypt and emerged from the chaos first as vizier, then as sultan in about 1171, managing to unify almost the entire Islamic world of North Africa and the Middle East under his banner.

Although Saladin's rule is often associated with a resurgence in the idea of the lesser *jihad*, waging holy war against the Christian rulers of both Byzantium and Jerusalem, the one thing we've seen about relationships between Christians and Muslims in this period is that they're complicated. Saladin enjoyed fruitful and even friendly relations with both Christian powers at times, even—quite commonly for the period—allying armies with them against other Islamic groups that constantly threatened Saladin's authority. And large Jewish populations, particularly in Egypt, seemed to have thrived.

Maimonides found stability in Saladin's Egypt. He studied Torah, became active in regional and local Jewish politics, and collaborated with his family in trade. He helped ransom Jewish captives taken during a conflict between the Islamic Egyptians and the Christian king of Jerusalem. In fact, because he served as *ra'is al-yahud*, or leader of the Egyptian Jewish community, from 1171 to 1173, before being replaced by a bitter enemy (though Maimonides would reclaim the position in 1195), we have a number of texts that he actually wrote

or at least signed that survive to this day, including a receipt for those ransom funds.

Along with his political role, Maimonides practiced medicine. He had trained in medicine at Fez, a field of expertise in which he was well served by Jewish scientific traditions, but also those from Greek, Persian, Syriac, and Roman antiquity—all of course filtered, in this context, through Arabic texts. There were, at the time, no formal medical schools; the study of medicine was a trade, passed down often within families. In that sense, it was rather artisanal. But in another sense, this type of specialized knowledge was also highly philosophical. Maimonides, best known for his theological-philosophical tracts, was in this way following in the footsteps of both Ibn Sina and Ibn Rushd, both also Aristotelians, theologians, and physicians. But that doesn't mean it was easy to do all these things at once. He wrote a letter to a friend, Judah Ibn Tibbon, a Jew from Granada who moved to southern France after the Almohad conquest and is famous for his translations from Arabic to Hebrew, urging him not to visit. "My duties to the sultan are very heavy. I am obliged to visit him every day . . . [and] I must stay during the greater part of the day in the palace. It also frequently happens that one or two royal officers fall sick, and I must attend to their healing. I do not return [home] until the afternoon. Then I am almost dying with hunger . . . I find the antechambers filled with people, both Jews and gentiles, nobles and common people, judges and bailiffs, friends and foes—a mixed multitude who await the time of my return." Mixing medicine with philosophy and politics was hard work.

When talking about the transmission of ideas, we tend to think in straight lines—this person to that person to that person, and so on—meaning we tend to think that philosophers and prophets don't overlap with one another and certainly that religious traditions don't engage seriously with other traditions' ideas. We know that's not

true in the Bright Ages. Maimonides and other Jewish, Islamic, and Christian interpreters of Aristotle pursued their religion via recourse to logic, their ideas entangling, conflicting, but always interacting. There have likewise always been mystical and prophetic traditions in all three monotheisms that overlapped, complemented, and disputed the academic ones. Sometimes, even often, the same person might embody both of these strands to one degree or another. Do we know, for example, that Maimonides's own introspective journey into the nature of a non-anthropomorphic God was influenced by the concerns of Ibn Tumart and his followers? That we can't say, but the similarity of concerns is striking.

So there's no simple linear thread to track, point by point, the engagement with Aristotle (and to some extent Plato) from early Islamic thinkers like Ibn Sina (Avicenna) in Asia, to Ibn Rushd (Averroes) in Almohad Córdoba, to Maimonides, and finally to Christian theologians north of the Pyrenees. We can only rarely pinpoint exactly how one writer picked up ideas from another, and that reminds us that this movement wasn't inevitable, a necessary "evolution" of ideas toward Europe. Instead, it's worth imagining complex multivectored networks of intellectual transmission that overlapped with other forms of exchange. For example, Abu Nasr al-Farabi—perhaps a Persian Shi'a Muslim, although this is debated by scholars—lived in Baghdad and then Damascus in the mid-tenth century. He wrote about music, physics, and math, but also wrote extensive commentaries on Aristotle in Arabic (the initial translation work from Greek had already been done). Al-Farabi was trying to figure out how best to structure society in order for individuals to achieve happiness; he developed a philosophy of religion to support that analysis. His work, in turn, was picked up by his near-contemporary Ibn Sina, who combined the study of medicine, natural science, and philosophy to write hundreds

of tracts, deploying Aristotelian logical proofs to demonstrate the necessary existence of God, and then to reconcile observable natural or scientific phenomena with his devout commitment to Islam. From there, at home in early medieval Islamic Asia, his influence spread as widely as books could be carried and, when necessary, translated.

For many medieval thinkers, Ibn Sina's commentaries on Aristotle were more important than the Greek philosopher's works themselves. In Almohad Iberia, for example, Ibn Rushd served as chief judge of Córdoba and court physician to the caliph (he and Maimonides overlap in more ways than one, roughly contemporaries from different religious traditions practicing medicine and using similar philosophical tools to ask similar questions). While he and Ibn Sina often disagreed when it came to the intricacies of Aristotelian metaphysics, and these differences are not unimportant in the history of ideas, notice that within a century of Ibn Sina's death, his works had traveled from Iraq to Iberia. This reveals an ongoing network of information flow, including a lively economy in selling books, for which debating Aristotle was just a small component.

Maimonides was part of that network, writing many varied treatises on both medicine and philosophy, but especially his most famous work, the *Guide for the Perplexed*. Written in the form of a letter to a student who was trying to choose between studying the sacred or studying philosophy, it's really an extended argument that the two modes of thought can be unified. Maimonides opens with an analysis of the nature of the divine itself, criticizing theological anthropomorphism (again, a critique he may well have drawn from the Almohads). God is not, he says, simply a humanlike being with powers, but is rather something so ineffable as to be indescribable except through negation. God so surpasses human understanding that human terms are inadequate to describe the divine—so far beyond "good," for

example, that to use the word does a disservice to what God is. There-fore you start with what God is not—not weak, not evil—and try to understand that which remains as the divine.

Hence a core of Maimonides's argument is against thinking of God as a superman, and instead urging knowledge as the best path-way to know and love God. Logic offered a way out. Logic offered a key to unlock the problem of evil, the challenge of prophecy, the complexities and even contradictions of biblical narratives and sacred law. Like Augustine and Ibn Sina, in fact like so many medieval intel-lectuals across so many traditions, the second Moses saw no tension between the learning and methods of antiquity and his monotheism.

With Aristotle firmly ensconced as a subject for debate—both among those arguing over subtle differences in metaphysical analysis and those in all the Abrahamic religions who deemed such musings heretical—in Baghdad, Syria, Egypt, across North Africa, and Iberia, is it any wonder that the north side of the Mediterranean was drawn into these topics as well? In the thirteenth century, scholars such as Thomas Aquinas would bring Aristotle (filtered through his Arabic, Jewish, and Islamic commentators, including of course Maimonides) into Latin Christian intellectual life. Indeed, even after the University of Paris banned the teaching of Aristotle and his commentators in 1229, just to the south, the new university at Toulouse boldly tried to recruit disaffected students by touting that in *their* university, "those who wish to scrutinize the bosom of nature to the inmost can hear here the books of Aristotle that were forbidden at Paris."

Medieval people, from Iraq to Iberia to Ireland, Cluny to Cairo to Constantinople, never lost their knowledge about the pre-medieval Greeks and Romans. And all were aware that they were drawing on the works of those that came before them, were moving across reli-gious boundaries, and were able to do so without threatening their own traditions. In some ways, adaptation of Aristotle to answer the

questions of monotheists about the nature of the divine reflects a wildly imaginative deployment of the methods of classical philosophy. And far from being opposed to science, it is the religious institutions of the medieval world that preserved, translated, adapted, and applied the surviving lessons of antiquity to the questions that mattered to them.

The story of Maimonides is about one of the greatest philosophers of all time, about the movement of peoples and ideas across borders, about the integration of logic and belief, and about how medieval thinkers understood themselves in relation to the past. It's not just that we can see the classical elements, but that they explicitly talked about this. Reportedly, in the early twelfth century the teacher Bernard of Chartres remarked that he and his students were no more than "dwarfs perched on the shoulders of giants"—that the moderns of his own time could see farther than their predecessors only because they were lifted up by the ancients. Although this was by no means the default assumption of the period, the sentiment does reveal how self-aware Bernard and his contemporaries were both of their debts and their merits. They stood tall because of others but they could indeed see farther, see more than their predecessors. Ideas moved throughout the whole of the Bright Ages. But moments of sparkling creativity were not solely the province of great men. By casting its light widely, the Bright Ages allow us to see other moments, other people, and realize how they, too, were participants in all that's been mentioned here and more.

A RADIANT WHITE HIND WITH THE ANTLERS OF A STAG

The hind walked quietly with its fawn. Its body was stunning, covered in gleaming white hair, with a towering rack of antlers that leaped from its head. The verdant green of the forest contrasted with the dazzling whiteness of the animal.

But, suddenly, red.

The arrow struck the hind's forehead, felling it, but not before the arrow rebounded toward the archer. Struck by his own shot in the thigh, he cried out in pain and fell from his horse, landing next to the mortally wounded deer.

The deer then spoke.

It called out a curse upon the archer, saying that he would never be cured of his wound until he found "a woman who will suffer for your love more pain and anguish than any other woman has ever known." The archer, Guigemar, was shocked—though not by the talking white female deer that nonetheless had male antlers and

couldn't be pierced by an arrow. No, he was shocked to hear that he might ever find a woman who would love him that much.

Resolving not to die before he found this woman, Guigemar set out, found a magic boat with a bed on it, and decided to rest there (as you do). While asleep, the boat set sail of its own accord and took him to a secluded tower with walls covered in murals depicting classical scenes and references to the classical poet Ovid. In this tower was a young wife who had been locked away by her cruel (much) older husband.

Discovering Guigemar, she took pity and nursed him back to health. They of course fell in love almost instantly and he finally "received relief" from the "wound in his thigh" when they confessed that love to each another and engaged in "the final act, which others are accustomed to enjoy." (This is a story about sex, if that was unclear up until now.)

Somehow, Guigemar stayed in the tower hidden away from the lady's husband for a year and a half. But when their adulterous relationship was finally discovered by the husband, Guigemar was forced back onto the magic boat and pushed off to sea. Before he embarked once again toward home, his lover tied a knot in his shirt's tailpiece, and he, in turn, fastened a belt around her loins. They encouraged each other to love whoever could undo the knot or unfasten the belt that ensured their chastity.

While separated they pined for each other, until one day the boat magically reappeared at the tower and the woman escaped, only to be captured as soon as she washed ashore—this time by another knight who asked for her love. She showed him the belt, but he couldn't undo it. Unsure of how to proceed, he decided it best to imprison her, and kept her locked up until one day the knight called a tournament to which Guigemar (conveniently) showed up. The woman recognized Guigemar immediately and undid his knotted shirt. Perhaps

a bit slow on the uptake, Guigemar himself wasn't convinced it was her until he saw her belt and undid it. Finally back together, they asked the knight to release her, but of course he refused. So Guigemar laid siege to the castle and killed everyone inside. The lovers rode off into the sunset.

THIS LATE TWELFTH-CENTURY STORY PORTRAYS A world full of color, with magic boats, valiant knights, nefarious enemies, and a damsel in distress—all launched into being by the brilliant whiteness of the intersex forest animal. It's a story both odd and familiar to us at the same time. Ultimately though, this is a story about *eros*—romantic love, related to passion, related to sex. Indeed, medieval people had sex, liked it, thought about it a lot, wrote about it perhaps even more, and still considered themselves Christian. But still the eros that pulled the couple together, the classical Roman poet Ovid, who goaded them via the paint on the lovers' walls, confronted a society trying to keep them apart. In the story, we experience the serendipity of meeting, a loveless marriage consumed with jealousy and a perilous age difference, other jealous suitors, and the dangers of war.

On the surface, it seems that the knight saves the damsel. The story, after all, is named for him. But appearances can be deceiving. Perhaps this isn't a story about "him" or even about "them," but about "her." Rather than simple escapism, the poet is showing what power women in the period actually had. Guigemar, and the reader, are horrified that a man would treat his wife in this way—it's seen as unusual and abusive. If you look closer you'll see that the woman, first locked in a tower then in a castle, retains her agency, her ability to act and influence events. She heals Guigemar. She chooses to love him. She escapes her husband. She resists the advances of her second captor. She recognizes her lover and ultimately gets to spend her life with him. Yet, even with all this, she doesn't even get a name.

THE STORY OF GUIGEMAR HAS ALL the elements we associate with what was once known as the "Twelfth-Century Renaissance." There's no doubting that the twelfth century is a significant one in the history of Europe. This was a period of urbanization, of rapid economic and population growth, of centralizing monarchs, of increased artistic and literary production. This is the age of romances and epics, of what would become universities, of fairs that would become regular markets that would become thriving cities. But the characterization of the period as reemergence is misplaced.

That phrase, "Twelfth-Century Renaissance," is most often connected to Charles Homer Haskins's book of the same name from 1927, which continues to haunt the study of the medieval world. We still see in the past a movement of time that has peaks and valleys, a ghostly roller coaster of inevitability that moves as it supposedly does simply in order to lead us to a new rebirth, a new "renaissance." The Carolingian "renaissance" takes us out of the miasma of Rome's "fall," while the twelfth-century "renaissance" leads us out of the attacks of the Vikings. In fairness, Haskins, as well as many others in the late nineteenth and early twentieth centuries, was pushing back against the idea of the European Middle Ages as a period of stagnation and decline, lacking political stability and culture. In that old telling, civilization only recovered in Italy during the fourteenth and fifteenth centuries—the big "Renaissance."

In working against this even earlier preconception, Haskins argued that twelfth-century Europe witnessed its own rebirth—a flourishing literary scene, burgeoning schools, and centralizing states. This was indeed a time of crusade, of emperors and popes, of philosophy and learned treatises. The twelfth century saw the beginnings of scholastic philosophy and a resurgence of the study of Aristotle. It witnessed the mystical theology and violent religiosity of Bernard of Clairvaux. Kings such as Henry II (1154–89) and Richard the Lion-

heart (1189–99) of England expanded both their practical powers and their claims to authority, bolstered by myths of predecessors like Arthur.

But there are two problems here. First, Haskins (and by extension us, even here in the twenty-first century) was trapped in a particular political model. "Renaissances" have to do with stable, centralized polities—the ninth century had one because it had an empire, the twelfth because it had centralizing kingships that would become the modern nation-state, and the fourteenth because Italian cities flourished under wise governance. But there is more to the past than great white men doing great white things. The historian Joan Kelly famously asked, thinking about the fourteenth and fifteenth centuries, "Did women have a renaissance?" She ultimately said no, because it mattered what criteria you were using to judge that supposed "rebirth." If you actually paid attention to women, their lives notably worsened as we move toward 1500.

Indeed, Haskins's narrow understanding of what a "renaissance" is relates to the second problem. In arguing against a "dark age" in medieval Europe, he inadvertently created a new one. The spotlight he cast on these schools, and the men who attended them, left the rest of the period—not to mention the previous centuries, vernacular culture, women, and everyone else in the Mediterranean world (which is to say, non-Christians and non-white people)—in the shadows. And there's a lot that people do in the shadows. So, if we cast about, if we illuminate the period further, we see that next to Bernard of Clairvaux stood Hildegard of Bingen, and that the court of King Henry II was graced not only by his wife, Eleanor of Aquitaine, but also by the author of the Old French story *Guigemar*, Marie de France.

We don't know much about Marie as a person. She authored three other works in addition to her collection of *Lais* (essentially short stories, of which *Guigemar* is one), and, in a world in which "Anonymous"

was the period's most prolific author, identified herself as "Marie" in three of those four. It's abundantly clear that she was working as part of a courtly society, almost certainly in the orbit of Henry II, with her stories diagnosing the world in which she lived. Guigemar, for instance, for all its fantastic elements, shows a profound understanding of aristocratic culture, of the pressures of dynastic politics, of household structures in everyday life. The lay of *Lanval* similarly demonstrates Marie's familiarity with court life and the wider intellectual world of France and England during the twelfth century. More important, it can be read as a subtle political and social critique, perhaps more a poem written *to* the court than *at* the court, a diagnosis or warning more than a panegyric.

Set in the expanded universe of King Arthur, the knight Lanval is unfairly forgotten by the king and has no wife or lands of his own. One day, however, Lanval meets a magical lady (perhaps a fairy queen) from a foreign land. They fall in love instantly and consummate their relationship. She swears him to secrecy, saying she'll leave him forever if he reveals their relationship. Lanval agrees and returns to court, continuing to do noble deeds.

His new attitude earns him notice. Gawain and Yvain, famous knights of the Round Table, invite him into their circle. Even Queen Guinevere takes notice and, wowed by Lanval's exploits, tries to seduce him. But Lanval rebuffs the queen. Guinevere, accustomed to getting her way, mocks him by questioning his sexuality as the only reason he could possibly have to reject her advances. Lanval isn't amused and retorts that his girlfriend is much more beautiful than the queen. This cuts Guinevere to the quick and she vows revenge, convincing King Arthur that Lanval had tried to seduce her. The king, now in a rage, arrests Lanval. The trial, however, moves swiftly and Lanval is saved when his fairy queen arrives at court to rescue him,

just in the nick of time. All agree she's the most beautiful woman in the world and Lanval and his lady ride off into the sunset.

By the time Marie was writing—most likely in the 1170s, at (or near) Henry II's court—the Arthur myth would have been relatively well known across the Angevin world. One of the first mentions of someone we might today recognize as "King Arthur" dates to the ninth century by a monk in Wales named Nennius. The legend, however, only really found its legs in the twelfth century, with the explosion of new writing by Geoffrey of Monmouth, and the poets Wace and Chrétien de Troyes, almost all of which connected in some way to Henry and Eleanor. As such, Marie's use of Arthur would have resonated with her courtly audience.

Often, we tend to think that Henry II used these legends to his benefit, to claim a mythical ancestor as king of "Britain," to mimic his court after the one imagined to have been in Camelot. This makes a lot of sense, as Henry throughout his reign cast about in search of a glorious predecessor to help him legitimize his reign, using legend to lay claim not just to England but Wales as well. The period now known as "the Anarchy," immediately before he took power in 1154 had been racked by civil war, so Henry II certainly needed an aura to lend him legitimacy and enhance stability, and to find it he looked to the past. We've seen this before with Charlemagne, who looked to Roman emperors and Israelite kings. But by the middle of the twelfth century, those other models were "taken." French kings and German emperors now battled to make Charlemagne their own. England, Britain, needed its own legendary hero and so "found" one in Arthur.

But what sets *Lanval* apart is its critique of the king's court. The tale shows a kingdom in disarray. We have a noble knight unrecognized, a feckless king, and a conniving queen. Arthur is feeble here. He ignores (and then treats poorly) a loyal servant, bends to the

will of his queen, and cannot control the implementation of the law. Guinevere is lustful, disloyal, and petty. The knights of the Round Table, save Lanval, are capricious and concerned more with fame than good deeds. The heroes, such as they are in this story, are outsiders and aristocrats—the selfless fairy queen, the titular loyal knight, the barons at the trial who sympathize with Lanval. The story is an attempted intervention to the king, and perhaps a warning about his current queen.

This is why the date at which Marie may have composed *Lanval* matters. Henry II faced civil war in 1173–74, at just the same time Marie's *Lais* were composed. His sons, supported by his wife, Eleanor, rebelled. Eleanor was wary of her husband's growing empire and this concern matched their sons', who all wanted power in their own right. We see here echoes of the Carolingian civil war. And just like in the ninth century, this revolt by a ruler's sons was ultimately a failure. Henry's sons sued for peace and Eleanor was captured and imprisoned for the rest of Henry's life, freed only when her son Richard took the throne in 1189.

But Eleanor's reputation suffered more. A so-called Black Legend followed her even during her lifetime, accusing her of serial adulteries, often with blood relatives. There were even whispers at court that her family was descended from a demon. As she is perhaps being critiqued for the disorder at the king's court in *Lanval*, so Eleanor was consistently accused throughout her life, blamed for her role in the English civil war of the 1170s and 1180s.

Born in 1124 to Count William X of Aquitaine, she seems to have received an exceptional education and inherited her father's lands when he died in 1137. King Louis VI of France (1108–37) became her guardian and betrothed her to his own son, the future King Louis VII (1137–80). He wanted her lands but she was politically savvy and quickly established herself as his most trusted advisor. But

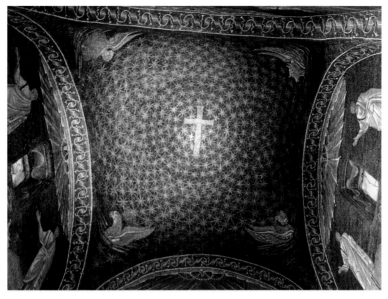

Ceiling of the so-called mausoleum of Galla Placidia, Ravenna, Italy. The canopy of stars is framed by symbols representing the Four Evangelists: Matthew, Mark, Luke, John. Early fifth century. (*Wikimedia Commons, user Incola*)

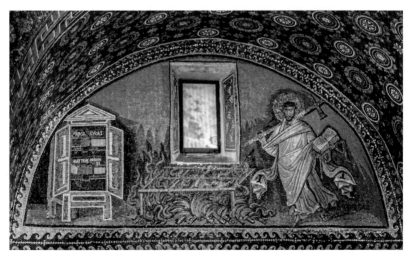

Mosaic from the so-called mausoleum of Galla Placidia, showing, most likely, St. Lawrence and the grate on which he was legendarily grilled to death. Note, too, the stars above and sea below. (*Alamy, Veronika Pfeiffer*)

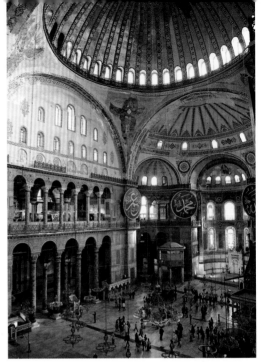

Interior of the Hagia Sophia, Istanbul. Built as a church in the Byzantine capital of Constantinople in the early sixth century, it was converted to a mosque in the fifteenth century, then made into a museum in the twentieth, before reverting to a mosque in 2018. (*Alamy, John Bedford Photography*)

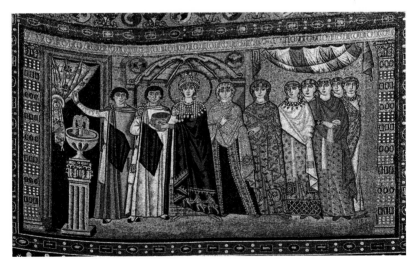

Mosaic of the Empress Theodora from the church of San Vitale, Ravenna. Construction of the church began before the Byzantines took the city from the Ostrogoths, and was completed with its mosaics afterward. Mid-sixth century.

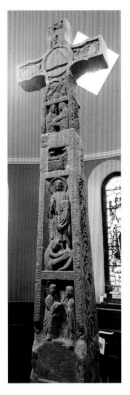

Ruthwell Cross, modern Scotland. Now in the small parish church, it likely originally stood outside in a field. Note the way the vine scrolls and animals on the side elide with the carved images of Jesus, Mary Magdalene, and others. Likely eighth century. *(Courtesy Dr. Heidi Stoner)*

Gold coin, front and back, minted for King Offa of Mercia. To the viewer's left, the Latin "Offa Rex" ("Offa the king") is clearly visible. But note too the pseudo-Arabic script, perhaps made by an artisan who didn't know the language but was trying to copy an early eighth-century dinar minted by the Abbasid Caliph al-Mansur. Late eighth century. *(Trustees of the British Museum)*

Drawing of an elephant in a French manuscript. The full manuscript contains scientific texts about plants and animals. Tenth century. *(Den Haag, Huis van het boek, MMW 10 D 7, f. 88r.)*

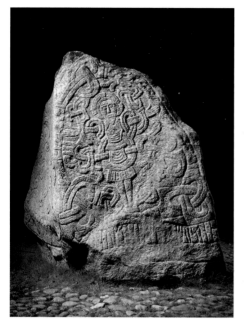

Carved standing stone showing crucifixion of Jesus from Jelling, modern Denmark. The inscribed runes relate that these were ordered made by King Harald Bluetooth to commemorate his conquest of Denmark and Norway, and conversion to Christianity. Some of the original paint is visible. Tenth century. *(National Museum, Denmark—Roberto Fortuna)*

Reconstruction of another carved standing stone from Jelling, modern Denmark. All the stones would have been brightly, vibrantly painted, perhaps like this one created by Erik Sandquist in 2003–4. *(National Museum, Denmark—Roberto Fortuna)*

Detail from the Bayeux Tapestry, Normandy, modern France. Created to commemorate William's conquest in 1066 CE, this detail shows the construction of a motte castle at Hastings—workers digging the earth and piling it in a mound, on which a fortification is built. Eleventh century. (*Courtesy City of Bayeux, Bayeux Museum*)

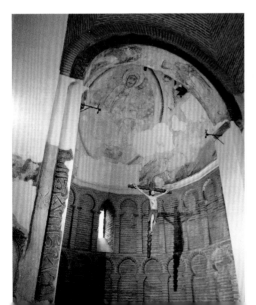

Apse of the Church of Cristo de la Luz, Toledo, modern Spain. Originally built as a mosque just before 1000 CE, it was converted into a church in 1085 after the city was given to King Alfonso VI. The apse was added in the late twelfth century though, retaining the Arabic inscriptions. Eleventh and twelfth centuries. (*Wikimedia Commons, user G41rn8*)

Manuscript image of Aristotle conversing with one of his commentators, Baghdad, modern Iraq. The full manuscript contains a bestiary discussing characteristics of and uses for a variety of animals. Thirteenth century. (*BL Or 2784 f. 96r, Courtesy Qatar Digital Library*)

Manuscript image of Pope Innocent III excommunicating heretics (Cathars) and then crusaders killing Cathars in southern France. The full manuscript is from Normandy and contains a revised edition of the *Grandes Chroniques de France*. Mid-fourteenth century. (*BL Royal MS 16 G VI, f. 374v, Courtesy Granger Historical Picture Archive*)

Hildegard of Bingen receiving divine inspiration, writing on a wax tablet, and speaking with her scribe, Volmar. Lost or destroyed during World War II, the original manuscript had this image at the beginning of its pages to communicate the authority of its author. Late twelfth century. (*Alamy*)

Stained glass windows behind altar of upper level, Sainte-Chapelle, Paris. The story of the Passion is directly behind the altar. Light through the windows on a sunny day is dazzling. Early thirteenth century. (*Jean-Christophe Benoist*)

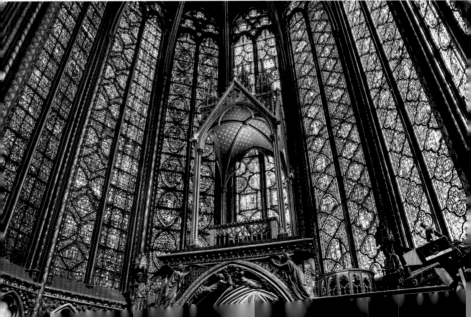

Mongol safe conduct pass, created during the Yuan dynasty, China. Likely dating from the reign of Kublai Khan, this token would be given to diplomats and travelers to ensure others knew they enjoyed the khan's protection. Late thirteenth century. (*Courtesy Metropolitan Museum of Art, NYC*)

Dante and Virgil on the shore, under a canopy of stars, before crossing to the gates of Purgatory. The manuscript contains the full text of *The Divine Comedy* and may have been in the possession for a time of King Alfonso V of Aragon, Naples, and Sicily. Mid-fifteenth century. (*BL Yates Thompson 36, f. 68, Courtesy Granger Historical Picture Archive*)

it didn't last. The height and nadir of their relationship came when she accompanied Louis on crusade in 1147. It was a disaster, and a spectacular one. The decision of the couple to go together was likely an astute political move, ensuring strong representation in the army from Eleanor's home region. Moreover, although churchmen generally didn't like women going on campaign, they did so frequently, thus the subsequent condemnation that somehow female participation doomed the military endeavor has the rank air of hypocrisy—more of that "Black Legend."

Indeed, the failures of that crusade—and it was almost all failures—should be laid at the feet of Louis and his advisors. Eleanor, taking the advice of her uncle who ruled the city of Antioch at the time, urged her husband to point his army in the direction of Aleppo. But Louis demurred and decided to attack Damascus instead, a city that had long held a truce with the Christians and had been antipathetic toward Aleppo. This contention between husband and wife, almost certainly enhanced by whispering courtiers (rumors she committed adultery with her uncle in Antioch) who saw a chance to increase their own standing at Eleanor's expense, led to the breakdown in their marriage. After the debacle of the crusade, they returned home to Paris and were divorced by 1152.

Eleanor remarried almost immediately, this time to Henry Plantagenet, duke of Normandy and soon to be king of England (as Henry II). Theirs seemed, at least initially, to have been a genuine partnership. Eleanor enjoyed substantial power and prestige throughout the first nearly two decades of their marriage, ruling as regent in Henry's absence in several instances, and bearing him several children—including the later King Richard I, King John (1199–1216), and two future queens of Castile and Sicily. She remained devoted to those children throughout her life, as noted siding with them against their father and her husband in several instances.

So, perhaps with *Lanval* we see a (partially distorted) reflection of 1173–74. We see a king who cannot focus and who has lost control of his subjects, whose loyalty is questionable. Guinevere the queen is the real villain, though. She schemes, is lustful and petty in seeking vengeance. At one point in the *Lais*, Marie says she writes to defend her reputation against whisperers who become consumed with jealousy and slander her. In *Lanval*, this may be projection, a snapshot of Eleanor's "Black Legend" in formation—a warning from Marie against a powerful woman with her own agenda who foments dissension among her husband's knights, his metaphorical children.

If this is indeed an admonition toward justice for the king, a concern about capriciousness directed to the queen, Marie was not the first woman to offer such advice. Sometime before the end of 1170, the nun Hildegard of Bingen (d. 1179) wrote to Henry II and urged him to beware tyranny, to administer justice equitably, and to avoid the whispers of sycophants. Hildegard separately counseled Eleanor to avoid turning this way and that, but rather to find constancy by returning to God. But unlike Marie's unsolicited advice, Henry and Eleanor had written directly to Hildegard to ask for help, recognizing her as one of the most powerful and influential thinkers in Europe at the time.

We know so very little about Hildegard's early life, save that in 1106 she was apparently immured (literally walled into a cell) with a local hermit named Jutta at Disibodenberg, southwest of Mainz, when Hildegard was just eight. By the time she formally became a nun in 1113, this hermitage had effectively become part of a double monastery like those we encountered in early medieval Britain. When Jutta died in 1136, Hildegard became leader of the female religious there.

In 1150, she moved her nuns to a new foundation and separated them from the monastery. There she remained until her death in

1179. Although she quarreled with the local archbishops and her community was excommunicated from 1178 to 1179, she generally maintained exceptional relationships with Emperor Frederick II Barbarossa, the papacy, and many of the most powerful men and women of Europe throughout her life. And during all that time, she wrote.

Having claimed she experienced visions from God since the age of five, these moments of supposed revelation became the basis for most of her works—particularly her longest and best-known, *Scivias*, written between 1141 and 1151. This work, particularly the claim of visions, attracted the attention of the papacy and a commission was sent to investigate. The men were satisfied with what they found, with the pope commanding her to make known any further visions she had. And she did. Her surviving correspondence is one of the greatest troves of extant medieval sources, with letters to and from kings, emperors, popes, and the greatest luminaries of twelfth-century Europe. In addition, she composed treatises on, among other things, music, science and medicine, hagiography, the monastic life, and, perhaps most important, theology—connected directly to reform and the direction of the church.

This last was dangerous territory for women. Professed women religious were certainly nothing new to Christianity in the twelfth century but the vast majority of holy women had achieved considerations of sanctity via their actions, not through their writing. The ability to interpret the divine plan was an activity generally reserved for men. And biblical commentary in the period was tremendously popular, with learned Christians (again, mostly men) turning to the sacred page to better understand not only the sacred past but the sacred present and future as well. Hildegard's ability to insert herself into that conversation via her visions was extraordinary, dodging patriarchal restrictions on female authority by *first* receiving authorization directly from the divine, then from the church hierarchy—by

the papacy in 1147–48 and then even, albeit faintly, by the famous abbot Bernard of Clairvaux. It was perhaps no wonder that emperors, kings, and popes sought her counsel.

Her letter to Henry II, for example, is more than a simple admonition of spiritual comfort. It is an exhortation on how to govern his kingdom. She was telling him how best to be a king. And Henry was not alone, as she sent similar messages to the emperors Conrad III (1138–52) and Frederick II Barbarossa (1152–89). This type of advice is an old genre, dating back to the time of Charlemagne at least, but Hildegard is flipping things on their head, inserting herself as a woman into the conversation with her measured words. Hildegard throughout her writings portrays herself as humble and relatively uneducated. She says in her letter to Bernard, "I have an inward understanding of the Psalter, the Gospels, and other volumes. Nevertheless, I do not receive this knowledge in German. Indeed, I have no formal training at all, for I know how to read [Latin] only on the most elementary level, certainly with no deep analysis . . . I am untaught and untrained in exterior material, but am only taught inwardly, in my spirit." And yet her letters and visions brim with allusions to ancient Greek and Latin authors, as well as biblical citations that engage directly with a long tradition of monastic biblical commentary going back to the Church Fathers.

As such, we have to conclude that her humility was a pose, albeit not a cynical one. Men in this period used it all the time as well. Hildegard was a woman in a patriarchal society and we cannot erase that patriarchy even as we recognize her agency. What this means is that given the context in which she lived, whereas someone like Roger of Ketton or Thomas Aquinas could derive *auctoritas* ("authority") from their training, Hildegard's couldn't come from her education, her training in how to read the Bible within Christian tradition. That abjection she performed for Bernard had to be repeated. Authority was

akin to two-factor verification; it had to come from her connection as a "prophet" to the Holy Spirit through her visions, and even then had to subsequently receive papal approval to continue.

But a woman's authority always rested on a knife's edge. Even at the height of her fame and authority, Hildegard was suspect. The prophetess who enjoyed the blessings of kings, emperors, and popes was still excommunicated by the archbishop of Mainz in 1178. She had allowed an excommunicated man to be buried on hallowed ground in her community, saying he'd been reconciled to the Church before his death. The archbishop disagreed and the excommunication was decreed. Hildegard first invoked her prophetic authority, that she knew she was in the right, but that failed. This was a dispute about authority and hierarchy, and one she was always going to lose. The excommunication was lifted only when she humbly submitted to the archbishop's authority. Hildegard may have possessed power and prestige, but in the twelfth century, even a prophetess had to know her place.

Hildegard then stands as a fitting place to end the chapter. She, like Eleanor, traveled at the highest levels of power, was an agent of her own destiny in her own right, and still was violently reminded that there were limits. It's fitting, too, that we see both Eleanor and Hildegard brought low in the 1170s, because Europe's history began to turn at just about that time, a moment when threats that had once seemed solely external now seemed to have infiltrated Christendom. Authority needed to be more tightly controlled, and those who could dole out that authority more tightly regulated. The threat to order and stability became more existential. Not prophetesses, but false prophets now walked the land. And the only way to cleanse the community, to keep Christendom safe, was to purge it with fire.

CITIES ON FIRE

I n November 1202, a divided army sat camped outside the walls
of the city of Zara, a city on the Adriatic coast under the protection of the king of Hungary but claimed by the Republic of Venice.
Venice had built a huge fleet to transport the army, but first wanted
"its" city back, claiming it needed to pacify Zara before its fleet could
sail away. Most of the army's leaders agreed to this, but a group of
dissenters, led by a noble named Simon de Montfort and Abbot Guy
of the monastery of Les-Vaux-de-Cernay, were vehemently opposed.
The dissenters said that theirs was an army bound for Egypt and Jerusalem on a crusade to fight the Muslims. They hadn't taken the cross
to fight fellow Christians and warned the army that they faced excommunication if they proceeded. Indeed, Pope Innocent III (1198–
1215), who called for the expedition in the first place, had explicitly
forbidden the army from attacking the city.

But their warning went unheeded and the army took Zara. The
plan changed even more when an exiled Byzantine prince sensed an
opportunity and struck a deal with the army to sail next to Constantinople, and so off the main body of the army went, besieging that
city in what we've come to know as the Fourth Crusade. It's a complicated story that doesn't work out well for the Byzantine prince (he is

eventually strangled in prison) and ends up with a count from Flanders being crowned as the Roman emperor on the throne of Constantine. But for now let's shift our attention to the dissenters—Simon, the abbot of Les-Vaux-de-Cernay, and the abbot's nephew Peter (also a monk), along with many others, who refused to participate, left the expedition at Zara and took ship for the Holy Land to complete their pilgrimage.

Seven years after the dramatic fireside confrontation at Zara, a different army on crusade sat outside another Christian city. Here, in southern France, the bishop of Béziers tried to negotiate a compromise for his city, which was under siege. He tried to get the citizens to hand over the ungodly, the heretics, within their walls to the crusaders outside them. The townspeople refused. The city was stormed and the walls fell. The inhabitants were massacred.

In the midst of the carnage, some soldiers approached the crusading abbot of Cîteaux and asked how they could tell the good Christians apart from the spawn of the devil. The abbot supposedly replied, *"Caedite eos. Novit enim Dominus qui sunt eius."* ("Kill them all. God will know His own.") The soldiers gleefully complied, slaughtering the population, many of whom had fled for safety to the city's cathedral of St. Nazaire. Christian swords made the nave of that holy place run red with Christian blood. That abbot of Cîteaux wrote to Pope Innocent III shortly afterward, effectively confirming that the army spared no one, acting as agents of divine vengeance and killing 20,000 people (an exaggeration, though not by much) regardless of rank, sex, or age. By 1217, surely having the events at Béziers in mind, a commentary on canon (Church) law would confidently assert that "if it can be shown that some heretics are in a city, then all the inhabitants can be burnt."

More massacres would follow, and this particular war on heresy, known popularly as the "Albigensian Crusade," would continue for

another twenty years. In that time, several chroniclers would record these "glorious" deeds, their pages illuminated by the pyres of heretics. One of those chroniclers who wrote so approvingly of the actions of the "soldiers of Christ" at Béziers, who marched alongside that army, was none other than Peter, the monk of Les-Vaux-de-Cernay. One of the leaders was his uncle, the abbot. One of the noblemen who led armies through the south of France looking for heretics was Simon de Montfort. And the man who called for the war on heresy in southern France? Pope Innocent III.

The major dissenters at Zara in 1202, who threatened the army with excommunication from the Church, who abandoned the army rather than kill fellow Christians—the very same people now enthusiastically approved such violence in 1208–1209.

So what changed?

THE TRANSITION (IF THERE WAS ONE) has much to do with what happened to the Fourth Crusade after Simon, Abbot Guy, and the monk Peter departed to the Holy Land. As reported by one of the participants, the siege of Constantinople by the crusaders was failing, so the churchmen in the army decided to hold a council. God seemed to be punishing them, causing their failures. The army wanted to know if this adventure truly was "God's will." In an impassioned speech, the bishops told the army that their cause was just—that the Byzantine defenders of the city were "traitors and murderers and disloyal . . . and they were worse than the Jews. [Thus the army] should not be afraid of attacking the Greeks, for they were the enemies of God."

The past doesn't repeat, but here it clearly echoes. The language used by the bishops here should be familiar from the so-called First Crusade, when Latin Christians marched east, first attacking the Jews of the Rhineland, and then making the streets of Jerusalem slick with the blood of the "enemies of Christ." Here, a century later, that

language has been redeployed. Just as European soldiers marched off in the 1090s to defend their fellow Christians in Constantinople, they sacked the city in 1204. Fires raged across New Rome for days.

The issue here isn't one of violence writ large, nor about who people were killing. Christians have been killing other Christians since antiquity, continued to do so throughout the Middle Ages, and have continued to do so well beyond. The concern was more about determining what kinds of violence were legitimate, who could decide when that moment came, how to handle the sin associated with violence, and under what circumstances killing could be justified. Augustine of Hippo had many centuries earlier, we remember, formulated two guiding ideals, and although scholars tend perhaps to overstate how rigidly medieval people held to those ideals, they nonetheless remained important frameworks.

The first of these was his conception of "Just War"—that the use of force should be used to defend citizens from outside aggression, with the goal of bringing peace afterward. The second of Augustine's ideas comes from biblical commentary, specifically related to Luke 14:15–24. In this parable, Jesus tells his disciples about a man planning a feast. All are invited but none attend. Fed up, the man tells his servants to go out, find those invited, and compel them to come in (*conpelle intrare*). For Augustine, this parable meant something important to his own time, characterized as it was by a wide variety of Christianities but still in search of a dominant orthodoxy, one that would label deviants as "heretics." The parable was about those Christianities; the man as orthodoxy, the feast as heaven, the refusers as heretics, the servants who forced the latecomers to conform as any exercise of power. When it came to enforcing discipline within the Christian community, Augustine argued that all force is legitimate to ensure right religion.

This helps us clarify what was going on eight hundred years later,

in the thirteenth century. Just War is an outward-facing idea of how Christians should react to other groups. *"Conpelle intrare"* is inward, within an intellectual community, about how Christians should engage heterodox groups within. And so the critical issue becomes who gets to define who is "inside" and who is "outside."

In the case of Simon de Montfort and the monks of Les-Vaux-de-Cernay, resolving that issue in their own time was a very simple question with a very simple answer. For them, the pope, and only the pope, could decide the boundaries of Christianity. Innocent III had (initially) thought the Zarans and Byzantines within the framework of Just War, while the inhabitants of Béziers and the rest of Aquitaine and Languedoc were governed by *"conpelle intrare."*

The papacy hadn't always had that actual power, even if the popes had long claimed they did. In the seventh century, for example, the papacy struggled to maintain control of Rome and was at least in part eclipsed by the religiosity of Constantinople. In the ninth century, Frankish kings had attempted to draw a line around themselves as the "chosen people," thereby excluding other Christian peoples they encountered (and conquered). In the tenth century, monks tended to be the arbiters of proper religiosity. This continued into the eleventh century, until the eruption of a conflict between emperors and popes. This Investiture Controversy (a debate about who could "invest" a new bishop, who could raise someone into that powerful and prestigious office), in which both sides marshaled religious leaders to their cause and called each other false Christians, led to direct bloodshed.

The resolution of that debate in the favor of the papacy, coupled with the conquest of Jerusalem in 1099, initiated by Pope Urban II and resisted by the emperor, shifted the balance of power decisively (for a time) in favor of the papacy. At least in theory, earthly kings and emperors remained in charge of the bodies of men, while the pope shepherded their souls. The path to heaven had rested with the

hierarchy of the Church, its priests, abbots, and bishops. What was new was that European Christians more broadly acknowledged that the bishop of Rome, the pope, sat atop that hierarchy.

It's always tricky to determine whether transformative individuals are themselves responsible for changing the pathway or history, or whether they are merely catalysts amid systemic change. The expansive power and deep anxiety of the twelfth-century papacy culminated in the election of the youngest pope in history. As a man in his late thirties, Lothar of Segni was elected to the papacy after the death of Pope Celestine III in 1198, and took the name Innocent III for reasons we don't know. Born to an aristocratic family just outside Rome in 1160, Lothar entered the clergy at an early age and was well educated in or around Rome until about the age of fifteen, when he went to study in Paris. Although not a formal *universitas* ("university") at that point, the cathedral school around Notre-Dame was widely recognized as the best in Europe and attracted students and teachers (all churchmen) from across the continent to study our familiar friend Aristotle and his Arabic and Latin interlocutors.

After his education, Lothar followed the path of many such liberal arts students over the centuries: he went to law school. In Bologna, the oldest university in Europe and the premier center for the study of both Roman and canon law, he was connected to the papal entourage and by 1189–90 was made a cardinal deacon of the church of Sts. Sergio and Baccho in Rome. From this privileged position in the papal inner circle under his predecessor, Lothar was elected at an unprecedented young age to the papacy by his fellow cardinals.

Lothar came to power obsessed with the holy war. Jerusalem had been lost to the Muslims under Saladin in 1187, and the massive, unprecedented expedition launched in response was an abject and utter failure. Led by the three most powerful rulers in Europe at the time, heavily financed and with huge armies under their command, it

ended up doing little but retaking some cities on the Mediterranean coast and securing what few had held out until that time. King Richard I of England (and lots of France) spent several years campaigning against Saladin, but never got to Jerusalem. Emperor Frederick I Barbarossa (1155–90) was the first to leave but drowned while crossing a river in Anatolia and his army melted away. King Philip II Augustus (1180–1223) arrived, started to help retake the city of Acre, then "fell ill" and went home to attack Richard's holdings in France. In the end, Jerusalem remained in Saladin's hands.

So Innocent called for another campaign—this is the one that went to Zara and then off to Constantinople. During it, right up until the moment the army took the city, the pope was livid at its progress. He threatened them against taking Zara, then placed them under excommunication when they disobeyed. He expressed dismay when they went to Constantinople, instead of Egypt as they had promised, warning the army not to continue on this path—to fight the real enemies of Christ. Nevertheless, they persisted and Innocent had to deal with the fallout.

Only then did Innocent's tone change suddenly and dramatically, evidence for how ideas about violence can change to fit new circumstances. In November 1204 and then again in January 1205, he wrote lengthy letters to the army praising the mysterious ways in which God worked. The conquest of Constantinople had advanced sacred history, uniting the "Greeks" (Byzantines) and Latins into one Church that could stand united against God's enemies. He had learned this, he said, by reading contemporary biblical commentators on the book of Revelation. Innocent was remembering 1099. Innocent was filled with apocalyptic hope.

The way that medieval people thought about apocalypse, sacred violence, and their position in history too often is either ignored—where religion becomes a smokescreen for the "real" economic or

political actions—or used as evidence that medieval people were unthinking religious fanatics. Neither is true. Medieval people did build a mental world to try and make sense of reality and to help guide them, as all people do. One place they turned was to scripture.

The abbot and biblical commentator Joachim of Fiore had, throughout his prolific writings, offered a new vision of the progress of sacred history. Generally, we think of Christian time as two-dimensional and linear; it starts somewhere and moves inevitably toward somewhere else. But it might be better, at least for people in antiquity and the Middle Ages, to see that they thought of time more three-dimensionally. Yes, history began somewhere (Creation) and moved toward something (Last Judgment) but the middle was a big mess. Sacred time had become somewhat muddled after Jesus's death, a blank space of repeating tropes, of looping cycles, until the events of the book of Revelation would pick up.

Joachim brought order to that chaos. Time was divided into three overlapping "stages," corresponding to the Trinity—the states of the Father, Son, and Holy Spirit. It's hard to overstate how powerful a grip Joachim's thinking had on the late twelfth and thirteenth centuries (and beyond), chiefly because Joachim—and Innocent III after him—posited that the world currently existed in the overlapping period between the second and third/final states. The final state, that of the Holy Spirit, would be characterized by the unification of all Christians, both for the salvation of their souls but also so they could stand united against their external enemies (servants of the devil). The outliers had to be gathered in.

But it can be a problem when facts don't line up with your feelings; at the very least, it forces a change of message. Innocent soon learned that the Greeks were not about to quickly convert to obedience to Rome. Moreover, Bulgars in eastern Europe invaded Byzantine Greece, dealing the new empire a brutal defeat at Adrianople

and killing Baldwin (formerly count of Flanders, now emperor) in battle, leaving the new regime badly destabilized. Innocent began blaming the loss of God's favor on the conduct of the soldiers when they took the city, specifically focusing on their looting of churches and alleged rape or murder of monks, nuns, and priests. But he never lost his apocalyptic hope. Apocalypses are, after all, infinitely postponable. God cannot err, but humans can misread the signs. Perhaps Innocent was wrong about the in-gathering of the Byzantines to the Latin Church, but then, just a few years later, the wayward Christians of southern France seemed to Innocent yet another sign, another opportunity to help move sacred history forward.

Heresy was not a new thing in medieval Europe. What happened in southern France at that time, however, was of a different nature than what had come before. We tend, based on our sources, to lump all these dissenters in as "Cathars" and ascribe to them a formalized dualistic theology—a hard division between things "of this world" and things "spiritual." Cathars, for example, were supposed to have abstained from sex, been vegetarian, and so on, and had a formal institutional structure. But that's a picture built up by centuries of writing by the enemies of the "Good Men" or "Good Women," as they called themselves. It seems reality was much more messy.

There was no "Cathar religion." There was, however, a widespread and deep-seated animosity toward priests ("anticlericalism") that derived in part from a skepticism about the usefulness of the priesthood generally, as well as a desire for a purer "apostolic" lifestyle that rejected worldly wealth. These ideas weren't unique to the lands of the counts of Toulouse. In fact, criticisms of overly worldly (lusty, gluttonous, greedy) priests and monks is a staple of medieval literature, especially in *fabliaux*, or fables—short moral tales, often extremely vulgar verging on the pornographic, that are supposed to teach a lesson (such as don't have sex with priests, how to cuckold your husband,

etc.). But there does seem to have been an interesting strain of lay religiosity in southern France that shocked and appalled a new class of university-educated elite churchmen like Innocent III.

This is not, of course, to say that bishops and priests throughout southern France were enablers or promoters of dissenting belief systems (though they were frequently blamed by their northern counterparts), nor that the population of this region wasn't Christian. Instead, at least part of the surge in concern about "heresy" that occurred after the turn of the first millennium and then continued through the late Middle Ages can be attributed to different people actually paying attention to what other people were saying about and doing with their religion. The thirteenth-century story of St. Guinefort, the "holy greyhound" (yes, an actual dog), for instance, is sometimes held up as an example of peasant superstition but a closer look reveals something akin to orthodox. Venerated by a local population near Lyon, the story went that Guinefort had saved an infant from a serpent but the child's father, returning home, misunderstood the scene and slayed the hound. Essentially what had happened was that an oral trope of the loyal hound had been conflated with a human saint and an element of class antagonism (the ungrateful master) had been emphasized. This was actually a combination of very traditional Christian rites, and stories about the saints, with some oral storytelling elements that had all merged over quite some time. It was singled out as "unorthodox"—the reason we know of it now—only when a friar from the University of Paris happened through the area looking for heretics.

In that case, as in many others, thirteenth-century churchmen, educated by reading Roman classics and the Church Fathers, attempted to see in their own day the struggles of the past and used an older vocabulary to describe their own world. For example, many of the charges laid at the feet of the so-called Cathars were verbatim those

levied against early Christians in the third and fourth centuries. We read, a thousand years later, about new "Donatists" and "Manicheans." The intellectual world in which men like Innocent III lived provided the framework within which they saw the world, but that framework was constrained within a nostalgia for a heroic Christian past.

Because of this way of thinking, these wayward Christians seemed to pose an existential threat to good Christians everywhere. In the middle of the twelfth century, the abbot of Cluny had asked the master of the Knights Templar, "Against whom should you and your men fight? The pagan who doesn't know God, or the Christian who confesses Him in word but battles Him in deeds?" But this was a rhetorical question with a clear answer; false Christians were the greater threat.

In the regions around Toulouse, trouble had been brewing for some time. "Good Christians" (as they called themselves) had been active in fortified towns and cities for at least a few generations by the time of the massacre at Béziers. At first, preachers from the north, primarily Cistercian monks, were sent in to reform the clergy and debate any "Good Christians" they found. But it was often hard to identify "heretic" from "orthodox," as the realities of life never matched the ideas conjured in the minds of these northern churchmen.

Things changed with Innocent III. His model came from Matthew 13:24–30. In this parable, a farmer's field has been sabotaged by his enemy, which means it now has both the wheat he planted and weeds. The story ends with the farmer allowing both to grow until the harvest, when the wheat will be saved, but the weeds gathered up and then burned.

For Innocent, this was an allegory for his own time. The church had planted well with the hope of Christianity growing strong, but the devil and his agents had intervened and spread dissent (i.e., the weeds). Those dissenters were hard to tell apart from the good

Christians, so the field was allowed to grow. Only at the time of the harvest, the apocalypse (again), will the two be separated—the heretics destroyed by violence and the good Christians gathered in for salvation. Innocent's apocalyptic hope never left him. The Church had planted, the devil had polluted the field, the plants and weeds were now indistinguishable in the south of France.

For the first ten or so years of his pontificate, Innocent III intensified preaching in the region, even approving a new group of wandering preachers committed to poverty and an ascetic lifestyle, led by a Castilian named Dominic de Guzmán. This group would soon become the Dominicans. These efforts seemed to be bearing fruit and the weeds seemed under control until 1208.

In January, a papal legate was murdered. The count of Toulouse, already at odds with the papacy about helping suppress heresy, may or may not have been involved but certainly wasn't unhappy it had happened. The papacy asked King Philip II Augustus to intervene but he refused. Innocent did, however, find other participants, nobles from the north happy to crush the enemies of Christ while also (perhaps) expanding their holdings in the south through conquest. Spirituality and materialism have always gone hand in hand. The army marched south. One of its first stops was Béziers. It was time for the harvest. It was time to burn the weeds.

THE WAR AGAINST THE CATHARS OR Albigensians lasted from 1208 to 1229. In the middle of this on-again, off-again campaign, Innocent called a great church council to meet in the Lateran Palace in Rome in November 1215. A massive host descended—bishops, archbishops, cardinals, monks, abbots, representatives from the kings of France, Hungary, Jerusalem, Aragon, and Cyprus, as well as the emperors in Germany and Constantinople, in addition to the leaders of those engaged in the holy war in southern France. By the end of the month,

the council had arrived at seventy-one canons that were universally adopted.

Canon 1 begins with a statement of "faith"—but *fides* in Latin isn't so much about belief (though that's a part of it) as about loyalty. It asserts the doctrine of the Trinity and the humanity of Jesus, the importance of the sacrifice. Then the statement "There is one universal church of the faithful, outside of which there is absolutely no salvation." This church, however, was open to everyone, the council assured its audience. Baptism allows anyone in and repentance returns to the community anyone who had fallen away. The remainder of the canons emphasize and clarify that statement, defining orthodoxy against the Cathars, reprimanding priests whose lax oversight had let heresy flourish, justifying violence against those seen as deviant. And then the decrees come full circle at Canon 71, the final decree of the council, completed.

Having defined the community in Canon 1, that now-unified community looked outward. Canon 71 is a call to holy war—a new expedition to the Holy Land. The council calls on all good Christians to repent of their sins, to return their *fidem* ("faith") to the church and strike out against God's enemies. God will grant victory to his purified followers but "to those declining to render aid [to help the holy war] . . . the Apostolic See firmly protests that on the last day they will be held to render an account to us in the presence of a terrible judge." Innocent III and the council were reminding their audience that the wheat had grown with the cockles and the time of the harvest was upon them. Time was short. The first batch of weeds was burned in Constantinople and then in Béziers. The next, and final, city ready for the harvest, ready for the fire, was supposed to be Jerusalem.

CHAPTER 14

STAINED GLASS
AND THE SMELL OF
BURNING BOOKS

As the sun streamed through the magnificent south-facing stained glass windows of the cathedral of Notre-Dame, so a cascade of candles lit the interior of Sainte-Chapelle, whose own walls of brilliant stained glass vaulted toward the sky. But fire consumes even as it illuminates; it guides the harvesters who take in the wheat. It allows them to destroy what they think to be weeds.

Thirteenth-century Paris tells us a story about the interplay of architecture and power, about kingship and place, and also the way that ideas built all of those things. Louis IX (1226–70) was one of a new generation of rulers, taking advantage of legal, economic, and political developments that had occurred over the last century to construct a type of rulership that put him more firmly in control of more of France than his predecessors would have imagined possible. His decision to construct a new chapel, the Sainte-Chapelle, to adorn his palace was part of that move to centralize power. The soaring glass within tells the story of a *translatio imperii* (a "transfer of imperial

power") by detailing how the Crown of Thorns, the most sacred relic in Christendom, traveled from the head of Jesus to the new Rome in Constantinople, and then finally to the chapel of the king of France.

Across the Seine from the Île de la Cité, almost directly opposite the nearly completed Notre-Dame, and perhaps within sight of the (likely) also under-construction Sainte-Chappelle, a fire that both illuminated and consumed was lit on the Right Bank. In June 1241, crowds gathered at the Place de Grève, a great plaza now located outside the current Hôtel de Ville. Gathering at this location was common, as it was the site of public executions in the medieval city, but this particular gathering was uncommon because the people had come together not to burn bodies but to burn books—twenty or so cartloads of a text deemed dangerous and heretical: the Talmud.

Although the holy war against the "Cathars" that we encountered in the previous chapter had in theory ended ten years earlier, heresy was still—and would continue to be—a prominent concern for the successors of Pope Innocent III, and not just in southern France. The Church still required harvesters to separate the wheat from the weeds. Pope Gregory IX had sent new religious orders throughout Europe to "seek out" (*inquisitio*, hence "Inquisition") heresy. These new religious orders, each named for their founder, were the Dominicans and Franciscans.

The Dominicans, also known as the Order of Preachers, we met already in southern France. The Franciscans date to about the same time, named after their founder, Francis of Assisi (d. 1226). The son of a silk merchant in central Italy, Francis supposedly lived a hedonistic life in his early years but, upon meeting a beggar, dedicated himself to extolling the virtues of poverty, and preaching his lifestyle to anyone who listened—to people, to birds, to a wolf (according to one of his biographers). At the Fourth Lateran Council in 1215, he received permission from Pope Innocent III to found an

order focused on poverty and preaching, surely with the threat of "Cathars" and "Crusade" heavy on the pope's mind, as we saw in the last chapter. Indeed, followers of Francis and Dominic could soon be found throughout Europe preaching against heretics, attempting to convert them back to orthodoxy. Both orders would be vital to the intellectual and spiritual life of medieval Europe, inspiring new models of devotion and conversion (from less active religious practice to more), and would become vectors for connection and conflict across the continents. The Dominicans in particular also served the papal mission against heresy, earning their sobriquet "hounds of the Lord" (literally, from *Domini canes*) for their ruthless pursuit of those deemed of questionable orthodoxy.

So, with the Inquisition burning across Europe, it perhaps would come as no surprise that in 1239 Gregory IX asked rulers throughout Christendom to investigate a book for possible heresy, worrying that it deviated from biblical truth. Most ignored the papal request, but the young King Louis IX of France responded enthusiastically and commissioned a tribunal. The queen mother would preside.

And so in 1240, the still-young king took Gregory's call to investigate this book, the Talmud, seriously and literally. The prosecution would be led by the chancellor of the University of Paris, alongside the bishop of Paris, the archbishop of Sens, and several friars. The defendants in this case weren't alleged Christian heretics, but instead were rabbis from Paris, facing the charge that Jews who used the Talmud were heretics within Judaism, that this collection of commentary on the law and tradition was a deviation from the Hebrew Bible.

The disputation had a foreordained conclusion, of course; the Jews of Paris would never have been allowed to prevail. Although they enjoyed a theoretically protected status in Christian Europe, that status was still bounded by intellectual antagonism that could—and often did—quickly slip into physical violence. Our familiar face

Augustine had argued long ago that that the Jews' subservient status "proved" Christianity's truth, that history had demonstrated by the destruction of the Israelite Temple and rise of Christianity that God's plan for the world was "punishment" for the Jews' failure to accept Jesus. For medieval Christians, Jews needed to be reminded of their subservience, often through violence—harassment, segregation, and sometimes assault and murder. So, in a trial requested by the papacy, supported by the king of France, staffed by Christian churchmen, the outcome of the trial was never in doubt.

The majority of the Christian jurors agreed that the Talmud was blasphemous and should be banned, its copies burned. So in June 1241, hundreds, if not thousands, of manuscripts were brought to the Place de Grève, stacked in a pile, and set alight. The fire may have burned so high it reflected off the stained glass of Notre-Dame across the river. Rabbi Meir of Rothenberg, who himself witnessed the book burning in 1241, would lament later in the thirteenth century that "Moses shattered the tablets, and another one then repeated his folly / Burning the law in flames . . . / I witnessed how they gathered plunder from you / Into the center of a public square . . . and burned the spoils of God on high." Rabbi Meir, in anguish, related that the fire that burned so high, so bright in the City of Lights paradoxically "leaves me and you in darkness."

PARIS WAS NOT ALWAYS THE CENTER of royal power and in fact had come to be so only fairly recently. Many rulers of medieval Europe called themselves king, but the title alone didn't come with any power. The question was to what extent they could marshal soldiers, acquire stable revenue streams, or exert judicial authority beyond their own court. So, kings traveled in order to hear petitions and make their presence visible, thus asserting that they had authority. When the empire of the Carolingians splintered, for example, the king of West

Francia (Charles the Bald and then his successors) moved constantly, with power centered around palaces such as that in Compiègne, bishoprics such as that at Senlis, and monasteries such as Saint-Denis. When the next dynasty, the Capetians, finally (after an earlier false start) took power under Robert II "the Pious" (996–1031), they focused their attention around the Loire, closer to the city of Orléans and the Abbey of Fleury. It was only in the time of his grandson Philip I (1060–1108), as we move past 1100, that the king's attention more permanently centered around the Île-de-France and Paris.

Philip revived the monarchy's relationship with the abbey of Saint-Denis to the north of the city, in part as a check on threats to his power by important lords such as the dukes of Normandy and counts of Flanders, but he ensured the monastery's future importance when he placed his son (the future Louis VI, 1108–37) in the monks' care for his education. At that time, Louis and a monk about his same age became close and would remain so throughout the rest of their lives. Suger, who became abbot of Saint-Denis around 1122 and would be a thorn in Eleanor of Aquitaine's side, spent massive amounts of time at the royal and papal courts, would serve as regent of the kingdom for Louis VI's son and successor, and would transform the physical landscape of not only the monastery of Saint-Denis but Paris as well. His idea was that through reshaping spaces, through grandeur and light, he could elevate the king—not just a specific king, but the very idea of Christian kingship and the relationship between Crown and Church. It just so happened, of course, that his home monastery would be elevated alongside the king when this all happened.

Suger claimed, later in his writing, that when he became abbot, the physical condition of the abbey was deplorable. And so he set out immediately to rebuild. This was, at least in part, a trope—a claim of necessary "reform" led by a pseudo-visionary leader (even if it was perhaps in part true, a leader who needs legitimacy needs a problem

that supposedly he alone can fix). Regardless, the rebuilt—and funda-
mentally reimagined—abbey church of Saint-Denis was completed
by the early 1140s and soared toward the heavens. This structure has
long been called the birthplace of the Gothic style, away from the
heavy, thick walls that supported a structure but often allowed little
room for windows and, hence, light.

Suger's church glowed. And this was intentional. He had a plan
to build a sacred space that would transport the viewer from earth
to heaven while supporting monarchical claims to be God's agent
on earth. Medieval monarchs elevated themselves through multiple
means: military, tax reforms, judicial control. But to make them stick,
they needed a story. And that's where religious men like Suger, and
the art they paid for, came in. For example, Suger commissioned sto-
ries of Frankish kings and the conquest of Jerusalem in 1099 on his
windows. He poured money into the church, keeping careful note
of the weight of gold and gems he required. Later, critics of Church
wealth like Bernard of Clairvaux or Francis of Assisi might have found
this display obscene, but Suger was not some hypocrite, preaching
poverty while living in luxury. Rather, this serious cleric saw bright-
ness, saw the gleam of gold light passing through colored glass and
reflecting off gemstones, as the closest one could come to replicating
heaven on earth, or to lifting one from earth to the heavens.

For proponents of the idea of the dark ages, even the soaring
arches, glimmering metal, and glowing stained glass are signs of de-
cline. "Gothic" was coined as a negative description of medieval art
by the sixteenth-century Italian Giorgio Vasari, who wanted to con-
demn it as barbarous, like the people who sacked Rome. Later, the
huge ornate churches stood as a symbol of exploitation, how the rich
used religion to oppress the workers. This makes it all the more im-
portant to set aside modern biases and engage medieval art, medieval

grandeur, on its own terms. And Suger made his best case in his writing and on the art he commissioned.

On the bronze doors to the church, for example, Suger had the craftsmen write, "Marvel not at the gold and the expense but at the craftsmanship of the work. Bright is the noble work; but, being nobly bright, the work should brighten the minds, so that they may travel, through the true lights, to the True Light where Christ is the true door." In the Bright Ages, a viewer could be transported allegorically to another place, to heaven itself, with an intellectual model of sacred design that would prompt cathedral builders, in particular, to build spaces that would maximize light.

But power and beauty rarely remain stable. The reconstruction of Saint-Denis touched off a sort of architectural "arms race" in and around Paris through the late twelfth and early thirteenth centuries. As Paris became the center of royal power, its constituent parts vied for royal favor, for the right to be the centerpiece of the monarchy's connection to the divine. The first salvo was launched by the bishops of Paris, who decided to rebuild their own church—the cathedral of Notre-Dame—just after the rebuilt Saint-Denis was largely completed, and almost certainly in response.

What was completed nearly a century later, around 1250, was not exactly the same as the iconic structure that tragically (and accidentally) burned in April 2019. It was instead a more coherent architectural statement about the role of the Virgin Mary (*Notre-Dame* means "our lady") in salvation history and how the bishops of Paris safeguarded her legacy and connected her to Paris, hence to the king, and thence to the kingdom as a whole.

We sometimes forget, looking back from modernity at the bare stone and magnificent empty space of medieval churches, that they were—just as much as a stone cross in a field in Britain—meant to be

total sensory experiences. A visitor saw that the sculpture of the stone façade functioned, in the words of Rebecca Baltzer, as a "giant billboard designed as a graphic depiction of all that the visitor needed to know about salvation." In Notre-Dame's case, it told a history from the kings of Israel and Judah through the Incarnation, through Denis (the first bishop of Paris), all the way to the Last Judgment. Entering, they smelled the incense burning from the near perpetual singing of the mass. Visitors heard the chant of a liturgy structured on connecting the Virgin to thirteenth-century Paris through its bishop, and through its bishop to its king. Walking farther in, perhaps proceeding to the crypt, where the relics of the saints were kept, they could taste holiness. Indeed, churches often had to station guards around their relics for fear that visitors would, in their devotion, literally bite off jewels from reliquaries, or pieces of cloth, or even bone. And standing inside an empty nave, particularly on a sunny day, they felt color upon their skin.

Everything led upward in this new Gothic style, with ceilings in the nave of the church often more than ten stories high. Pointed arches and exterior supports, known as "flying buttresses," relieved the weight of the ceiling and distributed it outward, allowing the walls to move from solid and fortress-like to ethereal and light. In a world made of wood, stone impressed; but for a world before electricity, more important was light. This wasn't a world lit only by fire, but more important, one illuminated by the sun. Allowing that sunlight *inside*, allowing an interior to gleam, was to capture something of the divine. So heavy stone walls were replaced by translucent and radiant colored glass.

Christian churches are oriented east-west, with the entrance to the west and altar at the east end. In most cathedrals, stained glass flanked the nave to the north and south, with scenes from the Christian Old Testament on the north wall and scenes from the New

Testament on the south. This was a theological statement: in Paris, as elsewhere in the northern hemisphere, the south-facing side of any building receives more sun, so the New Testament would be illuminated even as the Old Testament remained in the shadows.

The cathedral in Paris around 1200 was a focal point for more reasons than simply the bishop and his building. Beginning around 1100, the education of elites began to move away from local monasteries and toward cathedrals and the cities in which they could be found. The emergence of bigger cities, stable economies, more organized religious and political structures, all made these cities more appealing sites for education. The students who graduated from these new cathedral schools were then in high demand by churchmen and nobles alike, both looking for assistance in a world of increasing literacy, one adhering to more complicated forms of religious and secular law. And as the twelfth century progressed, the school attached to Notre-Dame began to shine most brightly, with young men (and women!) coming to the city from across Europe.

Then, in 1200, a bar fight. In that year, a German student and his friends studying at the cathedral school and living on the Left Bank went out to buy wine. Supposedly, the innkeeper tried to swindle him, apparently annoying him and his group of friends (who were, shockingly, likely drunk at the time), and leading them to assault the innkeeper and destroy the inn. The innkeeper then went to the secular authorities, who gathered a posse, and, in the ensuing melee, ended up killing a number of students in retribution. The school's teachers, in solidarity with the students, refused to teach and threatened to move the school elsewhere unless the king provided justice. He did. The secular authorities and their posse were imprisoned, and King Philip II Augustus (1180–1223) issued a decree protecting the school, its teachers, and its students. The king recognized that the teachers and students of the school at Notre-Dame were a collective

that enjoyed legal rights. We might call them a "corporation." They called themselves a *universitas*.

Although the term wasn't formally applied to the school until later in the thirteenth century, the University of Paris continued to enjoy royal support. But because the school grew out of the cathedral, the bishop and his servants were eager to continue to exercise their control of this collective, to master their transformed university even as their transformed cathedral rose toward the sky.

Then, another bar fight.

In 1229, another group of students disagreed with another innkeeper about the price of wine. They were swiftly beaten up, but returned the next day for revenge, smashing up the inn. History doesn't repeat but sometimes it echoes. Queen Blanche of Castile, acting as regent for her son King Louis IX, ordered the students arrested, and royal sergeants swept through the student quarter, injuring many and killing a few. Once more the teachers rallied to the students' side and demanded justice. This time, however, they were refused by the queen, the papal legate in Paris, and the bishop of Paris. Although, according to the contemporary chronicler Matthew Paris, this was all due to the "legate's penis" (he was rumored to be having an affair with the queen), the three all had their reasons to stand against the university: the queen because she gave the initial order, and the bishop and legate because they wished to curb the growing power of the school. The collective—the *universitas*—disbanded. Masters and students left the city in the spring of 1229 and vowed not to return for at least six years. Some went to other cathedral schools in France, while others joined the university in Oxford, and still others went "home" to Italy or Spain.

The king, queen, and pope were horrified at the closure of the university, as schools even then were engines of prosperity and prestige for communities. The crisis here was resolved only in 1231 when the

pope issued a decree effectively recognizing the university's authority to self-regulate, limiting the powers of the king and bishop over the teachers and students. "Paris," it began, "the parent of sciences . . . city of letters, shines clear, great indeed but raising still greater hopes in teachers and pupils." The devil had been working to disrupt the university, to plunge Europe into darkness. But in allowing freedom, recognizing formally the *universitas*, he hoped to restore to this city its lights.

But the school, this new university, was not the only thing moving away from that cathedral being built during the 1230s. Even architecturally, Notre-Dame was surpassed before it was finished. The architectural and iconographical arms race continued, this time simply moving to the other side of the same island in the Seine, to a new chapel commissioned by King Louis IX and thereafter known as Sainte-Chapelle.

By the time Louis IX came to power on his own, Paris was the unquestioned center of the monarchy. He benefited greatly from the centralizing moves of his predecessors who had introduced substantial bureaucratic, legal, and financial reforms to increase monarchical control over his subjects. The rise of administrative kingship, as some historians have dubbed it, did not come without tension. England saw several bitter civil wars, one of which resulted in the signing of the Magna Carta, which theoretically limited royal authority. In many ways, the wars against the Cathars—fought mainly for the papacy but with armies populated from the lands of the king of France— might also be deemed another civil war in its final stages, ultimately ensuring royal control over southern France. And now that power centered around the city of Paris, even more specifically the island in the middle of the Seine, in the middle of Paris.

By the early part of the thirteenth century, the French kings had made the Palais de la Cité on the western tip of the island their primary

residence, looking across at Notre-Dame as it went up. But by 1238, that palace became suddenly insufficient for its residents—not the king himself but the so-called King of Kings. In that year, Louis had scored a coup, purchasing relics of the Passion from Constantinople in a complicated debt-relief deal for the beleaguered Latin Empire, first and foremost among them the Crown of Thorns.

Byzantine emperors, like all medieval Christian elites, had often trafficked in relics, though usually it involved shaving tiny bits off preexisting objects and sending them as gifts. This was fairly easy to do with splinters of wood of the true cross, drops of the sacred blood, or tiny fragments of bone. The transfer, or *translatio*, of the Crown of Thorns, wood of the True Cross, and other relics associated with the Passion, built on and exceeded these traditions by an order of magnitude. When sacred objects move, they reorder the imaginary geography of the world, or at least make possible an argument for such a reordering. Louis and his supporters could argue that the center of the Christian world, that Christ himself, that Jerusalem had come with those relics. Just as the *Life of St. Daniel* argued in the fifth century that Constantinople had become a new Jerusalem, now Louis could claim that Jerusalem had migrated still farther, from the city of Constantine to the city of Paris. Artistic endeavor and political ritual cemented this claim. The Crown of Thorns was welcomed into Paris with a solemn procession led by the king, walking barefoot and wearing only a tunic, perhaps carrying the reliquary himself. It stopped at Notre-Dame, but only briefly. It had a different final destination: the king's private chapel in his palace, at that time dedicated to St. Nicholas.

Not long after he purchased the relics, Louis moved to reconstruct his palace chapel in preparation for the arrival of the Crown of Thorns. Although not completed by the time of the relic's arrival, the chapel was consecrated by 1248. And the king's actions during

the procession seemed quite intentional, signaling the relationship he envisioned between the city's cathedral (and its bishop) and the king's "holy chapel" (Sainte-Chapelle), one manifested in stone and glass. The Virgin Mary ("Our Lady," or Notre Dame) was, of course, important, but not as important as the Son of God Himself.

Even before Sainte-Chapelle was completed, it had received special papal exemption from episcopal jurisdiction, meaning that the bishop of Paris just across the island had no control over it. It belonged to the king and to the pope only. Although this was a private chapel within the royal palace, the general public seems to have been able to enter the palace courtyard and chapel itself on special feast days. Within, they saw walls almost entirely made of stained glass. Brilliant blues and reds made the gold of the reliquaries sparkle, illuminating on their own the vibrant paintings that adorned the walls.

Sainte-Chapelle told a story about kingship. Statues of the apostles flanked the walls, while the stained glass told a specific story of salvation history, but one centered on Jerusalem and how it had "moved." Starting at the northwest corner, the panels of the north wall told the story of the Christian Old Testament from Genesis through the struggle for the Holy Land in Judges. The east end, surrounding the altar and relic of the Crown of Thorns, was the culmination of allegory and history. Here, the Tree of Jesse—which tells the story of the ancestors of Jesus—is paired with the prophet Isaiah, followed by John the Evangelist next to Jesus's childhood. The story of the Passion appears directly above the altar. Finally, the south wall, the more illuminated (both figuratively and literally by the sun), pivots more directly toward kingship with both Old Testament rulers and an entire bay window depicting the reception of the relics in France by Louis IX. And every window is adorned with the fleur-de-lis of the kingdom of France.

This wasn't subtle. We have seen salvation history before, but this

one led ultimately to Louis IX as *christianissimus rex* ("most Christian king"). Indeed, the art historian Alyce Jordan has even pointed out that the biblical scenes depicted in the windows at times erase priests from the story. For example, in coronation scenes along the south wall, kings are crowned not by priests but by exemplars of kingship (i.e., the kings of Israel) and they are then acclaimed not by peers but by the people as a whole. This art positions secular rulers as divine agents without needing priests, bishops, and popes as interlocutors. The arms race of sacred architecture that began with the abbot of Saint-Denis and continued with the bishop of Paris is here ended by a king, who erased them all.

By 1250, with a soaring new cathedral and a resplendent and independent chapel in the middle of Paris, France was no longer under the protection of St. Denis and his monks to the north of the city. It was no longer under the protection of the Virgin and her bishop. France had a new king, one who stood in the midst of candles and light, awash with blues and reds, looking upon his predecessors who were kings in Israel, in both the Christian Old Testament and the New.

IN 1240, THE SENTENCE AGAINST THE Talmud was pronounced. But the burning that would occur a year later almost didn't happen. All history is about contingency, about decisions that might not have been made, or how things could have gone differently. The archbishop of Sens, the most powerful among the jurors at the "trial," interceded and convinced the king to return the books to the Jewish community. The papacy, too, said now that the Talmud was to be censored of "offending" material, but not banned, nor burned.

And yet despite the papal commandment and protestations of the archbishop, cartloads of the Talmud arrived at the Place de Grève in 1241 at Louis's request. Louis took to heart the lessons he learned and

that he taught, much as he took in the narratives of his monasteries, his churches, his palace and chapel. A "most Christian" king had a special responsibility to God to care for his people, and that responsibility required zeal. The king was to be zealous in caring for the poor, ensuring that justice was done. These were common refrains of kings, heard through the centuries. But the most Christian king, who received the Crown of Thorns from Byzantium, was also required to be zealous against those who, in the medieval mind, persecuted their Lord. Jews had to be punished. Muslims had to be defeated or converted. The world had to be purified, had to be brought to God by his vicar here on earth, Louis himself.

In the succeeding decades, amid the beauty of magnificent stained glass, the Crown intensified its efforts to convert the Jews in order to remind them of their subjugation. In the succeeding decades, Louis would wage holy war against Muslims in North Africa not once but twice. In the succeeding decades, perhaps as he stood outside Sainte-Chapelle, Louis contemplated the fires he had set in the Place de Grève and those he had set as he besieged Damietta in Egypt. But perhaps he also imagined fires he had never seen, such as those that followed in the wake of the Mongol conquests happening at the same time in lands far away, but yet close enough to matter. Almost certainly at least, Louis thought long and hard about the fires that lit Karakorum, the capital of the great khan, especially in 1259 after Louis's emissary to the Mongols returned to Paris bearing news about a possible alliance. Would the Mongols, like Louis (as he imagined himself), be agents of divine will to finally reclaim the Holy Land, if only he first purged his kingdom of those he considered heretics, unbelievers, and obstacles to his power?

GLISTENING SNOW ON THE EASTERN STEPPE

The men of Möngke Khan's court wondered why these men from the west weren't wearing shoes. It wasn't weird that they were Christians or had an exaggerated idea of their own importance—both were pretty common throughout the empire. But it sure was cold on the steppe, and didn't these men want to avoid frostbite on their toes? The courtiers' curiosity was resolved when the men were recognized by a Hungarian servant of the Khan as Franciscan friars who had traveled from the court of King Louis IX on a mission to convert the Mongols to Christianity.

The Christian Hungarian explained to the khan and his court about the friars' vows of poverty, and because extreme religious asceticism was also pretty normal in the broad scope of religious practices across Asia, everyone relaxed. The khan's chief secretary, himself a Christian (a Nestorian, the dominant form of Christianity in central and eastern Asia), quickly took charge and provided the men from the west with lodgings. Later, the khan offered them rice wine to drink, grilled them on the agricultural wealth of France, and told them they could stay in his court—or journey to the nearby capital

of Karakorum—and wait out the cold season in safety. This they did, now with shoes on their feet, though they were unsuccessful in their mission. Still, the friars crossed much of the length of Asia between 1253 and 1255 and returned home to tell their tale with their toes intact.

FROM THE TRADITIONAL UNDERSTANDING OF WESTERN EUROPEAN history, the voyages of the Franciscan friars into the Mongol Empire might seem to mark a transformation, one in which the backward West finally reached sophisticated Asia. There may well be a kernel of truth in this. The Mongols were a nomadic people on the fringes of China who emerged off the steppe into a wider, more urbanized and agrarian world. By the time Europeans reached the city of Kara-korum, the Mongols had built an empire of unprecedented size. Among other factors, the unity that the Mongols brought to vast swaths of Asia, unity forged in blood and death to be sure but also with ample soldiers deployed to keep roads safe, permitted easier and safer travel across much of the continent. Latin Christians from Europe, like many peoples both inside and on the fringes of the Mongol world, took advantage of that ease of travel. But as we've seen, people had always crossed borders, voluntarily or involuntarily, throughout the Bright Ages, bringing with them material goods, ideas, and even sometimes pathogens. In that sense, the Mongol conquests of much of Asia accelerated and intensified long-extant habits and connections.

Moreover, this intensification of cross-regional encounters mani-fested along multiple vectors. Europeans went east. East Asians went west (and north and south). Central Asians traveled in all directions. People moved more freely or were forced to move by both the chaos of war and through enslavement, often picking up multiple languages

either for personal advancement or simply survival. So it's not a surprise that a Hungarian seems to have been serving Möngke Khan, ready to translate. Later in the same (thirteenth) century, a Venetian merchant named Marco Polo might plausibly travel to Mongol-ruled China and serve Kublai Khan as a useful foreigner. While we'll never know for sure whether he was telling the truth about his journeys, we do know that many people roamed far from home in search of fortune, fame, knowledge, sanctity, diplomacy, or escape. The rise of the Mongols, intensifying the links between eastern Asia with western Europe by conquest and trade, reshaped the possibilities for individuals to move in the premodern world. Monks walked from China to Constantinople to Rome to Baghdad. Merchants took ship from Venice to China. Diplomats sojourned back and forth. Once we understand Europe as always connected, we see the change that the Mongols brought in quite a different light.

THE HISTORICAL EVENTS IN EUROPE THAT brought the Franciscan William of Rubruck to the khan and the city of Karakorum weave together the threads of twelfth- and thirteenth-century history that have been spinning over the last few chapters. We have a king of France with the grandest possible aspirations, Christian preachers ready to travel, an Islamic world at once powerful yet divided, and then come the Mongols, reshaping the map of the world.

The man who became Chinggis ("Genghis") Khan was born Temujin in 1162, and raised among the many nomadic peoples who occupied that region of the steppe. His rise to rule a massive transregional empire was, to put it mildly, unlikely—perhaps one of the most unlikely events in world history. His father, a tribal chief, was murdered when the boy was nine. Temujin failed to claim his father's position, and he and his family had to live a marginal life on the outskirts of

Mongol society, a dangerous situation on the unforgiving steppe. At seventeen, he was captured and enslaved, but escaped and began to build his reputation as a military leader.

Although of course the complicated interplay of conflicts and alliances within the Mongol communities has its own history, it's also true that the region had operated for centuries in the shadow of various states in China. In fact, throughout so much of Asia, agrarian and urbanized states interacted across borders, not only with one another but with shifting groups of pastoral nomads who made their livelihood via large-scale animal husbandry. These encounters could be fruitful, promoting trade and cultural exchange, but often led to intense conflicts when for any number of reasons the nomadic peoples would cross the borders and begin to raid more settled lands. Chinese states, therefore, tried to keep the nomads on its border embroiled in internal conflicts, while selecting individual groups as favored clients and agents on the steppe.

But Temujin, in a long and complex series of political and military moves, managed to unite the peoples to the north of the Jin dynasty of China, to become what we now know as the Mongol Confederation. By 1206, he took the name Chinggis Khan, or "fierce ruler," to mark his new dominance. Gradually, under his leadership, his people conquered large swaths of northwestern China (his descendants would conquer the rest). From this base of operations, his attention was drawn to the trading networks that stretched to the west across interlocking routes we sometimes call the Silk Road, and he dispatched merchant-envoys to the border of a great central Asian sultanate called Khwarazm to arrange for trade. But his officials were accused by the local governor of being spies; in fairness, they probably *were* spies. The governor had them massacred. A second group of emissaries were likewise humiliated then killed. War followed.

Over the next few decades, almost no one defeated the Mongols

in pitched battle, in part because the highly mobile steppe warriors simply avoided battle when conditions were unfavorable. What's more, although the Mongols have a well-justified reputation for ruthless atrocity as a way of punishing their foes, from the very early days Chinggis was careful to open pathways for conquered peoples—especially those who surrendered without resistance—to join his military and empire. He created a new pan-Mongol identity in order to minimize long-standing enmities and incorporate defeated Mongol groups into his empire. Non-Mongols could find positions and power and great wealth by signing on with the Great Khan. This is, in some ways, not so different from what we have seen practiced by the Franks and Byzantines.

Even as he conquered, Chinggis had his eye on logistics and economics. While the army moved against Khwarazm, the Mongols established a network of roads and small bases. These last were a combination of trading post and post office—stationed with fresh horses, so news could move quickly from one region to another, even across great distances. In peacetime, they'd become the nodes in the networks that held the empire together. The Mongols stamped out metal passports with trilingual inscriptions stating that the bearer was on official imperial business. Armed with a passport and fresh horses, a lucky rider could cross much of Asia in a matter of weeks.

During the twelfth century, central and western Asia consisted of a wide variety of states ruled chiefly by Muslims of various traditions from Turkish, Persian, Arabic, Kurdish, and other peoples. There were centers of power, such as the city of Samarkand in the Persian sultanate of Khwarazm, Baghdad to a lesser extent, and in Egypt. They would fall one by one. The conquest of Khwarazm, with Temujin leading a column of his troops across a desert and thus avoiding the much larger army blocking more hospitable routes into Samarkand, gave the Great Khan control over the great cities and trading

routes of central Asia. Western Asia, and the wealth of the Islamic states of the modern Middle East, beckoned.

But again, this tale of conquest is not one of cultural or religious enmity, for all Christian rulers and priests in western Europe hoped the Mongols would convert (and help complete their vision of sacred history we've seen play out so many times). Mongols were pragmatic about religion for both practical and cultural reasons, all of which made travel through their empire easier, and paved the way for the welcome that the friars received. Christians weren't unusual to them, nor were seemingly "strange" members of new ascetic sects.

The Silk Road had often been a refuge for heretics who either chose to leave or were forced from their homelands, and that heterogeneity continued. Moreover, as Mongol hegemony spread, the rulers of the new empire faced the major problem that there just weren't enough Mongols to run a vast empire. To remedy this, the steppe elites married into local ruling families, both men and women co-opting preexisting power and economic networks to quickly stabilize the newly held lands. Chinggis sent his daughters into diplomatic marriages with new allies, not simply as pawns in a great game, but to govern and administer in their own right. But no matter how many children the Mongols produced or how many marriages they fashioned, the vastness of their empire required non-Mongol governors, bureaucrats, soldiers, and even generals. Most of these foreigners were Muslims; others, Nestorian Christians. Chinggis and his Mongols worshipped Tengri, the eternal sky, but were well aware of other gods, and found no reason to persecute or diminish peoples based on their religion.

Nestorians were among those "heretics," a group expelled from Byzantium in the fifth century over a dispute about the nature of Mary and Jesus. For Nestorians, Mary was not the "mother" of God, but had been the one who brought him forth. Nestorians thought

Jesus's personhood somehow separate from His godhood, perhaps being more God-inspired than actually divine. This group of Christians was roundly condemned by several church councils in Byzantium and so was forced eastward, out of the empire.

Nestorians kept moving east and eventually would become the dominant mode of central and eastern Asian Christianity. A raised stone stele commemorates the arrival of Nestorians in Tang China's capital city of Xi'an in the seventh century, although they were expelled from China a few centuries later. Still, five hundred years on, Nestorian Christians could be found more or less throughout Asia, and by this point Mongols had also encountered and conquered Orthodox and Armenian Christians as well. Though the friars themselves were surprised to meet Christians (albeit heretics from their perspective), it did mean that Christians from one continent often found commonalities with others they encountered, despite their differences of doctrine. The friars' journey is a sign of acceleration of movement, but not something totally new.

Nor did the kingdoms of western Europe seem so alien to the Mongols; the legacy of thousands of years of moving peoples and ideas had long prepared the way for friars to end up at the court of the khan. Certainly, the specifics of the geopolitical transformation of central Asia did take a long time to filter west, traveling via word of mouth and becoming garbled along the way. The fog of war obscured the details, and even in peacetime, news could often contain only fragments of truth by the time it reached distant ears.

Western Europeans heard, over time, that a new army had conquered great Muslim cities and defeated large armies. They seem to have heard of Christians leading the Mongol forces. Hope for a new ally against the Ayyubid dynasty, founded by Saladin and based in Egypt, blossomed in the West. Latin Christian authors—in a way not dissimilar to how the idea of St. Guinefort spread—responded to this

by creating the idea of a ruler named Prester John, a priest and king somewhere far to the east, perhaps India, perhaps Ethiopia, who had a mighty Christian army and would conquer the Muslims who held the city of Jerusalem. The myth of Prester John proliferated in literature, art, chronicles of war, across medieval culture. In the course of trying to reveal the sacred truth of Prester John or forge a military partnership based in *Realpolitik*, many individuals went from west to east and east to west. The movement eastward was, of course, always troubled by European ethnocentrism. As the scholar Sierra Lomuto has shown, travelers from Europe were never neutral observers, arriving in the East already questioning (really, doubting) the fundamental humanity of those they met and insistent upon their own racial superiority. They expected to find a mirror of themselves in the East and looked down upon those whom they found to be different.

The friars traveled west after, as it turned out, Europe had received its own reprieve from Mongol invasions. This had nothing to do with actions taken by Europeans and everything to do with internal Mongol politics (and just the sheer size of Asia). Chinggis died in 1227 and was succeeded by his son Ögedei, who had been designated as his heir. The Mongols once again swept west but this time as a fractured people. The new ruler established his capital city in Karakorum, along the major Mongol migration routes, but over the next few generations, Chinggis's sons, daughters, grandchildren, and assorted other relatives and in-laws divvied up the conquered territories and the empire began to fragment into more or less independent principalities ("khanates"). This wasn't an entirely unwelcome development from the perspective of the rulers in Karakorum. The sheer scope of the Mongol realms required autonomy, even as the rulers expanded the network of post offices to enhance communication.

Europeans may not have known all of these internal politics but

they did know they were in trouble. Batu Khan, the grandson of Temujin, led a large army into the lands of the Kievan Rus in 1237, eventually toppling the Slavic principalities that never managed to unite in opposition. Then the Mongols turned their attention farther to the west. In 1241, two separate Mongol armies invaded and won major victories in Poland and Hungary, pushing as far as Zagreb and contemplating an assault on Vienna. But that attack never came. Ögedei died, allegedly from drinking too much grape wine, and news of his death traveled swiftly down the postal roads to the armies in Europe. The descendants of Chinggis turned to head back to Karakorum to participate in selecting the next great khan.

Christians across Europe gave thanks for their salvation; then religious, mercantile, and diplomatic missions departed to the east, taking advantage of the Mongols' own infrastructure in roads and trading posts. The Franciscans and their elite patrons were eager missionaries; after all, they were an order that traveled, endured physical hardship, and modeled themselves after St. Francis, who had himself gone to preach to the sultan of Egypt.

Pope Innocent IV sent Friar John of Plano Carpini on a mission— both diplomatic and religious—to the Mongols in 1245. The friars bore papal bulls that instructed the khan in basic Christian doctrine and told him that if he did not convert and repent his sins against Christian populations who had suffered Mongol depredations, God would surely bring him and his empire down. This went about as well as one might expect. The great khan, Güyük (Ögedei's son) pointed out that "from the rising of the sun to its setting, all the lands have been made subject to me. Who could do this contrary to the command of God?" He ordered instead that the pope submit to him, to come to him and offer his service. "If you ignore my command," the khan warned, "I shall know you as my enemy. I shall make you

understand if you do otherwise, God knows what I shall do." They were clearly speaking the same diplomatic language, even if they disagreed about who was more important.

Still, the trip wasn't useless from the Christians' point of view. Friar John witnessed the formal elevation of the khan to power and learned about the Mongol state. He and his companions met many Christians along the way and learned something about global Christianity (such as that there were lots and lots of Nestorians living comfortably throughout Asia). And he found ways to communicate across linguistic divides. Indeed, the sheer number of languages they encountered was staggering, with people speaking Latin, Italian, Greek, Arabic, Persian, a variety of Turkish tongues, and Mongol (which by then had been converted from a solely oral language to a written language one, using a Uighur Turkish script). People almost always spoke more than one language during the Bright Ages, but the Mongol hegemony across Asia and into Europe thickened the cultural, linguistic, and economic bonds among already connected continents, making it easier—and more necessary—to find potential translators.

King Louis IX's own mission to the Mongols left just a few years after the pope's, dispatched in the aftermath of a military disaster in Egypt, but a disaster that shows us once again the ongoing connections between central Asia and the Mediterranean world. After Louis burned the Talmud and brought the relics of Jesus into his private chapel, he went to war, proclaiming his desire to conquer Jerusalem. As before, these moments of militant piety ostensibly directed at Muslims often resulted in violence and state persecution of European Jews. As he prepared for a campaign to Egypt, he banned money lending for interest, which he characterized as usury, and ordered the confiscation of Jewish property to enrich the crown (it's not clear to what extent this order was carried out). In theory these efforts were supposed to promote Jewish conversion to Christianity—one

of many fantasies of mass conversion aimed at Jews, Muslims, and the polytheists of the steppe. In practice, they laid the groundwork for the future expulsion of Jews from France in the early fourteenth century.

After the completion of Sainte-Chapelle in 1248, architectural construction transitioned to military expedition. Louis's campaign in Egypt began auspiciously enough with the capture of Damietta, a major port on the Mediterranean, in the summer of 1249. It quickly turned into a disaster for the Christians and their allies. Egypt was hot, and the army was prone to disease. Marching up the Nile toward Cairo, Louis's army found its advance hindered by the annual flood of the great river. A journey of weeks became months, and they were harassed all the while by Egyptian raiders. Meanwhile, Sultan al-Malik, ruler of the Ayyubid dynasty founded by Saladin, had died, but his wife Shajar al-Durr was keeping his death secret.

Here is where the Asian steppe reached Egypt. Shajar al-Durr was Turkish, enslaved as a child and brought to Egypt, where she eventually became the caliph's concubine. She used the time after al-Malik's death to rally the loyalty of Turkish soldiers who, like her, had been brought to Egypt as slaves. This use of enslaved people (or previously enslaved, converted to Islam, then emancipated) as soldiers was a common pattern in a number of Muslim societies at the time, but always ran the risk of allowing them to form a cohesive, independent, and often power-hungry group. Turkish slave-soldiers had seized power from the Abbasid caliphs in previous centuries, and now these Mamluks would take over Egypt. Shajar al-Durr summoned her son by the sultan, Turanshah, and forged a document proclaiming him heir. The other Mamluks backed her play; they were unified and ready for Louis IX.

Meanwhile, Louis's army slowly advanced until they came to the town of Al Mansourah. A Mamluk general named Baibars

al-Bunduqdar—a man who would eventually conquer the entire region—came up with the plan to open the gates in hopes the French would think it was undefended. The French obligingly rode into the city, and when the Mamluks attacked, the Christian army was broken. Turanshah took personal command and declared himself sultan in public. A few weeks later, Louis IX and his brothers were captured and forced to surrender Damietta and pay a vast ransom. Humiliated, Louis made his way from there to the remaining Latin Christian settlements on the east coast of the Mediterranean.

It was after this humiliation, as Louis worked to shore up the defenses of what remained of the Christian Holy Land, that the king turned his attention to the east, wondering if the Mongols might be potential allies, wondering if Prester John had come at last. But even as missionaries returned home, providing rich ethnographic details, the era of major military expeditions from the west to conquer Egypt or Jerusalem had ended.

Observe the motion, the movement from Paris to Cairo to Karakorum. Mongol armies marching across Asia, the enslavement and forced migration of Turkish children to slave markets in cities far to their south, Jews preparing to leave France for Iberia and North Africa, sacred objects paraded west from Constantinople, a shoeless friar walking east. All of it is accompanied by a great quotidian flow of luxury goods over long distances, as well as food, especially grain, carted from hinterland to market. But none of this is entirely new. People and things had moved along all of these routes throughout the Bright Ages. Mongols and Mamluks, kings and popes, brought an acceleration to long-extant vectors of permeability.

THE END OF THE GREAT MONGOL invasions further illuminates the connections across regions and religions. Hülegü, brother of Möngke and ruler of the Ilkhanate (or Persian area) of the Mongol Empire,

smashed fortresses in Iran, sacked Baghdad in 1258, then turned his attention back to the Mongol power politics when Möngke died. When he was away, the Mongol army met a Mamluk army in 1260 at the "Spring of Goliath," or Ain Jalut. There, for nearly the first time, the Mongol advance failed. The general of that Mamluk army was Baibars, soon to become the new sultan. He had witnessed his parents killed by Mongols, was captured, enslaved, and sold in the markets of Anatolia. Now his empire took firm control over the southeast corner of the Mediterranean Sea, eventually ending the presence of the Latin Christians in the east, taking the city of Acre in 1291.

With the end of major warfare came a stabilization of borders. Mongol leaders, marrying into local elite families, began to convert to Islam. Many depended on access to workshops in China for their wealth, so were deeply committed to maintaining the free flow of trade and peoples. Goods and ideas went all directions, not just missions from the west and silk from the east. For example, starting in the 1260s, a Nestorian priest named Rabban (or "master") Bar Swama left the area near modern-day Beijing and embarked on a pilgrimage to Jerusalem that turned into a life of travel, his journeys taking him through Central Asia to Baghdad, Constantinople, Rome, and back to Baghdad again. Like other traveling religious figures, he not only sought converts but simultaneously played a diplomatic role, laboring to build an effective military alliance for his Mongol rulers in Persia with the kings of the west in order to attack the Mamluks. As with all other such efforts, the logistics and sometimes contradictory goals of the various parties made effective alliance impossible. His journeys done, he spent the end of his life in Baghdad, writing of what he had seen. He might well have crossed paths with Marco Polo, a Venetian merchant who spent decades in China serving as a functionary for Kublai Khan, yet another grandson of Chinggis. Years after his travels, Polo supposedly told his story to a writer of medieval romance, a

man named Rusticello, while the Venetian was under house arrest in the rival city of Genoa. Much of his account is credible, which is not to say it's true. The Mongol dynasty in China did, after all, bring in foreigners from across Eurasia to serve in its court, the better to avoid empowering potentially rebellious Chinese elites.

Regardless, editions of Marco Polo's travels spread rapidly, translated into myriad tongues, and at the very least they both reflect European interest and knowledge about Asia and stand as one example of European travelers to the East. The same can be said of Rabban bar Swama's mission or the enslavement of Shajar al-Durr. People moved. But so little evidence survives, a single drop in a torrent of travel throughout the vibrant century of the Mongol domination of Eurasia.

But when people move, so does their attendant humanity, their bodies being vectors of so much culture, language, and indeed disease. And sometime during the thirteenth century, a bacterium named *Yersinia pestis* jumped from animal to human, morphed and mutated, and raced across the steppe. This bacterium, cause of the Black Death, would ultimately reshape the entirety of the medieval world.

QUIET CANDLES AND FALLING STARS

In the city of Siena, according to a citizen and shoemaker named Agnolo di Tura, the "mortality" (the Black Death) began in May 1348. It arrived suddenly and terribly. Families fell apart as citizens attempted to quarantine the infected, but the plague still spread, moving by "bad breath" or even sometimes sight. The dead lay unburied in their homes and in the street. No one even bothered to ring church bells to mourn those lost. The city began to build mass graves, into which the victims were flung. New pits were dug every day.

Agnolo estimated that 80,000 died in Siena within just a few months, leaving only 10,000 remaining in the city. Valuables littered the street as no one was there to collect them, and no one much cared anymore. The world had been turned upside down, and material possessions no longer were valuable or, in many cases, needed. As the pestilence began to abate, Agnolo concluded, "Now no one knows how to put their life back in order."

We cannot wholly trust Agnolo's numbers (the data of medieval chroniclers are notoriously unreliable, and modern estimates suggest the death toll was below the 89 percent he suggested), but they do

at least convey a sense of what he saw—mass death on an unprece-
dented scale and a world transformed, with an uncertain future. Even
a decade later, as the Black Death lingered and recurred at moments
(as do most pandemics), people weren't sure what had just happened
and, maybe more important, what it all *meant*.

Jean de Venette, a friar writing in Paris around 1360, also saw a rav-
aged world. And yet, in the aftermath as he wrote, the world seemed
to be repopulating, with women often having twins or triplets. Then
he continued: "But what was most astounding was that children born
after the mortality . . . commonly had only twenty or twenty-two
teeth in their mouth, when before this time children in the normal
course of events had thirty-two teeth." Jean wondered aloud to the
reader what it could mean, concluding hesitantly that the world had
entered a new age.

Here, too, we should be careful with what Jean tells us. Human
physiology hadn't really changed; adult humans have thirty-two
teeth, while children have twenty (and it's always been so). Part of
Jean's assertion had to do with received authority, as the ancient
Greek thinker Galen, widely read on medicine throughout the Eu-
ropean Middle Ages, had written that all people had thirty-two
teeth. But perhaps more important, Jean, as a friar, wanted to call
out a warning, saying that the world experienced God's wrath in the
form of a plague, then was spared and allowed another chance—one
that humans were squandering. God had, according to Jean, even
changed man's physical makeup. This was a sign.

This isn't, of course, to say that medieval peoples were unaware
of the world around them, that the Black Death made them pay at-
tention to their neighbors for the first time, that from the grimy pile
of bodies arose a Renaissance. That is absolutely not the case. But
it is true that the Black Death changed the world. The widespread
nature of the pandemic—an event with which we're all too familiar

in the twenty-first century—had pervasive short- and long-term effects that cut across the sometimes all-too-neat lines we tend to draw between religion, politics, economics, culture, and society. This was a disease that touched three continents, remained endemic in areas for five hundred or six hundred years, and killed hundreds of millions of people. But the Black Death could only do so because of what had come before; all societies suffer the consequences of their histories, and the Bright Ages are no different.

THERE'S BEEN A REVOLUTION IN PLAGUE studies recently, spurred by a new interdisciplinary approach to the Black Death, or rather, what these new studies call the Second Plague Pandemic (the Plague of Justinian from the sixth to eighth centuries being the "First"). Working with archaeologists, such as those who excavated London's East Smithfield plague cemetery, and geneticists who have traced backward the ancient DNA (aDNA) of the disease itself, historians now have a much better handle on how global and deadly the plague really was.

As with most pandemics, this one began as a spillover event, when a relatively benign bacterium jumped from animal to human. We've understood that part of the process for a long time. But historians have tended to write about the Black Death as confined to 1347–50, with perhaps some acknowledgment of a Silk Road origin and trans-Asian and North African transmissions in the decades before and after. But thanks to the work of many scholars in many fields, and especially that of Monica H. Green, a historian of science and medicine, we've had the chance to write a whole new story.

We now know that by the time Jean de Venette had his revelation about the number of teeth in a person's mouth, a mutated strain of *Yersinia pestis* had likely been killing for nearly 150 years, had likely traveled more than 4,300 miles from its place of origin, and that the

strain hitting Europe was just one of many recent mutations of the disease. It would continue to kill people in Europe, across the Mediterranean, into sub-Saharan Africa (perhaps via a different variant), and throughout Asia for five hundred more years—a sanguine reminder, if ever there was one, that diseases could never simply disappear before the advent of vaccines.

Although scholars have long talked about different "types" of plague at that time—bubonic, pneumonic, septicemic—there really is only one, with all three terms relating to different symptomatic manifestations of *Yersinia pestis*. Bubonic plague, famous for its swollen lymph nodes, begins with the bite of an infected flea or tick. If the infection takes hold in the bloodstream, absent antibiotics, 40 to 60 percent die within a week or so of septicemic plague. Pneumonic plague occurs when the bacterium is inhaled. Death comes more quickly then, in just a couple of days.

In the past, we used to blame rats for the plague's spread—or more specifically rats and ships, the story being that the bacterium hitched a ride in the gut of a flea or tick, which in turn hitched a ride on the back of a rat, which in turn hitched a ride on European (mostly Italian) merchant ships traveling from the Black Sea back to Europe. The fleas, the rats, the people, all facilitated the spread of the disease. Some of that still holds. Rats were almost certainly a vector for carrying the ticks to their ultimate hosts, and a more interconnected commercial world surely helped spread the disease. Yet the jump from animal to human seems to have first come from the furry marmot, hunted for both its meat and pelt, somewhere in modern Kyrgyzstan or northwestern China sometime after 1200. From there, carried on the horses, clothes, cartloads of grain, and bodies of the Mongols, the plague radiated outward.

During the thirteenth century, it spread into China, maybe to the eastern shores of the Black Sea, but likely into Baghdad and farther

west into Syria. By the fourteenth century, it continued to spread in China, arrived in the south of Europe and moved northward within just a few years, raced across North Africa, and even seems to have crossed the Sahara—arriving in what's now Nigeria in the west and Ethiopia in the east. Another separate wave followed in the fifteenth century, pushing the Black Death farther south into modern Kenya, but also across the Arabian Peninsula, and deeper into central Europe. From there and then, it remained endemic across Europe, Africa, and Asia until at least the nineteenth century, existing in "plague reservoirs," hidden on the backs of so many different kinds of furry rodents and periodically leaping back to humans to devastate populations.

But, of course, although no stranger to pestilence, the premodern world didn't know about bacteria and was universally perplexed by what was happening. The responses people came up with are instructive, not just in how similar they are, but in how they were puzzling their way through this disaster. One of the more persistent myths of the "dark ages" is that there was no science, that superstition ruled. But that's a bad-faith argument, a cynical and patronizing reading of people and sources that don't have the accreted knowledge of seven hundred more years of history. Observers in China, Syria, Iberia, or France may not have gotten it right (far from it!), but the sources we do have reveal an understanding of how the disease spread, how important preventive measures were for the good of society, and how medieval people worked to make sense of the disaster.

In the first half of the fourteenth century, an observer in Aleppo in Syria reported that the plague had spread from the Indus River to the Nile, sparing no one. The author thought the cause was clear; the plague was God's reward for the believers (turning them into martyrs) and punishment for the unbelievers. Other Islamic observers, such as a physician in southern Spain named Ibn Khātima, drawing as much from fellow Muslim medical writers as ancients like Hippocrates and

Galen, noted how the plague moved from the infected to the uninfected rapidly, and how fresh, circulating air ameliorated the spread, as did washing one's hands. Ultimately, Ibn Khātima, too, had to conclude that God was the ultimate judge of who would be infected and who would escape.

European Christian authorities responded in similar ways to their Chinese and Islamic counterparts. Doctors and faculties of medicine at various universities assigned the ultimate cause of the disease to God but were also suspicious of "poisoned air" that could be inhaled. In his book *The Great Surgery*, the papal physician Guy de Chauliac looked, as his counterparts did, to historical works for precedents and found none. He, too, found poisoned air to be the ultimate cause (airborne transmission of some pathogen invisible to the naked eye—a familiar terror in the age of COVID), which in turn troubled humanity's internal fluids. In trying to expel those poisoned fluids, the body pushed them outward, causing the swelling of the buboes in the armpits and groins. Thus, again, bloodletting and purgatives were the best remedies to be found for those already infected. Few of the remedies mentioned here actually cured the disease, but they should interest us because of how people were working through the problem. Their premises were wrong—they didn't have germ theory, of course—but they managed to still describe effectively how the bacterium was moving.

Numbers are a notoriously tricky thing to pin down across the medieval world, but it's abundantly clear that the Black Death was nothing short of catastrophic. After the first onset of the plague, China had lost about one-third of its population (roughly 40 million). In Europe, in just sixty years between roughly 1340 and 1400, the losses could have been as high as 50–60 percent. In the Islamic world, both in what's now the Middle East and across North Africa, recent research estimates that mortality rates were roughly the same

as elsewhere—overall about 40 percent of the population, with numbers unsurprisingly often much higher in densely populated urban areas.

Even beyond the numbers, the sources we do have point to the continuous anguish experienced by those who lived through the pandemic. Agnolo di Tura, who we met at the outset of the chapter, lamented that he had buried five of his sons with his own hands, and that no one even grieved anymore because death was everywhere. Although writing from the early fifteenth century, Ibn Alī Al-Maqrīzī echoed Agnolo by recalling that so many had died in Cairo, the city had become "an abandoned desert." The Italian medieval author Giovanni Boccaccio in his *Decameron* reported that the plague spread "with the speed of a fire racing through dry or oily substances that happened to be placed within its reach." Perception matched reality, Boccaccio continued, as it seemed that physicians and their medicines were powerless against it.

But physicians were not, of course, the only healers in the Bright Ages. The medical faculty at the University of Paris, asked by the French king to offer its opinion on the plague, thought poisoned air (again, an invisible pathogen) to be the proximate cause of the disease and that physicians should absolutely be consulted to help heal those who'd been struck ill. Yet, they also warned the king that priests played a more important role. God punished the sinful, and that sin manifested outwardly in physical illness. God could remove the illness from the land if God's people acted in a righteous manner.

As we've seen again and again, religion provided medievals—as it does moderns—a frame with which to explain reality. Cleansing the world of sin was, in some ways, perhaps easier for monotheists across the Mediterranean world to conceptualize than ridding the world of invisible vapors. They had, after all, attempted to do so several times, with the canons of the Fourth Lateran Council springing immediately

to mind as an example. In addition, there were many rituals and structures on which they could rely, traditions of previous responses to pestilence—such as Gregory the Great's procession in Rome against the First Plague Pandemic—that could help them. The actions of their religious leaders served as models, and there are plenty of examples of priests, rabbis, and imams staying with their communities, offering what comfort they could to the afflicted. Often serving alongside physicians, they promoted charity toward the sick, as well as prayer, pilgrimage, and sacrifice to appease a wrathful God. Saints were invoked to once more act as protectors of their devoted followers, charitable donations were collected, and fasts were sometimes organized to wash away bodily temptations. This, of course, could all be done in moderation or it could be taken to extremes.

In the face of crisis, the recourse to extreme measures is always a temptation. The Black Death was no different. In Europe, groups called the Flagellants (from the Latin *flagellum*, meaning "whip or scourge") lived up to their name. Although relatively short-lived and mostly confined to the Rhineland and the Low Countries, groups of Christians would travel from town to town literally whipping themselves, performing a type of martyrdom by destroying their bodies, asking that God look down on their willing suffering and recognize their repentance by removing the plague from the world. Although often composed of laymen, these groups of flagellants could also include churchmen who would gather together to become a wandering community, directing their anger at local magistrates and priests, who supposedly weren't doing enough to lead their towns and villages. A monk of Tournai in modern Belgium wrote that the arrival of flagellants (led by a Dominican friar) attracted a great crowd, who watched their procession and mass self-whipping in the town square. Then followed a sermon that whipped up anger against the Franciscans and all the priests, calling the Franciscans "scorpions and the Anti-

christ," and saying that the actions of the flagellants were more meritorious than any action "aside from the shedding of the blood of our Savior." Unsurprisingly, speeches like this drove many people away from churches and caused general disorder.

In effect, the flagellants were rejecting Canon 1 of the Fourth Lateran Council, the idea that the structures and rituals of the Church were the only path to salvation. As such, the monkish observer was horrified and was quick to report that the king of France and the pope both condemned the practice. But there's another important point buried here. Part of the subject of the Dominican's sermon was recruitment, of course, that the flagellants were a "better" outlet for religiosity, but it was also a form of scapegoating, likely indicative of the pervasiveness of the late medieval anticlericalism we saw with the heretics of centuries before. Traditional forms of help had failed and so they looked for something new. All structures of authority, in this case manifested in disaffection with the Church, are exacerbated in times of acute crisis.

Crisis almost always falls most heavily on traditionally marginalized communities. Preexisting systems of violence, state or otherwise, descend on the most vulnerable. Throughout Europe, the long-term sick and the Jews were singled out for blame and subjected to horrific violence. The idea that the plague was, as we've seen, some sort of "poisoned air" led swaths of Christians to single out the Jews as the perpetrators, claiming that Jews had poisoned wells or food in order to seek revenge against the Christian majority; never mind that of course Jews were suffering and dying right alongside their Christian neighbors. These accusations against the Jews emerged from a longer, deeper strain of anti-Judaism embedded into the fabric of Latin Christianity itself. Pope Clement VI acted to try to protect the Jews from extrajudicial persecution across Europe, but his papal bull prohibiting Christians from harming Jews, "even though we justly detest

the perfidy of the Jews," was never universally honored. His injunction seems to have simply moved those attacks into the law courts, where Jews were often prosecuted, summarily tried, found guilty, and murdered.

In the Catalan town of Tàrrega in 1348, shortly after the arrival of the Black Death in early July, the Christian citizens of the town marched against their neighbors and slaughtered them, calling the Jews "traitors." Mass graves excavated in 2007 confirmed the accuracy of the events described, revealing in the skeletons the injuries the Jews suffered and that some of the murdered were children as young as three or four. The report of the Christians calling Jews "traitors" confirmed the motivation, as the only person or thing the Jews could have "betrayed" in this instance was Jesus, and that betrayal, that supposedly continuous sin, echoed into the medieval Christians' present and resulted in scores of mass graves, filled with Jewish men, women, and children. When leaders either cannot halt a crisis or choose not to do so, or at times they intensify that crisis, the most vulnerable are too often left behind or slaughtered. In the middle of the fourteenth century, elites too often chose conspiracy theories and scapegoating, which cost thousands their lives.

WHEN WE TALK ABOUT THE BLACK Death, our focus is often far too narrow. We think of one continent. We think of just a few years. We think of statistics. But if we've learned anything from the most recent twenty-first-century pandemic (still an open question), we've learned the dangers of thinking so narrowly. Across at least three continents, over several hundred years, in waves, the Black Death caused hundreds of millions of suffering people; and each of those hundreds of millions of people had a mother, a father, perhaps children, a spouse, and friends.

In the plague cemetery excavated at East Smithfield in London,

the vast majority of all the people there died before reaching the age of thirty-five. Of the approximately 750 bodies recovered, nearly 33 percent (about 250) were children. Disease took them all. Among the approximately sixty skeletons recovered at Tàrrega are those of toddlers. In this latter case, though, the disease didn't kill those children, people did. But in every case, around every soul lost, there was grief. The dead were mourned. The language of suffering we see in our sources, inscribed on vellum, entombed in the earth, represents pain on a scale that's almost beyond our comprehension. All of our sources, from China to Syria to France, struggled to figure out "why?" They looked to the past with confusion, they looked to the sky with awe, they looked at one another with hate, never realizing that the real cause lay on their own bodies, nearly invisible.

We can almost trace it backward, reversing the waves of disease that swept across the land, over the sea. The buboes that swelled in the armpits and groin, caused by the bite of a louse or flea. The flea jumped from a rat or mouse or other rodent that had simply come too close, perhaps living among humans in a city or perhaps hunted for food and fur in the case of some indigenous rodent. Or maybe the bacterium of that flea jumped from person to person in the course of everyday interactions. But in any case, those European people and European rodents that carried the fleas that carried the bacterium were, in turn, infected from elsewhere. They came in grain carts alongside the Mongol armies. Merchants who moved across the Mediterranean, sailing from Italian ports to Syria, to Egypt, or into the Black Sea, brought disease with them. Other merchants took the disease from Egypt and Syria into the Arabian Peninsula and across the Red Sea into sub-Saharan Africa.

The Black Death, the Second Plague Pandemic, is a story of the Bright Ages. It's about the expanding Mongol Empire, which conquered not only China but large parts of the Middle East, and even

reached the Danube in Europe. It's a story of war and politics. But it's also a story about economics, about merchants who sometimes traveled thousands of miles to connect China and Europe, who moved across the Mediterranean and sometimes across the Sahara as a matter of course.

We've long known of movement across the Sahara before the middle of the fourteenth century, with the pilgrimage of Mansa Musa (1312–37), ruler of the Malian empire, to Mecca in 1324 being the most famous. A Christian king from Nubia spent time in Constantinople in the early thirteenth century (with plans to continue on to Rome and then to Santiago de Compostella in northwestern Iberia), and there seems also to have been at least one embassy from Nubia that arrived at the papal court in the early fourteenth century, offering their fellow Christians aid in the fight against Islam. But trade routes both across the Sahara and, especially, inland from the Indian Ocean via the Horn of Africa were even more extensive. And given the way that we now know the plague traveled, these routes could well explain the archaeological evidence that certain settlements in eastern and central Africa were rapidly depopulated and even abandoned at this time. These included outposts on the coast as well as possibly larger inland cities, such as Great Zimbabwe (although much more research needs to be done). Further, although sparse, some Ethiopic writings from the period and Sudanese documents from a bit later hint heavily at the impact of the plague, citing widespread disease and in Ethiopia the new veneration of saints thought to be efficacious against plague (such as St. Roch) around the fifteenth century.

And then, too, it's a story of culture, of how communities began to both unravel and come together to understand the calamity. In the end, the history of the Black Death unfolds in slow motion, across hundreds of years, over thousands upon thousands of miles, and was inscribed upon the suffering of hundreds of millions of people.

As the first wave of the pandemic receded, we can safely agree with Jean de Venette that it left a world transformed. Jean may have been wrong that humans had been physically changed, but he wasn't wrong that humans had to adapt to new realities. The Black Death, in other words, may not have been the end of the world but it was an apocalypse (in the literal sense of the word), an unveiling of a hidden truth. The Black Death revealed that people had always moved into and out of Europe, across the Mediterranean, into and out of Asia. The Black Death revealed that those people's mental and material worlds touched both the Atlantic and Pacific Oceans. The Black Death resulted in a world afterward that began to shift its gaze, to focus on different points of light.

One of the oddest theories about the origins of the Black Death was that it was caused by a star. William of Nangis wrote that in August 1348 "a very large and bright star was seen in the west over Paris . . . Once night had fallen, as we watched and greatly marveled, the great star sent out many separate beams of light, and after shooting out rays eastward over Paris it vanished totally." This, William concluded, seemed to presage the great mortality. The Black Death caused its victims and narrators to look in its neighbors' mouths, yes, but it never stopped them from keeping one eye fixed on something greater, on how God worked in the world, on the heavens—in the words of several fourteenth-century poets, on the stars.

STARS ABOVE AN
OCTAGONAL DOME

The year was 1292 and the people of Florence, which is to say "certain good men, merchants and artificers," were pissed off. According to the *New Chronicles* of Florence, written in the 1300s by Giovanni Villani (d. ca. 1348), a wool merchant, banker, and allegedly corrupt government contractor, the city had grown "happy in all things" and its citizens "fat and rich." But tranquility brings pride, and pride brings envy, so citizens began to fight with one another. The magnates, the greatest families in Florence, were the worst of all. Villani said that in the city and the countryside, these magnates took what they wanted, killed anyone who got in their way, and left the merely well-off, an "upper middle class" of sorts, with only one choice: to seize power.

And so they did. The "Second Popolo," as Villani called it, enacted the Ordinances of Justice, which elevated non-elite members of the city's guilds, limited the powers of the most elite families and excluded them from the highest offices, and punished patricians for their crimes. Then, having taken control, the Popolo looked around and decided that their church was too small for a city so rich and

grand. By 1296, the communal council appropriated funds for the initial design and construction of the rebuilt church and hired a sculptor as master builder. In 1300, the work had begun: the builders were erecting a new façade and offering the council a plan that they declared was "magnifico."

But construction stalled after just a couple of years. Another civil war erupted, the French king and papacy got involved, and many of those in government were killed or forced into exile. Among those who fled Florence, never to return, was the medieval poet and politician Dante Alighieri.

It wouldn't be until the 1330s that work on the cathedral resumed. By then Dante had died in exile, in Ravenna, and it would be yet another century (1436) until the citizens of Florence could celebrate the formal consecration of their cathedral, a majestic building with an octagonal dome soaring into the sky, truly one of the great wonders of the so-called Italian Renaissance. But like everything in the Italian Renaissance, the story of the Florentine cathedral finds its foundations literally and figuratively squarely in the Middle Ages. This includes not just the building itself, but the processes and governmental systems that brought it about: that is, democracy.

As WE HEAD TOWARD THE END of the Bright Ages, let's quickly look back to their beginning.

The Early Middle Ages did see a decline in the scope of urbanized life in western Europe but cities never fully fell away. Throughout the Middle Ages, people lived in close proximity to one another, working in diversified economies, with hinterlands providing food and other agricultural products through localized market economies. Iberian and Italian cities, some with origins dating back centuries, and others, like Venice, relatively new, continued to exist throughout the history of early medieval western Europe. Granted, as time moves

toward the turn of the first millennium, most of this activity and density gravitated toward the eastern Mediterranean and more generally to the coasts, where growing seasons are longer and climates more temperate. This eastward movement was also spurred by the expanding Islamic world, which pushed urban development and even built new cities wholesale (such as Abbasid Baghdad in the eighth century). But even far to the north, Vikings built port cities, small by Mediterranean standards, but recognizable as such.

Still, the greatest urban habitations of Europe outside of Byzantium did require significant political, economic, and agricultural development to sustain growth over the long centuries. Shifts in animal husbandry, farming techniques, and relatively benign weather allowed for surplus food and surplus population growth, sparking local economies. As these economies developed in parts of medieval Europe, political authorities found it advantageous to yield some direct oversight of these communities in exchange for the economic benefits that more populous and diversified settlements could bring. Starting in the eleventh and twelfth centuries, the city became once again one of the core features of the western European landscape, a center of religious life and education (homes to universities and cathedrals), and capitals of political authority. And with cities, we have citizens and their culture and their government. We have medieval democracy.

Citizenship in these cities was both a formal concept, as an exclusive and often gendered category that granted certain rights and privileges, but it also could at times informally extend to anyone living within a given locale's boundaries. As such, citizens participated in multiple forms of overlapping community. A medieval city dweller might be a citizen of the city, a member of a specific parish, a member of a voluntary charitable association and/or professional body, a resident within a specific political district (a ward, for example),

self-identify with a neighborhood, and participate within any number of subcommunities within these structures. Sometimes these associations combined functions—a guild for a specific trade might perform charity, or a semi-religious fraternal body might exist within a parish hierarchy. These overlapping semi-egalitarian communities challenge the notion of medieval society as rigidly hierarchical or simple. People then, just as people now, lived complex lives and moved between communities often.

Guilds were one of the most indelible features of medieval urban life. The best-known types were craft or trade guilds (merchants' guilds, weavers' guilds, grocers' guilds, and so forth), in which people in related occupations joined together to train new members, but also set standards, control prices, minimize competition, and engage in various kinds of other mediation, regulation, and celebration. Parishes might have organized religious guilds around particular festivals, public rites, or charities. Social guilds might have formed around neighborhood, social class, charity, or just for the fun of drinking together. In sum, guild functions might overlap and were often not rigidly economic, religious, or social.

As they formed urban communes, they developed traditions of writing by-laws and established systems of voting that were particularly unique. In government, they might elect mayors, judges, or other officers. Residents of a neighborhood could select an alderman or other designated representative. Members of large councils would vote for members of small councils. None of these systems were universal democracies—cities reserved the right to vote to male citizens only, guilds often only to masters, neighborhoods sometimes had requirements based on wealth and property. Still, these kinds of selection criteria had also been present in the ancient republics— Athens, Rome—that tend to be touted as the great models for modern electoral systems. Electoral systems almost always construct an

electorate by excluding people, then as now. The right to elect rulers is always jealously guarded by those who already have the power. But voting was a normal part of medieval urban life.

The cities of Italy are just one set of examples, but an important one. Great and small, up and down the coasts, with varying degrees of oversight by imperial, papal, and royal powers, the Italian republics sent ships across the Mediterranean. They welcomed merchants from abroad, and served as means by which people (not all voluntarily; the slave trade was a major source of revenue for some of these cities), goods, and ideas could spread into the rest of Europe. The key is to understand these cities not as aberrations in the fabric of medieval European history, but as normal. They are as much a part of what we should imagine when we hear the word "medieval" as a castle in Wales, a cathedral in Germany, or a farm in Iceland. This is true not only because of the connections between these cities and the broader medieval world, but because their ways of life and systems of government and the material cultures in which they engaged would not have seemed foreign to a Londoner, a Parisian, or even a peasant toiling in the fields.

Voting was a prominent part of medieval urban life, sometimes for governance of the whole polity, at other times for organizing local systems. Medieval voting systems were often secret, and clever, ostensibly to limit the creation of voting blocs or factions but often simply ensuring that those with power retained it. Although this varied by time and place, of course, more rural areas were generally dependent upon the nobility for protection and subject to their economic and social whims. Cities, on the other hand, through collective power, could work to their own benefit or could play factions off against one another. The medieval English city of Bath and Wells, for example, had a corporation that brought in elites from numerous trades, who could then avoid other kinds of judicial proceedings

by using internal arbitration processes when members had disagree-
ments with each other. Capital cities like London or Paris functioned
as above but also had to negotiate their relationship with the crown.
In London, the semi-elites of the city tended to side with the king
against the landed gentry, a position that won them considerable in-
dependence and political authority through royal concession in the
thirteenth century.

During the eleventh and twelfth centuries, as the nobility looked
to take control of these cities, wary of their moves toward forms of
self-government, city dwellers bristled and demanded increasing in-
dependence from hereditary rulers, whether local or regional lords.
Sometimes this could be reconciled amiably, with the opportunities
for greater profits from regional and long-distance trade inducing
kings, dukes, and counts to loosen their grip over cities in exchange
for a cut of tax and toll revenue. A "commune"—a formal corporate
body composed of citizens who determined how their city would be
governed—might form peacefully in the wake of such an agreement.
But as time went on and more cities sought independence, urban
leaders had to decide how to position their city in relation to bigger
powers such as the Holy Roman Empire and the papacy. Even long
after the era of communal revolts had ended and democratic systems
of government were entrenched for the next few centuries, urban
politics could easily devolve into armed factional struggle. In these
cases, the shift from heredity rule to democracy, or at least elected
oligarchy, seemed to require violence.

SOMETHING OF A LATECOMER TO MAJOR political power, Florence
climbed to independence amid the tumultuous conflicts among re-
gional nobles, popes, and emperors. When Emperor Henry V (1111–
25) appointed a loyal count from Germany to take over Tuscany, the
Tuscans rebelled, eventually killing the count in battle and estab-

lishing an independent commune centered on Florence and led by a handful of elite aristocratic families. They remained technically part of the empire but answered to no hereditary noble and maintained an uneasy relationship with the emperor. Although inland, thanks to their position on the broad Arno River they could participate in international trade and international politics, growing in prosperity over the course of the twelfth century. Although the city lost its independence briefly during the conquests of Emperor Frederick Barbarossa, by 1200 the Florentine commune had once again asserted mastery over its city.

The empire, however, still cast a long shadow, and such matters of international statecraft led to internal factional fighting between and within cities. In the late thirteenth century, Dante Alighieri's family was on the rise in Florence, with Dante himself the first in his family to attain an important civic rank. At the same moment, unfortunately for him, the major families of the city split into two vehemently opposed factions, loosely along papal-imperial lines. One faction backed the emperor, the other the papacy (although, to be fair, it's just as likely that this schism was an excuse for leading families to fight for dominance over the city). Nevertheless, the battles grew brutal, and nonaligned Florentines—including Dante, it seems—tried to expel the worst of the miscreants. The faction that Dante had aligned with initially took power and began to build the cathedral. But by 1302, the other faction was back and had retaken the city, murdering and exiling its foes, who now included Dante. If democracy was medieval, so too were the intricate politics of faction, seduction, assassination, and loss.

In his years of exile, in the first part of the fourteenth century, Dante began writing his *Divine Comedy*, a massive poem divided into three sections, written in Tuscan (a vernacular version of Italian), and focused on a vision of the poet himself visiting Hell, Purgatory, and

Heaven. The first canto of the first book opens with the poet wandering, alone, in a wood, in darkness. Dante in exile. But he lifts his eyes and sees the sunrise, and then climbs a hill to seek the light. The work is a culmination of centuries of developments, a text of the Bright Ages itself.

In many ways this quest for light—a successful one in the end—is the quintessential medieval narrative, depending on centuries of transregional interaction, the movement of Aristotle into western Europe and his impact on Christian theology, and medieval understanding of astronomy, math, and medicine. *The Divine Comedy* is not an inert theological meditation, though. Dante also relies on a rich sense of history, including the never-forgotten classical past. The Roman poet Virgil guides Dante through Hell and Purgatory, and other classical figures both mythological and real permeate the text. So too, among his "virtuous pagans" who are spared Hell, Saladin, Ibn Sina, and Ibn Rushd (among others) sit alongside their classical counterparts. Dante could not, within his worldview, allow non-Christians to ascend to Heaven but he found them a place away from eternal torment.

Dante's *Inferno* perhaps lingers longest in the modern imagination, titillating and horrifying in equal measures. The point of those visions, however, is not simply moralistic; Dante is also offering a biting political satire. He is angry about his exile, placing political rivals and contemporary religious figures by the dozens in hell, and ultimately—through the poetic version of himself in the text—learns about the relationship between God and the world, the application of justice, the course of politics. The deepest part of Hell is reserved for traitors. Moving through that ninth circle, Dante finds the worst characters of Italian factional politics—an archbishop who betrayed his co-conspirator, immuring him along with his sons so they slowly starved to death, a friar who slaughtered his guests at a banquet, and then Satan himself with his three mouths gnawing eternally on

Judas, Brutus, and Cassius. But at that darkest moment, Dante pushes through, literally scaling Satan's body, passing through the center of the earth to emerge on the other side, and greeted by shimmering stars above. As the *Inferno* concludes, through chaos and factionalism, sinners and torture, Dante comes to a vision of light and unity in both this world and the next.

The Divine Comedy as a whole drives toward the *luce etterna* ("eternal light"). Hell is characterized by an absence of that light, and Dante's passage through it allows him to understand divine love as the light's source, illuminated by a blanket of stars. The *Inferno* begins with Dante in total darkness, but ends with him and Virgil literally climbing out of Hell to "walk out once more beneath the stars." In fact, Dante ends each of the three books with that word, "stars," a symbol of divine hope. The *Purgatorio* concludes with Dante cleansed, reborn, and ready for Heaven, "healed of Winter's scars, perfect, pure, and ready for the stars." And then, finally, at the end of the *Paradiso*, Dante returns to earth, having seen the eternal light, his "instinct and intellect balanced equally . . . by the Love that moves the Sun and the other stars." This is a unity that links all creation, both life and afterlife. At the end, there is hope; there is always hope.

This insistent reference to stars makes sense as we return, here at the end of the Bright Ages, to Ravenna. There, in the ancient city, among its glittering mosaics, Dante in exile would have had ample opportunity to gaze upon luminescent depictions of God and eternity. The *Inferno* was just where he embarked, but he ascended with his guides through *Purgatorio*, and then finally to *Paradiso*. This last, his vision of heaven, is full of birds, flowers and natural beauty, and of course brightness. Perhaps in Ravenna Dante found inspiration where we started this book, beneath and amid the shimmering stars of Galla Placidia. We won't ever know if Dante specifically went to the mausoleum and looked up at the blue-and-gold sky, but we do know that

at one point in the *Paradiso* he broke the narrative to make a direct address: "Reader," he exhorted, "lift your eyes with me to see the high wheels . . . there begin to look with longing at that Master's art." He adds, "Now, reader, do not leave your bench, but stay to think . . . you will have much delight before you tire."

Let's leave Dante, then, in Ravenna, his final resting place. Yet before we do, let's imagine him alive and struggling to find the words to describe a vision of heaven. We can imagine him on his own bench in the empty mausoleum of Galla Placidia, staring up at a blue sky made of lapis lazuli and stars made from glass infused with gold, hung there by artisans nearly a thousand years before. Let's imagine Dante picking up his stylus, despairing of his exile but inspired by the heavenly vision, ending his journey through eternity by writing about a light that moved across a millennium, flickering down on him from a canopy filled with stars.

THE DARK AGES

In the year 1550, in the kingdom of Castile, in the city of Vallado-lid, a great crowd gathered at the cathedral to hear a debate about what it meant to be human. The topic at hand was more specifically what—not "who"—the natives of the so-called New World were, and by extension what rights the monarchs of Spain and their coloniz-ing landowners had over them. On the side of the landowners was a noted humanist, Juan Ginés de Sepulvéda, a devoted follower of the new Greek learning, informed by Aristotle, that adhered to the goal of breaking from the darkness of the medieval world and restoring the light of antiquity. On the other side was a Dominican friar, from a religious order born in the crucible of Inquisition and crusade, Bar-tolomé de las Casas, himself a former landowner in the New World, but now converted and steeped in the best "medieval" ecclesiastical training available.

Sepulvéda argued that Spanish power had an almost unlimited scope in the Americas because, following Aristotle, the natives were "barbarians" who didn't know civilization. Their inferior rational abil-ities, according to Sepulvéda, were manifested in their demonic pa-ganism and justified their conquest, pacification, and ultimately conversion. De las Casas, however, thought this brutal, unjustified,

and illegal. Invoking *convivencia*, the friar argued that the indigenous peoples of the Americas were polytheistic, yes, but that made them no different (in the Christians' eyes) from Muslims and Jews in Europe and therefore entitled to the same right to live peacefully as any others. In fact, he continued, trying to convert the natives by force would damn not only their souls but the Spaniards' as well. Conversion to Christianity (which de las Casas did support) must be done only by peaceful preaching.

The debate itself, held before a council of theologians and representatives of the king, technically finished without resolution. No formal judgment was offered. In the short term, de las Casas seemed to have won. The Spanish crown expanded its direct oversight of landowners and took responsibility for the natives' welfare, limiting many of the abuses suffered. But longer term, Sepulvéda should be judged the ultimate victor. The friars' role in advocating for the natives was slowly quashed and the landowners expanded their power at the expense of the indigenous population. Perhaps more important, moving forward in the sixteenth century, Aristotle's definition of "barbarism" overtook Europe—deployed by Catholics and Protestants against each other in the Wars of Religion, justifying state violence against natives in the Americas as well as each other.

This was a debate, at its core, about medieval vs. modern, about religion vs. secularism. Sepulvéda was the modern secularist, using Aristotle and natural law for the centralizing state and "progress" to justify colonization, violence, and oppression. But the one arguing for peace, for tolerance, was de las Casas, the medieval religious. Though he didn't know it at the time, he was arguing for a lost world, a Bright Ages now eclipsed.

This outcome of the debate at Valladolid in 1550, perhaps better than any other moment, signifies the triumph of modernity. The complexity of the medieval European world, all of its possibilities, all

of its horrors, and all of its hopes, collapsed upon itself—in a church, in front of theologians, on behalf of a Holy Roman Emperor, as they debated a world that just sixty years earlier had been beyond their imagination.

IF THE BRIGHT AGES PERHAPS ENDED in the middle of the sixteenth century, its waning can be traced to much earlier. Historical periods, of course, never summarily "begin" nor "end" but the accreted changes do begin to weigh heavily upon our analysis and at some moment it becomes clear that things are qualitatively different from what came before. In the 1370s, one figure at least—the poet Petrarch—was so certain his own time had just emerged from an age of darkness that he generated clouds of obscurity from which we're still trying to emerge.

Petrarch, who wrote stunning poetry in Tuscan (the language of Dante) that dances between celebration of earthly beauty and religious allegory, also wrote surly prose in Latin. In Cicero's tongue, as he imagined he was replicating it, he griped about his critics and praised himself as the originator of the New Age—a new era of cultural and intellectual production. According to him, he began a "Renaissance," if you will.

But not everyone agreed with him. In an "apology" to his French critics (really a diatribe against them), he lamented the intellectual milieu of art and thought that had preceded him, saying that they were cloaked in "darkness and dense gloom." They were "dark ages." He characterized the classical past as an era of "pure radiance," and in a different letter wrote that antiquity "was a more fortunate age and [that] probably there will be one again; in the middle, in our time, you see the confluence of wretches and ignominy." Petrarch saw himself at the tail end, he hoped, of this middle—or medieval—era.

Although we (rightly) lay much of the blame for the concept at Petrarch's feet, the idea of a dark age was not entirely new by the

time we get to the late fourteenth century. Thinkers of the preceding centuries were deeply interested in the structure and organization of time. The general pattern, they believed, had been laid out in their sacred scriptures, with the world heading inevitably toward disorder and chaos just before the final End—good, bad, then finally good once more. But Petrarch's campaign was on another level. As propaganda campaigns go, the period we now think of as "the Renaissance" was spectacularly successful. Petrarch and his contemporaries argued that the knowledge of antiquity had been lost for a thousand years but now was recovered, reborn, translated into their fourteenth- and fifteenth-century Italy. This argument was political as well as cultural; Petrarch, for example, wanted to make Florentines as devoted to Florence as his idealized Romans were to Rome, willing to die for their republic. It was a campaign he could launch, ironically, only because of a centuries-long tradition of engagement, commentary on, and reproduction of classical texts and knowledge. He also required the earlier development of vernacular literary traditions, such as by Dante, in order to produce his own poetry. There certainly were innovative artistic movements centered around the adaptation of classical norms in late fourteenth- and fifteenth-century Italy, but that movement depended on preexisting intellectual and artistic life, even as Petrarch claimed to be rejecting it. Despite his claims, he didn't build it by himself.

What's more, Petrarch and those who followed him as "Humanists" saw their mission as vital not because they were living in a glorious golden age of art and beauty, but because things were so terrible. War and disease ripped through Italy, with factionalism and internal strife, rising tyranny, overt corruption, and worse. By 1506, a Florentine captain general urged Machiavelli to take up again his plan to write a history of the Florentine Republic. "Without a good history of these times," the captain general wrote, "future generations will never

believe how bad it was, and they will never forgive us for losing so much so quickly."

But just as we cannot sever Renaissance humanism from medieval intellectual life, we also cannot sever Renaissance horrors from medieval practices. The famous works of Renaissance art, whether civic, devotional, or personal, all required vast sums of wealth from a world becoming more unequal, profiting from centuries-old practices in quite new ways. Recent scholars, for example, believe that Leonardo da Vinci's model for the *Mona Lisa* was the wife of a slave trader. We can look on *"la Gioconda"* and admire her smile and Leonardo's brilliance but we can't do so and ignore that the wealth of her class came at least in part from the intensification of an economy fueled by mass human trafficking. As we have seen throughout our history, at least some people were unfree in every medieval society. Being unfree could and did mean different things, with a wide variety of rights, protections, obligations, and pathways—or not—to freedom. Nevertheless, although chattel slavery—the buying and selling of humans—was more common in the urbanized Mediterranean than elsewhere, a factor of easier access to markets, the principle of buying and selling humans was known to medieval people, just as to ancients, just as to moderns. In the later Middle Ages, access to Black Sea ports brought new waves of enslaved peoples to the medieval Mediterranean and Europe—a trading culture common to Christians and Muslims, Italians and Egyptians. Medieval people also formed the foundational ideas about racial difference and otherness that underpinned the transatlantic slave trade, which brought so much misery. As scholars such as Geraldine Heng, Dorothy Kim, Sierra Lomuto, Cord Whitaker, and others have shown, the roots of modern white supremacy emerge not from the fantasy of a racially pure Europe (one that never existed) but rather from intellectual foundations in the Christian encounter with Jews, Muslims, and Mongols.

TODAY'S DARK AGES

Throughout this book, we have labored to show a medieval world filled with brightness. Sunlight passes through stained glass. Fire consumes the books judged heretical or sacred to the Jews. Golden, bejeweled reliquaries glint as they are raised above armies marching to war. Great conflagrations consume cities. Spiced foods and fine texts, knowledge of antiquity, music, and fine art all move throughout the greater medieval world inspiring and illuminating the senses and the mind. Enslaved peoples are forced from their homes and sold right alongside those fine products, perhaps just down the road from where scholars of three different religious traditions toil together over Aristotle. Africans live in Britain, Jews are neighbors to Christians, sultans and friars hold theological debates; and then just as often, they all do violence to one another. Our Bright Ages are not simple or clean, but messy and human, and we think that's as close as we can come to the truth.

Meanwhile, the story of the "Dark Ages" and an isolated, savage, primitive medieval Europe continues to pervade popular culture. It was never true, and yet the myth's development and survival has done much harm across the centuries. Its survival gives us a place to put our unfamiliar selves, the things we don't want to recognize when we look in the mirror.

Petrarch and his contemporaries may have laid the foundations for seeing the medieval world as backward and dark, but the Enlightenment of the seventeenth and eighteenth centuries built the house in which we still live. It was then that citizens of the monarchical European powers attempted to explain how they got to where they were by looking to their roots. They started from the idea that their world was "better" than what had come before. Europe had supposedly crawled out of the darkness and into the light. Those familiar

terms—dark and light—mirrored the value judgment behind this investigation of the past, one that selectively privileged white skin. These were, after all, countries ruled by rich white men for other rich white men. So in searching for the history of themselves, they ignored stories they didn't recognize—stories of people who didn't act, think, or look like them. That was true even when those stories were central to European and Mediterranean history, stories we have tried to tell throughout this book—a history that must include the views of those who spoke Arabic, Turkish, and Hebrew, among others; stories written or enacted by women or people of color.

Although these early modern histories of Europe began as national legends, thinkers in the eighteenth and nineteenth centuries looked to fourth-century Germanic peoples as their pure, white ancestors, with a distinctive cultural legacy that needed to be valorized. In alliance with the "scientific" study of the past, scientific racism, the international slave trade, and colonialism, this approach began to change the way people understood the past. No longer individual nations—and also no longer simply "Europe" because of the need to include North America—these thinkers used the term "the West" to encompass one (supposedly) common heritage that explained why white men ought to rule the world. Western civilization, then, became the story of a supposedly unbroken genealogy that stretched from Greece to Rome to the Germanic peoples to the Renaissance to the Reformation to the contemporary white world. In between, in the middle, was a period of aberration that was polluted by superstition (meaning Catholicism, when Protestant historians of northern Europe did the telling).

All this meant that by around 1900 it was pretty common for European leaders to try to shore up their political narrative by referring back to the Middle Ages. Legitimacy needed deep roots. Kaiser Wilhem II, for example, went with his wife to Jerusalem in 1898 and

dressed up as a supposed crusader. He even forced his hosts to re-
move a section of the city's walls so he could enter it in the same place
that Emperor Frederick II, in the thirteenth century, had. During
World War I, several British publications referred to the 1917 taking
of Jerusalem by Allenby as a "completion" of the unfinished Third
Crusade of King Richard I. Similar stories could be told of almost
any European nation and how it looked to the medieval past to justify
its contemporary colonial ambitions and political pretensions.

The United States was of course part of this, leveraging a con-
structed "Anglo-Saxon" heritage and imagined, genteel class- and
race-based chivalry to justify its own white supremacy both before
and after the Civil War. It is not a coincidence that the members of
the Ku Klux Klan called themselves "knights," and that from the time
of Thomas Jefferson the term "Anglo-Saxon" was valorized as a racial
category that "ennobled" white Americans. This was, as Matthew X.
Vernon and others have shown, consistently contested by Black Ameri-
cans, who rightly insisted the medieval world belonged to them, too.

Nevertheless, this kind of ancestral medievalism was founda-
tional to how nations in "the West" constructed a usable past in the
eighteenth and nineteenth centuries, one that served the needs of
imperialism. But we can never forget that it's a virulently racist usable
past, often associated with acts of nationalistic aggression and the
development of society-wide bias. And no sector of society was un-
touched by it. Twentieth-century scholars often participated in this
work, willingly constructing national narratives that engaged—and
often supported—these colonial ideals.

We live, today, with the legacy of all this in our own dark age.
White supremacists continue to reach back to medieval European
history as a way to tell a story about whiteness, a sense of lost (but
imagined) masculinity, and the need to shed blood. We see this across
Europe when they cosplay as crusaders at anti-immigrant rallies, as

they wield spray-painted shields with "Deus Vult" at rallies in Virginia, as they post screeds linking themselves to an imaginary new Knights Templar in Norway, as they invoke battles between Muslims and Christians to justify a massacre in New Zealand. They draw on the popular, political, and scholarly stories of the "Dark Ages" but use new technologies to connect across oceans. They want to return to their imagined Middle Ages. Wherever you find white supremacists, you'll find medievalism, and you'll almost always find murder.

The fight against the "Dark Ages" is one that spans centuries. It continues to be of critical importance, but not just because people hold false impressions of the medieval world. The truth of all historical periods suffers under the weight of latter-day myths. Instead, this fight is critical because what binds all of these appropriations of the medieval together is the void at their core. That is to say, the particular darkness of the Dark Ages suggests emptiness, a blank, almost limitless space into which we can place our modern preoccupations, whether positive or negative. The Dark Ages are, depending on the audience, both backward and progressive, both a period to abhor and one to emulate. It is used as whatever one wants, as a "justification" and "explanation" for those ideas and actions because they supposedly go back so far in time.

We wrote this book in a moment of great global upheaval, during a raging global pandemic, radical climate change, and widespread political turmoil. We have, as we composed this book mostly from the inside of our homes during a quarantine, seen repeatedly how the medieval world springs forward into ours—how "plague" and "crusade" and "apocalypse" became commonplace terms to describe contemporary events. The temptation can at times be overwhelming to succumb to lamenting a coming Dark Age, to call our hypermodern economic systems "feudal," to criticize the 2020 response to the COVID-19 virus by comparing it to the Black Death. We return to the comfort of the

"Dark Ages" to distance ourselves from what we cannot bear to see in our own world, to impose at least some chronological alterity between then and now, between horror and hope.

But this we cannot abide. Simplistic comparisons to the past do violence not just to their time but to ours. By pretending *this* is just like *that*, we excuse ourselves from trying to really understand the "how" and "why" of the thing we lament or the thing we adore. The historical analogy becomes a simple explanation for what inevitably is a complex phenomenon. And as historians, it's always our job to remind people that anyone who offers that type of simplistic narrative is selling something. It's always the historian's job to say "it's more complicated than that." Indeed, it *is* always more complicated than that.

We hope that *The Bright Ages* rises to this challenge by illuminating the history of what we call the Middle Ages. It started with Galla Placidia staring up at a blanket of stars in a mausoleum in Ravenna, and an antiquity, a Rome, that didn't fall. We ended with Dante, who at the end of his textual journey was perhaps inspired by the same canopy Galla Placidia saw nearly a millennium before. Both in their own way, as they gazed upon the tesserae that sparkled above them, were perhaps rejoicing in what Dante called "The Love that moves the sun and all the other stars." And across that nearly thousand years, we have seen how people in their own times enabled and resisted oppressive systems, how they created beauty and engendered terror, how they both crossed and erected borders—how they engaged their own times as full, complex human beings. They loved, they hated, they ate and slept, cried and laughed, protected and killed. They lived in color. *The Bright Ages*, we hope, allows us to see all of the beauty and the horror. The way out of darkness is illumination—the way a mosaic can twinkle in the candlelight or blood can shimmer on the street. The past, if anything, shows us possible worlds, the roads

not taken as well as those that were. We hope a better-illuminated, if not always happier, narrative of the medieval past, one that makes both the realities and possibilities more visible, will also reveal more pathways before us in our own modern world.

May *The Bright Ages* help light our way forward.

ACKNOWLEDGMENTS

The debts we owe for this book are far too numerous to list. Thanks first go to our agent, William Callahan, and to our brilliant editor at Harper, Sarah Haugen. Both have labored and helped us make this book much better than it originally was in our heads. In that vein, thanks to (alphabetically) Roland Betancourt, Cecilia Gaposchkin, Monica H. Green, Colleen Ho, Ruth Karras, Nicole Lopez-Jantzen, Daniel Melleno, James T. Palmer, S. J. Pearce, Mary Rambaran-Olm, Andy Romig, Jay Rubenstein, Rachel Schine, Andrea Sterk, Tonia Triggiano, and Brett Whalen, who all read individual chapters and offered feedback and suggestions during the drafting process. Errors and omissions, of course, remain ours alone.

We also thank our wonderful colleagues past and present at Virginia Tech, the University of Minnesota, and Dominican University. Perhaps more important, though, we thank both our teachers and our students. *The Bright Ages* is fundamentally inspired by our time in classrooms, by our love of the conversations we have both during and after class, when our teachers generously entertained our questions and encouraged our interests, when we now get the chance to pass that on, to stay a bit after class ends because a student hangs around to ask just one more question. We hope this book answers some of those questions and spurs so many more.

Finally, our deepest and warmest thanks go to our families, who have been unwavering in their support and unflinchingly patient as we mentally moved across a millennium and more. This book, attempting to illuminate the past, hoping to show us possible worlds as we try to move toward a better future, is dedicated to them.

FURTHER READING

I't's too often thought that the work of the humanities is a solitary pursuit—that it's mostly lone scholars, sitting with their musty books, thinking deep thoughts. As *The Bright Ages* was composed mostly in the midst of a pandemic, we sat alone with our musty books, illuminated by the dim light of our computer screens, so that's true enough when it comes to the actual writing. Nonetheless, this book owes a tremendous amount to the exhilarating scholarship that continues to be done on the whole medieval world. The European Middle Ages have been chronicled since they were happening, even if the conception of it as a discreet period was only launched into being beginning in the late fourteenth century and then cemented into the modern academy in the nineteenth century. But something significant has changed in how we think about the past just in the past few years, as scholars try to formulate new (and better) questions that are more honest to the people, places, and events we collectively study.

Often works we mention in regard to one chapter illuminate several others as well, but for the sake of brevity we've listed them only once. In addition, understanding the European Middle Ages requires facility in traditions of scholarship across many countries, and in many, many languages, but we decided to list here only works in

English, and limit our suggestions to those that are more freely available than others.

Our suggestions for further reading are intended to allow you to dip your toe into a vast ocean of work. Its currents have comforted and terrified, warmed and chilled, but its mysteries have always fascinated us. What we have here is just the beginning of a journey.

Introduction

Every topic touched on in this book is a rabbit hole, a hyperlink, a portal to decades or even centuries of study and conversation. The European Middle Ages are vast, even beyond the more than thousand years of their purported existence. For a general overview of the makings of the *idea* of the period, including the phrase "the Dark Ages," you could read Wallace K. Ferguson, *The Renaissance in Historical Thought: Five Centuries of Interpretation* (Houghton Mifflin, 1948), Patrick Geary, *The Myth of Nations: The Medieval Origins of Europe* (Princeton University Press, 2003), or John Arnold, *What Is Medieval History?* (Polity, 2008). Important within that is the realization that power constrains how we divide up the past and how we think about our sources, and for that, see Michel-Rolph Trouillot, *Silencing the Past: Power and the Production of History* (Beacon Press, 1995). On the journey of the medieval coconut, see Kathleen Kennedy, "Gripping It by the Husk: The Medieval English Coconut," *The Medieval Globe* 3:1 (2017), article 2. Recently, exceptional research has been made more widely available thanks to a stronger ethic of public engagement, and blogs such as InTheMedievalMiddle.com stand out; Sierra Lomuto's "White Nationalism and the Ethics of Medieval Studies" (December 5, 2016) is an important example of this kind of work, one that has set the tone for conversation in succeeding years.

Chapter 1

Judith Herrin, *Ravenna: Capital of Empire, Crucible of Europe* (Princeton University Press, 2020), is the most recent book to unpack the history of this vitally important city where we began our own story, though there are plenty of others, such as Deborah Mauskopf Deliyannis, *Ravenna in Late Antiquity* (Cambridge University Press, 2010). Galla Placidia herself has, understandably, attracted a great deal of scholarly attention and there is much to digest in order to get the full scope of her incredible life. Perhaps start with Hagith Sivan, *Galla Placidia: The Last Roman Empress* (Oxford University Press, 2011), or Joyce E. Salisbury, *Rome's Christian Empress: Galla Placidia Rules at the Twilight of the Empire* (Johns Hopkins University Press, 2015); but for an overview of women in late antique Rome, see Julia Hillner, "A Woman's Place: Imperial Women in Late Antique Rome," *Antiquité Tardive: Revue internationale d'histoire et d'archéologie* 25 (2017), pages 75–94. On the magnificence of the mausoleum in Ravenna generally, see Gillian Mackie, *Early Christian Chapels in the West: Decoration, Function and Patronage* (University of Toronto Press, 2003); but particularly for its blue sky details, the idea that it works as a kaleidoscope, see Ellen Swift and Anne Alwis, "The Role of Late Antique Art in Early Christian Worship: A Reconsideration of the Iconography of the 'Starry Sky' in the 'Mausoleum' of Galla Placidia," *Papers of the British School at Rome* 78 (2010), pages 193–217. If you want to dive into the primary sources themselves, a decision we always recommend heartily, here start with Jordanes, *The Gothic History*, translated by C. Mierow (Oxford University Press, 1915).

Chapter 2

A solid discussion of Theodoric's attempt to recapture Rome can be found in Jonathan J. Arnold, *Theoderic and the Roman Imperial Restoration*

(Cambridge University Press, 2014). Averil Cameron, *Procopius and the Sixth Century* (Routledge, 1996), offers a great introductory pathway into the world of the historian and the monarchs he served, though more specialized analysis can be found in academic articles such as Henning Börm, "Procopius, His Predecessors, and the Genesis of the Anecdota: Antimonarchic Discourse in Late Antique Historiography," in *Antimonarchic Discourse in Antiquity*, edited by Henning Börm (Franz Steiner Verlag, 2015), pages 305–46. For a necessary reevaluation of the critical role Theodora played during the Byzantine sixth century, read David Potter's *Theodora: Actress, Empress, Saint* (Oxford University Press, 2015); and if you want to know more about the continuing medieval tradition of chariot racing, the sport that ostensibly almost brought down the empire, we recommend Fik Meijer, *Chariot Racing in the Roman Empire* (Johns Hopkins University Press, 2010). But over all of this looms Hagia Sophia. On that building specifically, we suggest Bissera V. Pentcheva, *Hagia Sophia: Sound, Space, and Spirit in Byzantium* (Pennsylvania State University Press, 2017). On the architectural world of Hagia Sophia, turn to Robert Ousterhout, *Eastern Medieval Architecture: The Building Traditions of Byzantium and Neighboring Lands* (Oxford University Press, 2019). And, again, we always encourage you to read some of the primary sources for yourself. Procopius himself always entertains, so see his collected works translated within the Loeb Classical Library series. His *Secret History*, translated by Peter Sarris (Penguin, 2007), is readily available as well.

CHAPTER 3

The world-changing events that occurred in Arabia during the seventh century have understandably inspired a literature that's as vast as any topic in all of human history. To start with the figure at the center of those events, we suggest Kecia Ali, *The Lives of Muhammad* (Harvard

University Press, 2014). Also important is to think about the religious, cultural, and political movement that Muhammad began, as well as how it developed in the years immediately after his death, and for that see Fred M. Donner, *Muhammad and the Believers: At the Origins of Islam* (Harvard University Press, 2012). There are many works detailing how the believers quickly moved out of the Arabian Peninsula, spreading across the Mediterranean world and beyond, encountering (and defeating) Byzantium and Persia, but the reader should beware of modern polemic masquerading as history. A general introduction such as Hugh Kennedy, *The Great Arab Conquests: How the Spread of Islam Changed the World We Live In* (Da Capo, 2008), offers a good overview of the period, while the full extent of the expansion can be grasped in more specialized academic work like Michael Flecker, "A Ninth-Century Arab or Indian Shipwreck in Indonesian Waters," *International Journal of Nautical Archaeology* 29 (2000), pages 199–217. The specifics of the encounter with Byzantium, and Patriarch Sophronios, rightly fascinate, and more detail can be found in Jacob Lassner, *Medieval Jerusalem: Forging an Islamic City in Spaces Sacred to Christians and Jews* (University of Michigan Press, 2017); or the collection of essays in *Byzantium and Islam*, edited by Helen C. Evans and Brandie Ratliff (Yale University Press, 2012); or in much more detail in articles such as Daniel Sahas, "The Face to Face Encounter Between Patriarch Sophronius of Jerusalem and the Caliph ʿUmar Ibn Al-Khaṭṭāb: Friends or Foes?" in *The Encounter of Eastern Christianity with Early Islam*, edited by Emmanouela Grypeou and Mark N. Swanson (Brill, 2006), pages 33–44.

CHAPTER 4

The two primary threads that entangle in this chapter are, first, on Italy and the continuation of the city of Rome in the early Middle Ages, and second, the relationships between elite women and church

leaders (and historians) of the time. For Italy, turn to Chris Wickham, *Early Medieval Italy: Central Power and Local Society 400–1000* (University of Michigan Press, 1989); also Christina La Rocca, *Italy in the Early Middle Ages, 476–1000* (Oxford University Press, 2002). On that peninsula and in that city lay the nascent papacy, with Gregory the Great at its center. On him there are numerous biographies. A recent one is George E. Demacopoulos, *Gregory the Great: Ascetic, Pastor, and First Man of Rome* (University of Notre Dame Press, 2015). But as we labored to show in this chapter, if we really want to know more about the early European medieval world, men are only part of the story, half of the picture. On the central role that women played, we suggest works such as Jennifer C. Edwards, *Superior Women: Medieval Female Authority in Poitiers' Abbey of Sainte-Croix* (Oxford University Press, 2019), and E. T. Dailey, *Queens, Consorts, Concubines: Gregory of Tours and Women of the Merovingian Elite* (Brill, 2015); as well as more specialized articles such as Ross Balzaretti, "Theodelinda, 'Most Glorious Queen': Gender and Power in Lombard Italy," *Medieval History Journal* 2 (1999), pages 183–207, and Walter J. Wilkins, "Submitting the Neck of Your Mind: Gregory the Great and Women of Power," *Catholic Historical Review* 77 (1991), pages 583–94. If you want to go back to the sources themselves, works by the two Gregorys (of Tours and the Great) are generally available in decent translations online. There's also Gregory of Tours, *A History of the Franks*, translated by Lewis Thorpe (Penguin, 1976).

CHAPTER 5

Although the poem *Beowulf* looms large in most people's imaginations when they think of early medieval England, and rightfully so, we hope that this chapter has shown how much more there is to this place and this period. Still, you should read *Beowulf*. We both enjoy

Beowulf, translated by Seamus Heaney (W. W. Norton, 2001), as well as a very recent translation that aligns with how we deal with the story here, *Beowulf*, by Maria Dahvana Headley (FSG, 2020). Although it's just one monument, it's a magnificent one, and the study of the Ruthwell Cross might begin with Eamonn Ó Carragáin, *Ritual and Rood: Liturgical Images and the Old English Poems of the Dream of the Rood Tradition* (University of Toronto Press, 2005), but our discussion also owes a lot to the insightful scholarship of Catherine E. Karkov, "Weaving Words on the Ruthwell Cross," in *Textiles, Text, Intertext: Essays in Honour of Gale R. Owen-Crocker*, edited by Maren Clegg Hyer, Jill Frederick, et al. (Boydell & Brewer, 2016), pages 183–98. Also, on medieval European art generally, Herbert L. Kessler, *Seeing Medieval Art* (University of Toronto Press, 2004), is brilliant. Women play an important part of the story of this (and almost every) chapter, and rightfully so. For more here on queens, see generally Theresa Earenfight, *Queenship in Medieval Europe* (Palgrave, 2013). On religious women, Sarah Foot, *Veiled Women: The Disappearance of Nuns from Anglo-Saxon England*, 2 vols. (Routledge, 2000); and also about the fascinating leader of Whitby, see Patrick J. Wormald, "Hilda, Saint and Scholar," in *The Times of Bede: Studies in Early English Christian Society and Its Historian*, edited by Patrick Wormald and Stephen Baxter (Wiley, 2006), pages 267–76. Most of the work of Bede is available online but his most famous work is *Ecclesiastical History of the English People*, translated by Leo Sherley-Price (Penguin, 1990). Finally, importantly, the idea of early medieval Britain as a crossroads, a place on the periphery but interconnected to many other places, has been the subject of intense study in the last few years. See generally for a culture that evolved and adapted within a larger world Susan Oosthuizen, *The Emergence of the English* (ARC Humanities Press, 2019); as well as the work of Dr. Caitlin Green, collected at www.caitlingreen.org. Further on this topic, we recommend Mary Rambaran-Olm and Erik Wade, *Race in Early Medieval England*

(Cambridge Elements, 2021); but also consider local studies such as S. E. Groves et al, "Mobility Histories of 7th–9th Century AD People Buried at Early Medieval Bamburgh, Northumberland, England," *American Journal of Physical Anthropology* 150 (2013), pages 462–76.

CHAPTER 6

The story of Charlemagne's elephant Abul-Abass still delights, and his story has recently been unearthed in detail in Paul M. Cobb, "Coronidis Loco: On the Meaning of Elephants, from Baghdad to Aachen," in *Interfaith Relationships and Perceptions of the Other in the Medieval Mediterranean: Essays in Memory of Olivia Remie Constable*, edited by Robin Vose et al. (Palgrave, 2021); and you can read more about the ideological connotations of his arrival at Aachen in Paul Edward Dutton, *Charlemagne's Mustache and Other Cultural Clusters of a Dark Age* (Palgrave, 2004). If you want to take a step back to get an overview of the period as a whole, the best place to start is now Marios Costambeys, Matthew Innes, and Simon MacLean, *The Carolingian World* (Cambridge University Press, 2011), as well as the collected and translated primary sources in Paul Edward Dutton, *Carolingian Civilization: A Reader* (University of Toronto Press, 2004), and the full text of the *Royal Frankish Annals* in *Carolingian Chronicles*, translated by Bernhard Walter Scholz (University of Michigan Press, 1970). To learn more about Charlemagne himself, there's now the magisterial and essential Janet L. Nelson, *King and Emperor: A New Life of Charlemagne* (University of California Press, 2019); but you can also learn more about the afterlife and legend of the emperor in Matthew Gabriele, *An Empire of Memory: The Legend of Charlemagne, the Franks, and Jerusalem Before the First Crusade* (Oxford University Press, 2011). The best way to find out more about Dhuoda is to read her words. See Dhuoda, *Handbook for William: A Carolingian Woman's Counsel for Her Son*, translated

by Carol Neel (Catholic University of America Press, 1999). Valerie L. Garver, *Women and Aristocratic Culture in the Carolingian World* (Cornell University Press, 2012), and Andrew J. Romig, *Be a Perfect Man: Christian Masculinity and the Carolingian Aristocracy* (University of Pennsylvania Press, 2017), both also do great work to help us understand both the aristocracy and the period as a whole.

CHAPTER 7

There are so many books on the Norse and their legacy, many appearing in just the past few years. Among them, Neil Price, *Children of Ash and Elm: A History of the Vikings* (Basic Books, 2020), stands out, and Anders Winroth, *The Age of the Vikings* (Princeton University Press, 2014), although a few years older, is still very good. Also critically important to remember is that there weren't just men in the Viking world; for that look to the new Jóhanna Katrín Friðriksdóttir, *Valkyrie: The Women of the Viking World* (Bloomsbury, 2020). For a sense of the scope of their voyages into Asia, see such works as Peter Frankopan, *The Silk Roads: A New History of the World* (Knopf, 2016), but also Marianne Vedeler, *Silk for the Vikings* (Oxbow Books, 2014). One of the main reasons Vikings traveled was to enslave people. They were a slave society and we shouldn't ever forget or romanticize that. For more on that aspect, see Ruth Karras, *Slavery and Society in Medieval Scandinavia* (Yale University Press, 1988), as well as more recently and more generally, Alice Rio, *Slavery After Rome, 500–1100* (Oxford University Press, 2017). Many primary sources from the period survive, though often, alas, long postdating the events they describe. Many of those texts have been published as Penguin Classics. Of those, you could select *The Vinland Sagas*, translated by Keneva Kunz (Penguin, 2008), or Snorri Sturluson, *King Harald's Saga*, translated by Magnus Magnusson and Hermann Pálsson (Penguin, 1976). To balance those,

perhaps look to Ibn Fadlan, *Ibn Fadlan and the Land of Darkness: Arab Travellers in the Far North*, translated by Paul Lunde and Caroline Stone (Penguin, 2012).

CHAPTER 8

The turn of the first millennium in Europe, the moments of the "Terrors of the Year 1000" and "feudal revolution," has tended to fall between the scholarly cracks of late, with attention (at least in the English-speaking world) focusing on the Carolingians before and Crusades after. There is still a lot to explore in this period. Our chapter considers interrelated religious and political changes. If you want to know more about the aristocracy, start with Dominique Barthélemy, *The Serf, the Knight, and the Historian*, translated by Graham Robert Edwards (Cornell University Press, 2009), or Constance Brittain Bouchard, *Strong of Body, Brave & Noble: Chivalry and Society in Medieval France* (Cornell University Press, 1998). For more on the connection between religious changes and political ones, Katherine Allen Smith, *War and the Making of Medieval Monastic Culture* (Boydell & Brewer, 2013), is exceptional; and the brief Geoffrey Koziol, *The Peace of God* (Arc Humanities Press, 2018), is a good, readable introduction. For more on medieval religious devotion to saints, still essential is Peter Brown, *The Cult of the Saints: Its Rise and Function in Latin Christianity* (University of Chicago Press, 2014). The creation of castles is an important development in this period too, and we benefited from Charles Coulson, *Castles in Medieval Society: Fortresses in England, France, and Ireland in the Central Middle Ages* (Oxford University Press, 2003). For a reevaluation of the meaning of apocalyptic expectation in the early European Middle Ages, the essays in *Apocalypse and Reform from Late Antiquity to the Middle Ages*, edited by Matthew Gabriele and James T. Palmer (Routledge, 2018), are quite good. But read the sources; despite the

period around 1000 being the stereotypical darkest of dark ages, there are many. We centered our gaze on Odo of Cluny, *Life of Saint Gerald of Aurillac*, translated by Gerard Sitwell, in *Soldiers of Christ: Saints and Saints' Lives from Late Antiquity and the Early Middle Ages*, edited by Thomas F. X. Noble and Thomas Head (Pennsylvania State University Press, 1995), 293–362; and Bernard of Angers, *The Book of Sainte Foy's Miracles*, in *The Book of Sainte Foy*, translated by Pamela Sheingorn (University of Pennsylvania Press, 1995).

CHAPTER 9

The Crusades have likely sparked more historical writing than any other event in medieval European history. Most of the primary sources have been translated. Extracts from the Latin sources are collected in the readily available Edward Peters, *The First Crusade: "The Chronicle of Fulcher of Chartres" and Other Source Materials* (University of Pennsylvania Press, 1998); and the most-copied full-text Latin account can be found at Robert the Monk, *History of the First Crusade*, translated by Carol Sweetenham (Ashgate, 2005). Important to the events, but written much earlier, are the works of Augustine of Hippo, especially his mammoth *City of God*, translated by Henry Bettenson (Penguin, 2004). Thankfully, sources from languages other than Latin and European vernaculars are now being translated and made available to us. For a Byzantine perspective, you can't do much better than Anna Comnena, *The Alexiad*, translated by E. R. A. Sewter (Penguin, 2009); and for a Syrian Arabic one, Usama ibn Munqidh, *The Book of Contemplation: Islam and the Crusades*, translated by Paul M. Cobb (Penguin, 2008). As far as modern scholarship, English-speakers are spoiled for choice. Absolutely start with the brief and insightful Susanna A. Throop, *The Crusades: An Epitome* (Kismet Press, 2018), and the important Paul M. Cobb, *The Race for Paradise: An Islamic History of the Crusades*

(Oxford University Press, 2016). Related to the beginnings of the movement, Jay Rubenstein, *Armies of Heaven: The First Crusade and the Quest for the Apocalypse* (Basic Books, 2011), stands out; while the subtle textures of Christian holy war have been teased out by scholars such as Elizabeth Lapina, *Warfare and the Miraculous in the Chronicles of the First Crusade* (Pennsylvania State University Press, 2015); Beth C. Spacey, *The Miraculous and the Writing of Crusade Narrative* (Boydell & Brewer, 2020); and Katherine Allen Smith, *The Bible and Crusade Narrative in the Twelfth Century* (Boydell & Brewer, 2020).

Chapter 10

For more on Peter of Cluny's journey south and the translation of the Quran into Latin, the critical work is Thomas E. Burman, *Reading the Qur'an in Latin Christendom, 1140–1560* (University of Pennsylvania Press, 2009); and also Dominique Iogna-Prat, *Order and Exclusion: Cluny and Christendom Face Heresy, Judaism, and Islam (1000–1150)*, translated by Graham Robert Edwards (Cornell University Press, 2003). For more general overviews of multireligious Iberia, see María Rosa Menocal, *The Ornament of the World: How Muslims, Jews and Christians Created a Culture of Tolerance in Medieval Spain* (Back Bay Books, 2003); as well as Jerrilynn D. Dodds, María Rosa Menocal, and Abigail Krasner Balbale, *The Arts of Intimacy: Christians, Jews, and Muslims in the Making of Castilian Culture* (Yale University Press, 2009); and most recently Brian A. Catlos, *Kingdoms of Faith: A New History of Islamic Spain* (Basic Books, 2018). In addition, Hussein Fancy, *The Mercenary Mediterranean: Sovereignty, Religion, and Violence in the Medieval Crown of Aragon* (University of Chicago Press, 2018), engages just these topics with a narrower scope but some important observations about how modern understandings of religion have been projected backward onto the medieval past. To that end, not about medieval Europe specifically, but important to the

debate is Tomoko Masuzawa, *The Invention of World Religions; or How European Universalism Was Preserved in the Language of Pluralism* (University of Chicago Press, 2005). The stakes of the debate as a whole are well examined by Alejandro García-Sanjuán, "Rejecting al-Andalus, Exalting the Reconquista: Historical Memory in Contemporary Spain," *Journal of Medieval Iberian Studies* 10 (2018), pages 127–45; and S. J. Pearce, "The Myth of the Myth of the Andalusian Paradise: The Extreme Right and the American Revision of the History and Historiography of Medieval Spain," in *Far-Right Revisionism and the End of History: Alt/ Histories*, edited by Louie Dean Valencia-García (Routledge, 2020), pages 29–68. Finally, an excellent collection of primary sources from all three religious traditions of medieval Iberia is contained in *Medieval Iberia: Readings from Christian, Muslim, and Jewish Sources*, edited by Olivia Remie Constable (University of Pennsylvania Press, 2011).

CHAPTER II

The life of the great Rambam (Moses Maimonides) has inspired numerous biographies, including relatively recently Sarah Stroumsa, *Maimonides in His World: Portrait of a Mediterranean Thinker* (Princeton University Press, 2009), and Joel L. Kraemer, *Maimonides: The Life and World of One of Civilization's Greatest Minds* (Doubleday, 2010). The same could be said for the other central figure in this chapter, the sultan Saladin. Jonathan Phillips, *The Life and Legend of the Sultan Saladin* (Yale University Press, 2019), is a fine very recent biography; and we also recommend, for his time in Egypt, Ya'acov Lev, *Saladin in Egypt* (Brill, 1998). The larger social and political forces that buffeted Maimonides's life, pushing him from Iberia, across North Africa, and finally to Egypt, are fascinating in and of themselves. For more on those, see Amira K. Bennison, *The Almoravid and Almohad Empires* (Edinburgh University Press, 2016), as well as more specifically on the question

of conversion in this period, Maribel Fierro, "Again on Forced Conversion in the Almohad Period," *Forced Conversion in Christianity, Judaism, and Islam*, edited by Mercedes García-Arenal and Yonatan Glazer-Eytan (Brill, 2019), pages 111–32. Also interesting are the (primarily trading) contacts that linked North Africa with southern Asia in this period. On that, see Shelomo Dov Goitein and Mordechai Friedman, *India Traders of the Middle Ages* (Brill, 2007). And of course you should read Maimonides for yourself: see his *Guide for the Perplexed*, translated by Chaim Rabin (Hackett, 1952).

CHAPTER 12

We cannot convey how much of a joy and delight it is to read Marie de France, so you should just do it for yourself with her *Lais*, translated by Keith Busby (Penguin, 1999). Hildegard's visions are also wonderful. See Hildegard of Bingen, *Selected Writings*, translated by Mark Atherton (Penguin, 2001). And as should be expected, there's a ton of really great analysis of both of their work, for example, Geoff Rector, "Marie de France, the Psalms, and the Construction of Romance Authorship," in *Thinking Medieval Romance*, edited by Katherine C. Little and Nicola McDonald (Oxford University Press, 2018), pages 114–33; as well as the various essays collected in *A Companion to Marie de France*, edited by Logan E. Whalen (Brill, 2011); and Sharon Kinoshita and Peggy McCracken, *Marie de France: A Critical Companion* (D. S. Brewer, 2014). On Hildegard, see such works as Sabina Flanagan, *Hildegard of Bingen: A Visionary Life* (Routledge, 1998), and *A Companion to Hildegard of Bingen*, edited by Beverly Mayne Kienzle, Debra L. Stoudt, and George Ferzoco (Brill, 2013). Of the three women around whom this chapter revolves, Eleanor of Aquitaine is likely the most famous, but also the one whom we oddly perhaps know the least about, and who suffers the most from a plethora of mediocre biogra-

phies. On her life, we suggest *Eleanor of Aquitaine: Lord and Lady*, edited by Bonnie Wheeler and John C. Parsons (Palgrave, 2003), and Ralph V. Turner, *Eleanor of Aquitaine: Queen of France, Queen of England* (Yale University Press, 2011). Related to the Arthur legend, we benefited from the work of Martin Aurell, "Henry II and Arthurian Legend," in *Henry II: New Interpretations*, edited by Christopher Harper-Brill and Nicholas Vincent (Boydell & Brewer, 2007), pages 362–94. Finally, a nice revision to the Haskins thesis can be found in John Cotts, *Europe's Long Twelfth Century: Order, Anxiety, and Adaptation* (Palgrave, 2012); and for thinking about "renaissances" generally, Joan Kelly-Gadol, "Did Women Have a Renaissance?" in *Women, History, and Theory: The Essays of Joan Kelly* (University of Chicago Press, 1984), pages 175–201.

Chapter 13

This chapter centers on the rise of the papacy as an institution, pivoting around the career of one figure—Innocent III. There's no finer introduction to the institution in the Middle Ages than Brett Edward Whalen, *The Medieval Papacy* (Palgrave, 2014). On Innocent himself, see John C. Moore, *Pope Innocent III (1160/61–1216): To Root Up and to Plant* (University of Notre Dame Press, 2009). Crusading, as we've seen, dominated the papal world at this time. For the expeditions facing east, against Muslims and the Byzantines, look to Jessalynn Bird, *Papacy, Crusade, and Christian-Muslim Relations* (Amsterdam University Press, 2018), as well as David M. Perry, *Sacred Plunder: Venice and the Aftermath of the Fourth Crusade* (Pennsylvania State University Press, 2015). But then Europe turned inward, and began to be consumed by concern with heresy. The work of R. I. Moore is essential and field-defining here. His most recent book is *The War on Heresy* (Belknap Press, 2014). One can also look to general introductions to medieval heresy such as those of Christine Caldwell Ames, *Medieval*

Heresies: Christianity, Judaism, and Islam (Cambridge University Press, 2015); and Jennifer Kolpacoff Deane, *A History of Medieval Heresy and Inquisition* (Rowman & Littlefield, 2011). There are many books on the Albigensians specifically; many of those traffic in conspiracy theories and new age nonsense. To help cut through that, look to Mark Gregory Pegg, *A Most Holy War: The Albigensian Crusade and the Battle for Christendom* (Oxford University Press, 2009). The amazing, almost too amazing to be believed, story of the sainted dog Guinefort was first elaborated by Jean-Claude Schmitt, *The Holy Greyhound: Guinefort, Healer of Children Since the Thirteenth Century*, translated by Martin Thom (Cambridge University Press, 2009).

CHAPTER 14

The intellectual ferment of Paris during the thirteenth century is worthy of a book-length treatment on its own. Look out for Cecilia Gaposchkin's, coming soon. On the brilliant buildings in and around the city, you can read Suger's own theories on light and his church in Suger of Saint-Denis, *On the Abbey Church of St-Denis and Its Art Treasures*, translated by Erwin Panofsky (Princeton University Press, 1979). On Sainte-Chapelle and its connection to King Louis IX, see Meredith Cohen, *The Sainte-Chapelle and the Construction of Sacral Monarchy: Royal Architecture in Thirteenth-Century Paris* (Cambridge University Press, 2014); and Alyce A. Jordan, *Visualizing Kingship in the Windows of the Sainte-Chapelle* (Brepols, 2002). Related to the rivalry among the churches on the Île-de-la-Cité, Rebecca A. Baltzer, "Notre-Dame and the Challenge of the Sainte-Chapelle in Thirteenth-Century Paris," in *Chant, Liturgy, and the Inheritance of Rome: Essays in Honour of Joseph Dyer*, edited by Daniel J. DiCenso and Rebecca Maloy (Boydell & Brewer, 2017), pages 489–524. But brilliant stained glass wasn't the only light of the city, as we've seen. There was also fire. On the persecution of

minority communities, especially the Jews of Europe, during this pe-
riod, see generally David Nirenberg, *Communities of Violence: Persecution
of Minorities in the Middle Ages* (Princeton University Press, 2015). On
France specifically, William Chester Jordan, *The French Monarchy and
the Jews: From Philip Augustus to the Last Capetians* (University of Penn-
sylvania Press, 1989); and read the sources themselves at *The Trial of
the Talmud: Paris, 1240*, translated by John Friedman and Jean Connell
Hoff (Pontifical Institute of Mediaeval Studies, 2012). For those who
did the persecuting, on the formation of the Inquisition, see James
B. Given, *Inquisition and Medieval Society: Power, Discipline, and Resistance
in Languedoc* (Cornell University Press, 2001). On the birth of the
medieval university and the intellectual culture that opened minds
and crushed dissent, start with Ian P. Wei, *Intellectual Culture in Medieval
Paris: Theologians and the University, c. 1100–1330* (Cambridge University
Press, 2012).

CHAPTER 15

The movement across the steppe, between Europe and Asia, is per-
haps one of the most consequential in all the Bright Ages. Often,
discussions about that persistent encounter across centuries centers
around religious contact, first in the modern Middle East. For that,
there's the exceptional Christopher MacEvitt, *The Crusades and the
Christian World of the East: Rough Tolerance* (University of Pennsylvania
Press, 2009). As that encounter moved deeper into Asia, particularly
in the thirteenth and fourteenth centuries, it encompassed the fri-
ars. Still useful is Christopher Dawson, *Mission to Asia* (University of
Toronto Press, 1980); and you can read one of those friars' journals
in William of Rubruck, *The Mission of Friar William of Rubruck: His Jour-
ney to the Court of the Great Khan Möngke, 1253–1255*, translated by Peter
Jackson (Hackett, 2009). But more recent work, attentive to issues of

race, has made us rethink how we talk about this period. See Shirin Azizeh Khanmohamadi, *In the Light of Another's Word: European Ethnography in the Middle Ages* (University of Pennsylvania Press, 2013); as well as Sierra Lomuto, "Race and Vulnerability: Mongols in Thirteenth-Century Ethnographic Travel Writing," in *Rethinking Medieval Margins and Marginality*, edited by Anne E. Zimo et al. (Routledge, 2020), pages 27–42. It's critically important that, as we tried to show in this chapter, we make sure we think of the Mongols and other groups along the Silk Road as subjects and not just objects. For that, such works as Richard Foltz, *Religions of the Silk Road* (St. Martin's Press, 1999), and Jack Weatherford, *The Secret History of the Mongol Queens: How the Daughters of Genghis Khan Rescued His Empire* (Broadway, 2011); as well as more specialized articles noting the expansive connections the empire made, such as Hosung Shim, "The Postal Roads of the Great Khans in Central Asia under the Mongol-Yuan Empire," *Journal of Song-Yuan Studies* 44 (2014), pages 405–69.

CHAPTER 16

There are many massive and thoughtful collections of sources that enhance our understanding of the Black Death both in Europe and across the Mediterranean. Two such books are *The Black Death*, edited by Rosemary Horrox (Manchester University Press, 1994), and John Aberth, *The Black Death: The Great Mortality of 1348–1350: A Brief History with Documents* (Bedford St. Martins, 2005). David Herlihy, *The Black Death and the Transformation of the West* (Harvard University Press, 1997), attempts to think through the transformations the plague brought. His conclusions should be treated with caution, though, as new research has demonstrated how several of his hypotheses need to be revisited. More recently, Bruce M. S. Campbell, *The Great Transition: Climate, Disease and Society in the Late Medieval World* (Cambridge

University Press, 2016), has attempted to do something similar and think about the big-picture changes wrought not just by plague but by significant climate change at the end of medieval Europe. But if one wants to understand the Black Death itself, one absolutely must start with the work of Monica H. Green. Her recent essay "The Four Black Deaths," *American Historical Review* 125 (2020), pages 1601–31, has changed the way we think about everything. In addition, the collection of essays in *Pandemic Disease in the Medieval World: Rethinking the Black Death*, edited by Monica H. Green (Arc Humanities Press, 2015), were first steps toward demonstrating how global the Second Plague Pandemic truly was. The essay in that collection by Robert Hymes, "Epilogue: A Hypothesis on the East Asian Beginnings of the *Yersinia pestis* Polytomy," pages 285–308, is particularly important for showing the plague's origins, as well as the necessity of interdisciplinarity in researching this topic. Gérard Chouin, "Reflections on Plague in African History (14th–19th c.)," *Afriques* 9 (2018), also shows why Africa needs to be a part of this conversation. Finally, when talking about disease, we cannot forget that medieval people were *people*, with bodies that suffered. To get a sense of how Europeans in the period thought about themselves, see Jack Hartnell, *Medieval Bodies: Life and Death in the Middle Ages* (W. W. Norton, 2019).

CHAPTER 17

Everyone should read Dante. One of the most readily available translations is Dante Aligheri, *The Divine Comedy*, translated by Mark Musa (Penguin, 2014). Dante's time in both Florence and Ravenna, outside his writings, is rich and exceptional, and brought vividly to life in John Took, *Dante* (Princeton University Press, 2020). You could spend a lifetime reading commentary on Dante, but in English and on the narrow topic of Ravenna, you might look back to Rachel Jacoff,

"Sacrifice and Empire: Thematic Analogies in San Vitale and the Paradiso," in *Renaissance Studies in Honour of Craig Hugh Smyth* (Giunti Barbéra, 1985), volume 1, pages 317–32; or more broadly, on mosaics and Byzantine art, E. D. Karampetsos, *Dante and Byzantium* (Somerset Hall Press, 2009), especially for an early discussion of the mosaic of the emperor Justinian. On Dante's native Florence, the focal point of so much scholarship on art and the so-called Italian Renaissance, look to works like John Najemy, *A History of Florence* (Wiley-Blackwell, 2008); or more specialized works such as Franklin K. B. Toker, "Florence Cathedral: The Design Stage," *Art Bulletin* 60 (1978), pages 214–31. There were, of course, other important cities on the Italian peninsula during the late Middle Ages, and the ferment caused by their rivalries is a cause of understandable, and endless, fascination. For example, on Venice, see Deborah Howard, *Venice and the East* (Yale University Press, 2000); or for an overview you could start with Trevor Dean and Daniel Philip Waley, *The Italian City Republics* (Routledge, 2013); on the economic and social life of those cities, Sheilagh Ogilvie, *Institutions and European Trade: Merchant Guilds 1000–1800* (Cambridge University Press, 2011). But as we mention in the chapter, we ought always to be thinking of cities as part of the medieval landscape, and there's now no better place to get a sense of them than the meditations in Miri Rubin, *Cities of Strangers: Making Lives in Medieval Europe* (Cambridge University Press, 2020).

Epilogue

On the fascinating debate between the friar de las Casas and the humanist Sepulvéda—perhaps the end of the Bright Ages—there are many works worthy of your time, including Anthony Pagden, *The Fall of Natural Man: The American Indian and the Origins of Comparative Ethnology*

(Cambridge University Press, 1982), and Lewis Hanke, *All Mankind Is One: A Study of the Disputation Between Bartolomé de Las Casas and Juan Ginés de Sepúlveda in 1550 on the Intellectual and Religious Capacity of the American Indians* (Northern Illinois University Press, 1994); as well as, most recently, the excellent Rolena Adorno, *Polemics of Possession in Colonial Spanish American Narrative* (Yale University Press, 2007). That debate, however, didn't set out a "middle" time period. For that, we certainly owe quite a bit to Petrarch, and the old but insightful essay by Theodore E. Mommsen, "Petrarch's Conception of the 'Dark Ages,'" *Speculum* 17 (1942), pages 226–42, remains helpful. Also important here is the work of the nineteenth-century historian, particularly Jacob Burckhardt, *The Civilization of the Renaissance in Italy*, translated by S. G. C. Middlemore (Penguin, 1990). Burckhardt inadvertently remains useful though, demonstrating how the *idea* of the Middle Ages shapes how we think about the period. Studying those ideas, especially in the twenty-first century, can be as important as studying the period itself. Luckily, we are in awe of the magnificent work being done in this regard. For an overview, begin with works like David Matthews, *Medievalism: A Critical History* (Boydell & Brewer, 2015); or Andrew B. R. Elliott, *Medievalism, Politics, and Mass Media: Appropriating the Middle Ages in the Twenty-First Century* (D. S. Brewer, 2017); or the essays collected in *Medievalisms in the Postcolonial World: The Idea of "the Middle Ages" Outside Europe*, edited by Kathleen Davis and Nadia Altschul (Johns Hopkins University Press, 2010). Finally, the issue of race in the Middle Ages, as well as that idea's legacy, as it's been appropriated and deployed is finally getting the wider scholarly attention it deserves. See for example Geraldine Heng, *The Invention of Race in the European Middle Ages* (Cambridge University Press, 2018), and Cord J. Whitaker, *Black Metaphors: How Modern Racism Emerged from Medieval Race-Thinking* (University of Pennsylvania Press, 2019). In the end, the humanity and

horror of the Bright Ages belongs to everyone. By examining the medieval past as it's been analyzed by Black Americans, Matthew X. Vernon, *The Black Middle Ages: Race and the Construction of the Middle Ages* (Palgrave, 2018), shows us possible worlds—a goal so very close to the heart of our *The Bright Ages*.

INDEX

ABOUT THE AUTHORS

MATTHEW GABRIELE is a professor of medieval studies and chair of the Department of Religion and Culture at Virginia Tech. His research and teaching focus on religion, violence, nostalgia, and apocalypse (in various combinations), whether in the Middle Ages or the modern world. He is the author of the book *An Empire of Memory: The Legend of Charlemagne, the Franks, and Jerusalem Before the First Crusade*, many articles on medieval Europe and the memory of the Middle Ages, and he has edited several other academic volumes. His public writing has appeared in numerous newspapers and magazines, and interviews with him have aired locally, nationally, and internationally. See more at www.profgabriele.com.

DAVID M. PERRY is a journalist, medieval historian, and senior academic advisor in the History Department at the University of Minnesota. He was formerly a professor of history at Dominican University for ten years. His first book was *Sacred Plunder: Venice and the Aftermath of the Fourth Crusade*. His journalism on history, disability, politics, parenting, and other topics has appeared in the *New York Times*, the *Washington Post*, the *Nation*, *The Atlantic*, CNN, and many others. See more at www.davidmperry.com.